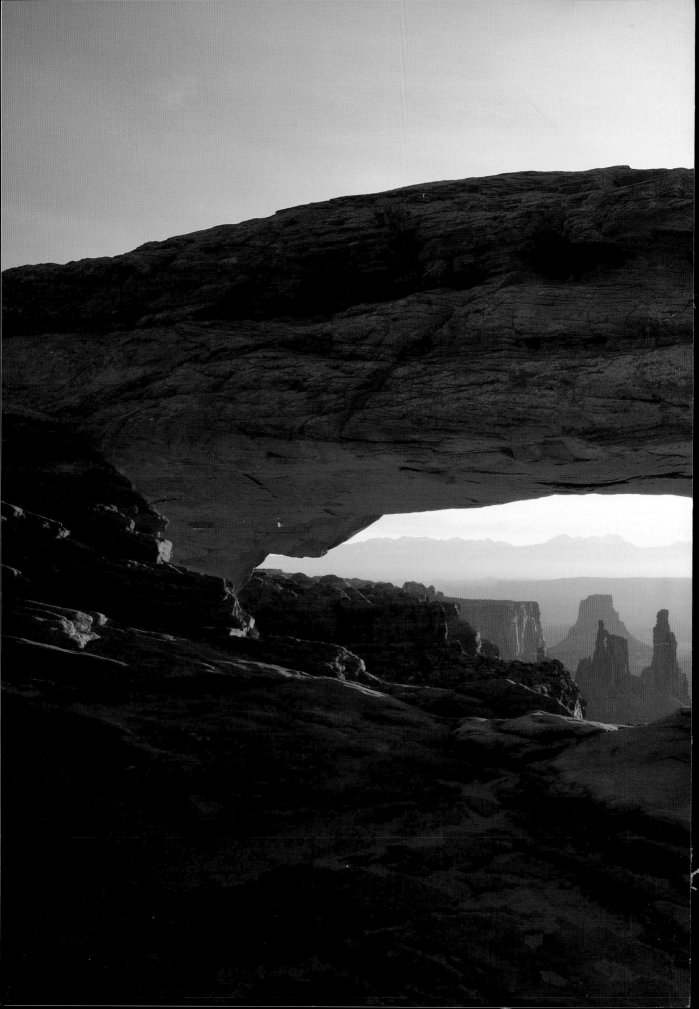

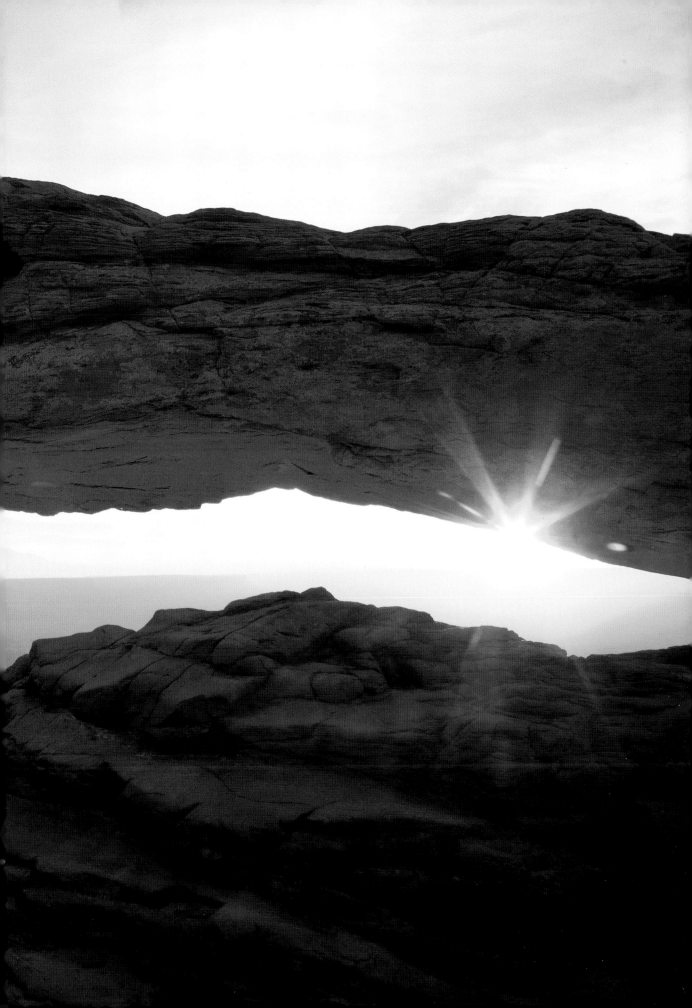

Text by Michael Bright

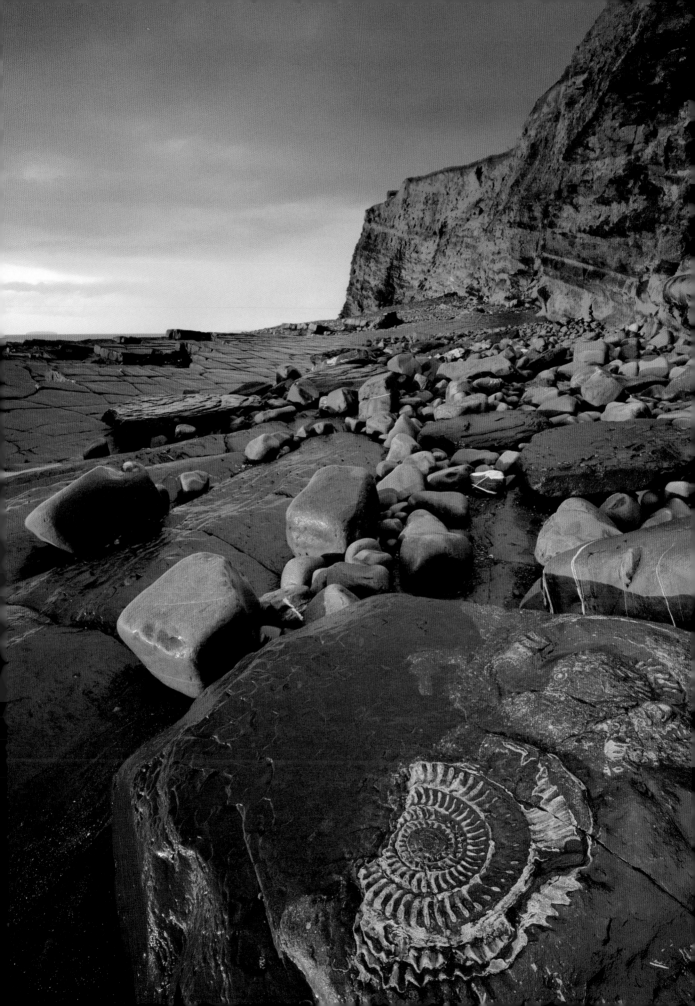

INTRODUCTION

The Earth was born of fire. About 4.54 billion years ago, a dense, swirling cloud of dust and gas collapsed under its own gravity and came to form a gigantic spinning disc in the Milky Way galaxy. The Sun formed at its centre, and the material left over went to build the planets of the Solar System, including the Earth. At first, our home looked very different. The sky was dark, for there was no atmosphere, and an inferno of fiery magma oceans blazed all across the Earth's surface. They bubbled with molten rock more than 1,000 kilometres deep, at an estimated temperature of more than 1,000°C. Asteroids, comets and meteorites rained down from space and slammed into our young planet. They fed the magma oceans, and brought valuable minerals, delivered water, and may even have carried the basic ingredients of life.

Scientists call this earliest eon in Earth's history 'the Hadean', from the Greek god of the underworld, but Hades did not rule for long. Water is thought to have been present as early as 4.4 billion years ago, so the hellish conditions of the early Earth must have given way to periods when the climate was cooler and wetter. It was a time when life could have appeared for the very first time.

The water was either locked away in space rocks that fell to Earth or was spewed out as water vapour from the countless volcanoes that dominated the primeval landscape. Their vents out-gassed an atmosphere, and, as the planet cooled, iron sank into the depths, creating a core, along with the other layers of the planet's interior – the crust and mantle. There was and still is fire at the centre of the Earth. Today the highest temperature on our planet is at the boundary between the Earth's solid inner core and molten outer core, a staggering 6,000°C, the same temperature as the surface of the Sun.

The Masterpieces of the Earth are located on the Earth's crust, the same layer on which we live. This thin, solid outer layer, like the skin of an orange, 'floats' on the top of the viscous part of the mantle. Together, the crust and uppermost layer of the mantle are divided into immense tectonic plates, great

moving slabs of the Earth's surface that carry the continents across the world like a gigantic and constantly moving jigsaw puzzle.

The most geologically active areas are at the edges of the plates, precisely where they are created or destroyed. Here, they might collide violently and fold like concertinas to build massive mountains, or dive one below the other to form deep ocean trenches. The margins also ooze magma from the Earth's interior and give rise to astounding geological features such as the Mid-Ocean Ridge system, the longest mountain chain on the planet, which is almost totally underwater. In the North Atlantic, Iceland straddles the Mid-Atlantic Ridge section. It sits over a hotspot on the ridge, which has given rise to hundreds of geothermal features, such as geysers and hot springs, and 30 active volcano systems, of which 13 have erupted since people moved to the island in 874 CE.

The ridge is what geologists describe as a 'divergent plate boundary', where magma flows out from the depths of the Earth and moves to either side, adding new material to the Eurasian plate on one side and the North American plate on the other. This means Iceland is being split apart and transatlantic flights between Europe and North America are getting longer by 2.5 centimetres a year.

The same is occurring at plate boundaries the world over, all places with heightened volcanic activity and shaken by frequent earthquakes, the most powerful forces in nature. They build continents, push up mountains, stretch rift valleys, and create new landforms, but nature does not rest. The relentless forces of erosion wear them down, break them up and move the debris elsewhere. The agents are many — water, ice, snow, sun, and wind, as well as bacteria and other tiny organisms, plants, animals … and even humans.

Glacier ice and liquid water cause rocks to smash together, scrape against each other, or shatter and crumble. Plant roots grow into crevices and widen them, and the activities of burrowing animals, from rabbits to earthworms,

displace soil and rocks. The heat from the sun causes boulders to expand, split and fall apart, rainwater in cracks turns to ice and shatters rock, and windblown sand blasts it until it is worn smooth into fantastical shapes, like the delicate Mesa Arch in Canyonlands National Park and the striking sandstone buttes of Monument Valley.

How fast these processes work depends on the hardness or softness of the rock, the steepness of a slope, and the vagaries of the weather. Many take millions of years to shape the land, but violent storms, crashing waves, flash floods and intense heat or freezing cold can change a cliff face or cave in weeks or days, and landslides, rockslides, and mudslides can transform a landscape in seconds. And, all that debris is carried away, deposited elsewhere, and recycled. In nature, nothing is wasted. All the products of erosion are transported to locations where they are dumped, ground up, and used again.

Great rivers slice through the land creating deep and multi-coloured canyons, like North America's Grand Canyon, or they tunnel underground, gouging out eye-catching caves like the Sol Omar Caves in Ethiopia, and, where hard rocks resist, they pour over spectacular waterfalls such as Iguazú in South America and Dettifloss in Iceland. The rivers then carry the eroded sediments to the sea. Soil is washed from the land and dust, known as loess, is carried to rivers by the wind, and this silt is deposited on riverbanks at times of flood or dumped in estuaries, forming deltas and mudflats, places where wildlife feeds and people farm, fish and forage. They are among the most fertile places on Earth.

In the sea, waves, currents and tides chisel away at the land. The sheer force of the waves breaks away chunks of rock and hollows out sea caves and blowholes. Weak acids in seawater dissolve rocks made of calcium, such as chalk and limestone. Soft rocks erode faster than harder rocks, giving rise to rocky promontories and sandy bays, natural sea arches and sea stacks, and

▶ 2-3 Sunrise at the glorious 'Mesa Arch' in Canyonlands National Park, Utah. Geologists classify it mundanely as a 'pothole arch' formed when rainwater pooled behind the arch and gradually eroded the sandstone rocks. U.S. novelist, environmentalist and former national park ranger Edward Abbey, however, described the park as "the most weird, wonderful, magical place on Earth – there is nothing else like it anywhere." Hiking trails lead to the arch, which is on the eastern edge of the 'Island in the Sky'.

wave-cut platforms with rocky pavements, like those in Kimmeridge Bay in southern England.

The churning action of the waves causes fragments of rock to smash together and to become gradually smaller, first as pebbles and then sand. These build up by natural processes, such as 'longshore drift', during which inshore currents flowing parallel to the shore and inside the surf zone carry sediments in a zigzag pattern along the shoreline. The breaking surf sends sand and pebbles up the beach — the swash — and gravity drains the water, carrying the sediments back towards the sea — the backwash. In this way they form spits, sandbanks, beaches and dunes, like the famous black sand beaches and dunes of east Iceland, and the iron-red monster dunes of the Namib that tower up to 383 metres above the desert floor.

So, the Earth beneath our feet may seem solid and immoveable, but it is not. The surface of the Earth is constantly changing. Volcanoes spew out molten magma from the depths of the Earth, creating new land and rejuvenating old. Earthquakes shake and reshape the Earth's crust, triggering tsunamis and landslides, setting off new volcanic activity and even changing the soil temporarily from solid to liquid. Monumental collisions of the continents push up new mountain chains, reshaping the Earth's surface and changing the global climate. They can have such an impact that they shift the jet stream and alter regional weather patterns like the Asian monsoon. Vast sedimentary basins fill with material eroded from elsewhere, creating new rocks, some filled with the fossils of plants and animals. They become the new building materials for even more mountains and valleys, and then the three fundamental forces of erosion — water, wind and ice — scour our planet and break it all down in a great natural cycle that takes millions of years to complete a single circuit. All this creates the most spectacular landscapes on our planet — the Masterpieces of the Earth.

5 The rays of the setting sun illuminate 200-million-year-old fossil ammonites. These extinct relatives of modern nautiluses are embedded in limestone and shale rocks washed out of the crumbling cliffs at Kilve on the Somerset coast of southwest England.

10-11 The stark natural beauty of Vestrahorn dominates Stokksness Peninsula, Iceland. It is one of the island's most breathtaking mountains. The sea has eroded its dark rocks and the sediments are washed up to form black sand beaches and sand dunes.

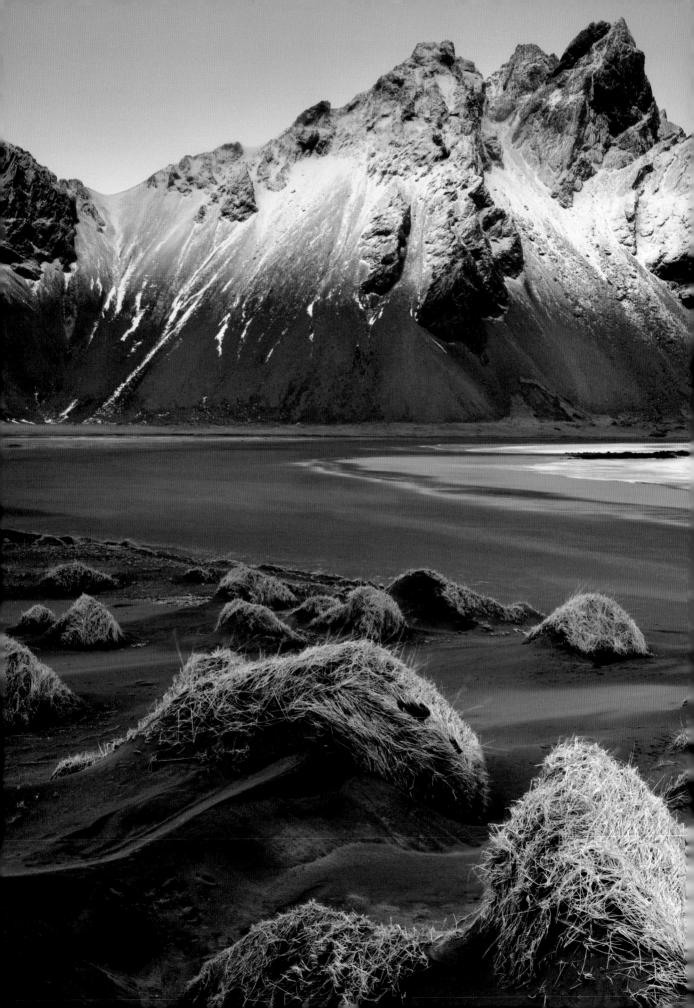

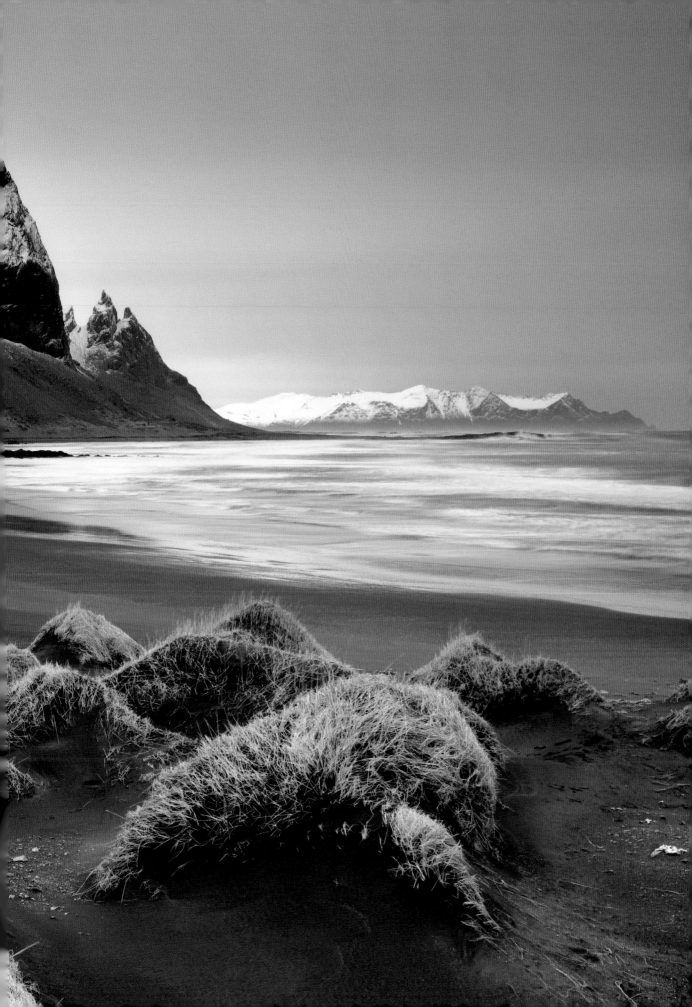

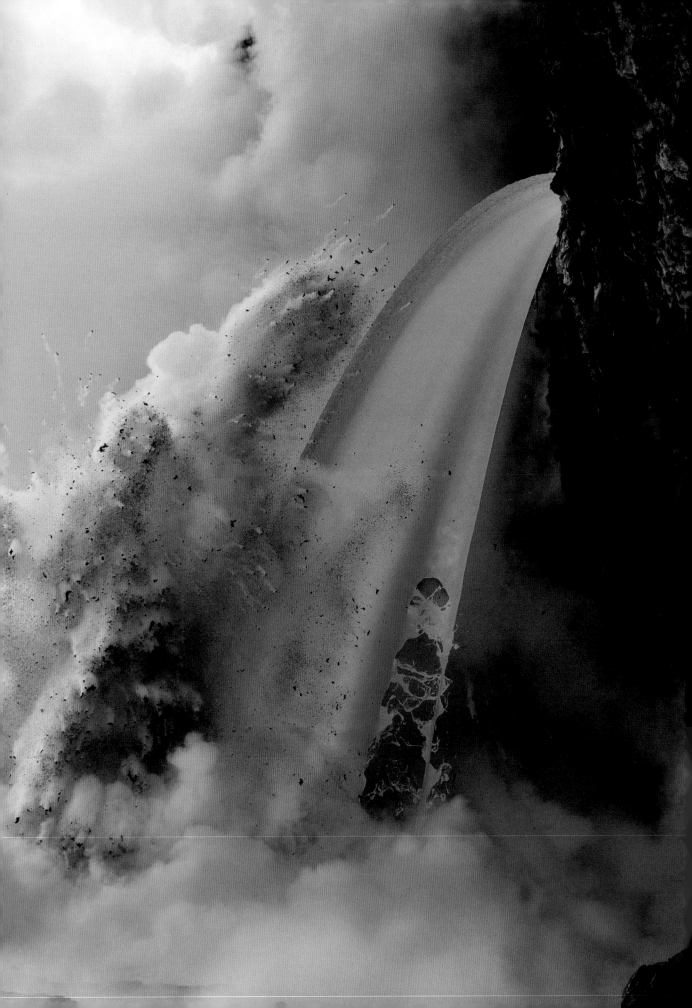

FIRE

Disruptor and Creator from the Depths

Named for Vulcan, the Roman god of fire, volcanoes are great ruptures in the Earth's crust that enable molten magma, volcanic ash and hot gases to break out of the surface of our planet. The magma is hidden many kilometres underground in a vast magma chamber that is under enormous pressure. Over time this pressure causes the surrounding rocks to fracture, and the magma eventually finds its way to the surface and spews out as molten lava. The temperature of the red-hot lava is generally between 700°C and 1,300°C, but when it hits the air, it cools rapidly and solidifies as hard volcanic rock. It is a dramatic and often spectacular reminder that our planet is still blisteringly hot and very much 'alive'.

On the Earth today, there are more than 1,500 active volcanoes, excluding those on mid-ocean ridges, and about 500 have erupted in historic times. They occur mainly, but not exclusively, at the margins of tectonic plates, where material is brought up or returned to the Earth's mantle. The largest seismically active zone in the world is the 'Pacific Ring of Fire', a chain of active volcanoes around the edge of the Pacific Ocean, where all but three of the 25 most powerful volcanic eruptions in the past 10,000 years have occurred.

The volcanoes of Kamchatka, in the Russian Far East, are part of the northeastern sector of the Ring of Fire. They have formed because the western edge of the Pacific plate is plunging below the eastern margin of the Eurasian plate. The unstable zone above gives rise to 109 active volcanoes, the highest concentration of erupting volcanoes in the world. Plosky Tolbachik volcano is one, and its neighbour Ostry Tolbachik is another. Plosky's most notable eruption in recent times was in 1975. A swarm of earthquakes preceded an eruption that produced the most lava of any Kamchatka volcano.

Not all volcanoes are at plate margins. The volcanoes of Hawaii are located, not at the edge of a tectonic plate, but in the middle. This is because they sit over a hot spot, an upwelling of molten

▶ LEFT New land is created. Red-hot molten lava from Hawaii's Kilauea volcano pours from a lava tube into the Pacific Ocean, causing violent steam explosions and the sea to boil. This large and active shield volcano is in Hawaii Volcanoes National Park, where it erupted almost continually from 1983 to 2018, each time adding new land to Big Island. It is the youngest of the island's volcanoes, having formed between 300,000 and 600,000 years ago. The oldest, Kohala, is more than a million years old.

rock from the mantle, in the Earth's crust. As the plate moves imperceptibly over this hot spot, volcanoes push up from the seabed to form volcanic islands; in fact, they are the highest mountains in the world. Measured from base to summit, Mauna Kea on Hawaii's Big Island is over a kilometre taller than Mt Everest, although much of it is underwater. Its neighbour Kilauea is currently over the hot spot, and is the most active of Hawaii's volcanoes. As the tectonic plate moves eastwards, however, the islands move away from the hot spot. Eruptions slow and then cease altogether, and the ocean gradually erodes the islands away. The Emperor Seamounts to the northwest of Hawaii were once over the hot spot, and millions of years ago they were the Hawaiian Islands, but now they are underwater mountains.

Hawaii's volcanoes are shield volcanoes. They produce low-viscosity, fast-flowing basaltic lava that spreads a great distance from the vent, forming a broad volcano with gently sloping sides. Iceland's volcanoes are basaltic too, but they sit astride a hot spot on the Mid-Atlantic Ridge. Evidence of ancient eruptions can be seen in the island's rocks. The Svartfoss waterfall, for example, tumbles over dark, hexagonal columns of solidified basaltic lava. The same rock formations can be seen at the Giant's Causeway in Northern Ireland.

Shield volcanoes are just one of several types of volcanoes recognised by scientists, each type categorised by the viscosity of lava it produces and how much gas it contains. The most hauntingly beautiful are stratovolcanoes. Pico do Fogo in the Cape Verde Islands is one. Like the Hawaiian volcanoes, Cape Verde's peaks in the eastern Atlantic are also over a hot spot below the Earth's crust. As the islands move eastwards on the Africa plate, the youngest are at the western end of the archipelago, and the oldest in the east.

The symmetrical cone shape of this type of volcano has inspired artists and religious leaders alike, but their splendour belies a sinister history. They tend to go off with a bang! They produce thick, viscous lava that does not flow

easily and gases cannot escape. The gas pressure builds inside the volcano until, and usually with little warning, the volcano erupts with a violent explosion that releases enormous amounts of magma, ash and hot gases. Deadly pyroclastic flows, which are incandescent clouds of super-heated dust and gas, barrel down the steep slopes and incinerate everything in their path. Pompeii and Herculaneum were victims of pyroclastic flows and buried in a six-metre-deep layer of volcanic ash from Mt Vesuvius in 79 CE.

While stratovolcanoes and shield volcanoes account for most major eruptions, there are minor events, such as fissure eruptions, that can have a big impact on our lives. These occur when magma finds a long fissure in rocks and erupts at the surface in fountains of lava that form 'curtains of fire'. Icelandic volcanoes, pushing up from the Mid-Atlantic Ridge, tend to erupt in this manner. They start first as fissure eruptions, with fire-fountains from a dozen vents reaching up to 100 metres into the air, but after swarms of earthquakes, the nature of the eruptions changes. The second phase is explosive, with fine particles of volcanic ash thrown up to an altitude of 8 kilometres. The melting of the island's ice caps produces a second explosive phase, and in 2010 the plume of ash formed from one particular volcano – Eyjafjallajökull – caused most of

European airspace to be closed to commercial flights, resulting in the biggest disruption to air travel since World War II.

One of the world's most dramatic of volcanic features is 'the gateway to hell' – a lava lake. It forms when so much magma is pushed up through the vent so fast that it pools in the crater and remains molten, constantly circulating like a gigantic witch's cauldron. They lakes appeared in the crater of Hawaii's Kilauea volcano, where lava fountains burst from the surface, but the most spectacular one in recent years has been in the crater of Mount Nyiragongo, an active stratovolcano in the Democratic Republic of Congo. This lava lake is about 600 metres deep, making it the largest in recent times, and its lava is unbelievably runny. Similar lava flows from volcanoes elsewhere generally move at speeds up to 6 mph, usually slower, and a person could easily outrun them, but Nyiragongo's lava travels at 60 mph! The volcano has been dubbed 'the most dangerous volcano on Earth'.

On an even bigger scale is the caldera. If the magma chamber beneath a volcano empties, the chamber roof can collapse, forming a large bowl-shaped hollow with very steep walls. This is the caldera, and it can be many kilometres across. One of the most closely watched calderas contains Yellowstone National Park. This area of

FIRE

intense geothermal activity, with an extraordinary number of geysers, mudpots and hot springs, is a vast caldera complex, the leftovers of a super-volcano that has erupted in at least three known caldera-forming eruptions 2.1 million, 1.3 million and 640,000 years ago. According to recent measurements, magma has refilled its chamber, which is a staggering 90 kilometres by 30 kilometres. The level is now similar to what it was before the last eruption, so it is ready to blow its top any time soon! The amount of energy released during such a volcanic eruption is hard to comprehend. The amount of thermal energy produced by the eruption of a super-volcano like Yellowstone would be greater than the entire nuclear arsenals of the USA and Russia combined.

A geothermal area a little different to that at Yellowstone can be found in the Danakil Depression of Ethiopia. In this area on the Horn of Africa, the source of underground heat is not a dormant super-volcano or a simple hotspot, but a place on the Earth's surface where the crust is splitting, a triple junction where the edges of three tectonic plates meet. In the region of Lake Karum, it has given rise to volcanoes, lava lakes, hot sulphur springs and extensive rifting. It is part of the East African Rift Valley, which stretches from Ethiopia to Mozambique, and could be the product of a super-plume of magma lying below the African continent, which is pushing up and causing the whole place to crack. The end result is that Africa will be parting company with Asia, and is likely, one day, to give birth to a new ocean.

Volcanoes not only eject lava and volcanic ash, but also a cocktail of gases that enter the atmosphere. Dominant among them is the greenhouse gas carbon dioxide, which is always in the news these days as the cause of global warming, but even volcanoes pale beside our contribution. The world's volcanoes account for an estimated 200 million tons of carbon dioxide per year, but people, through fuel for transportation, energy supply, industry and agriculture, pour 24 billion tons into the atmosphere. The difference is that global warming can be curtailed by volcanic activity. Sulphur dioxide, ash and other particles from volcanoes become trapped in the stratosphere and shield the planet. They reflect solar energy back into space. Scientists have estimated that, after a major eruption, the atmosphere can cool by as much as 0.5°C within a year. So, killer volcanoes can have a very positive affect on our everyday lives.

▶ RIGHT This primeval landscape is Lake Karum (Assale). It lies in the volcanically active Danakil Depression, part of the Afar Region of Ethiopia. Salt and sulphur deposits, hot springs, and miniature geysers give the lakebed an unearthly appearance, and it's hot. It has the world's highest average annual air temperature of 35°C, and in summer this can peak at 55°C. It rarely rains. The lake is over 120 metres below sea level, so Lake Karum is one of the hottest, driest, and lowest places on Earth.

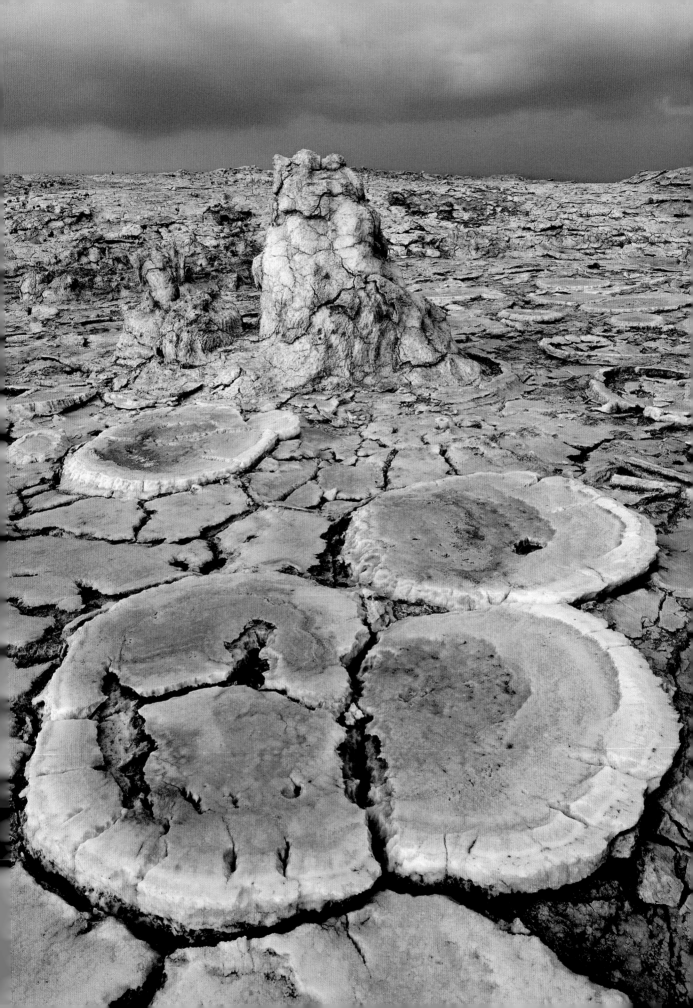

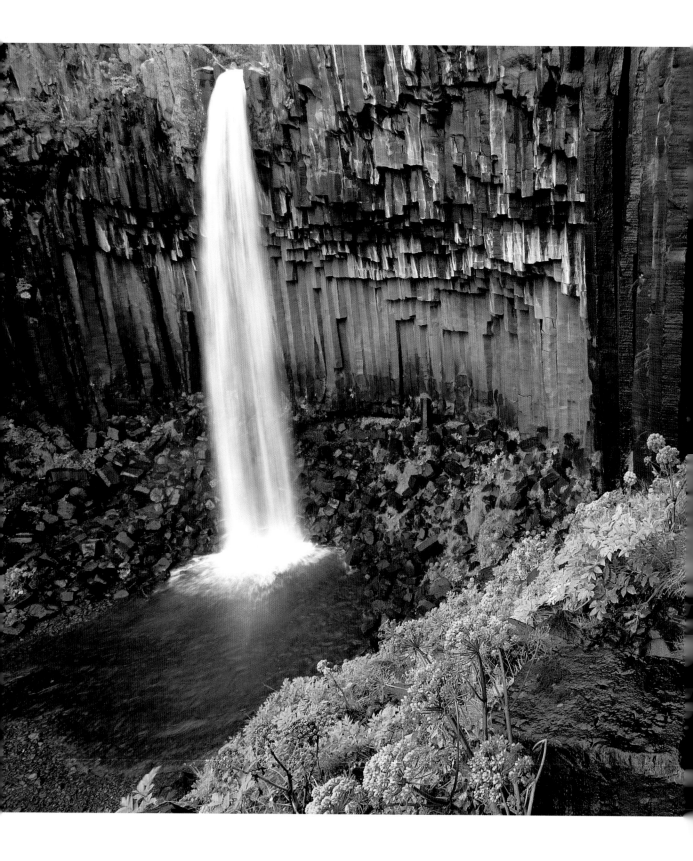

LEFT and 20-21 Columns of dark volcanic basaltic lava form the backdrop to Iceland's Svartifoss waterfall. The name means 'black waterfall', the dark basalt rocks resembling the pipes of a great church organ. Its shimmering, clear water is fed by melt water from the Vatnajökull glacier. It drops about 20 metres from a crescent-shaped cliff and, at the base of the falls, the rocks have surprisingly sharp edges because the columns break off faster than the falling water can wear down their edges.

22-23 The 'Giant's Causeway', on the north coast of Northern Ireland, is made of interlocking rows of hexagonal blocks of basalt, the result of a fissure eruption about 50 million years ago. In Gaelic mythology, the giant who walked on it was Finn MacCool.

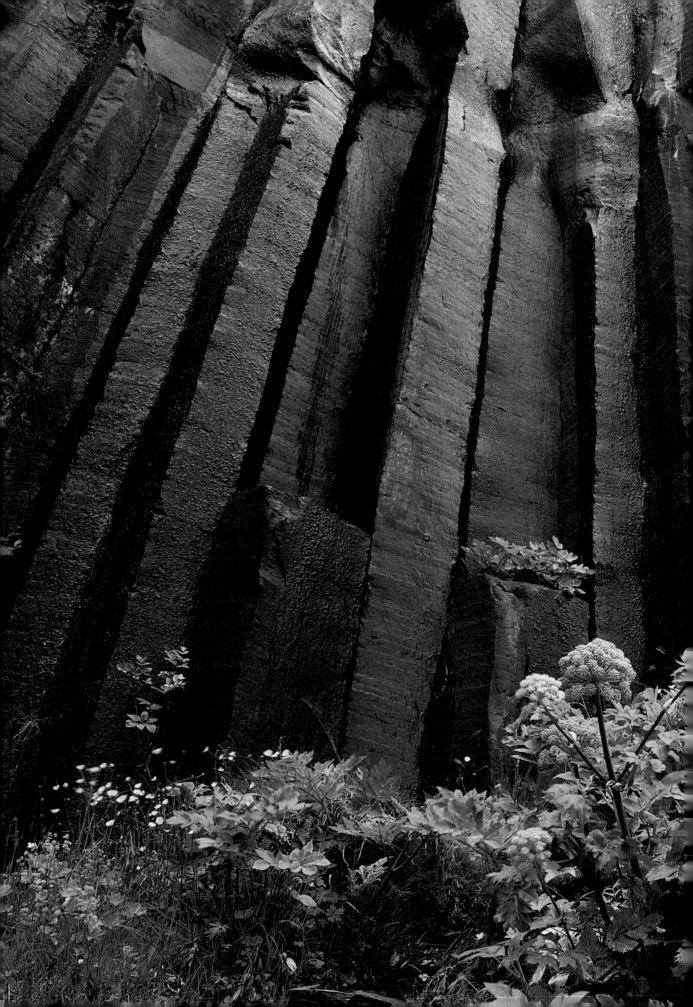

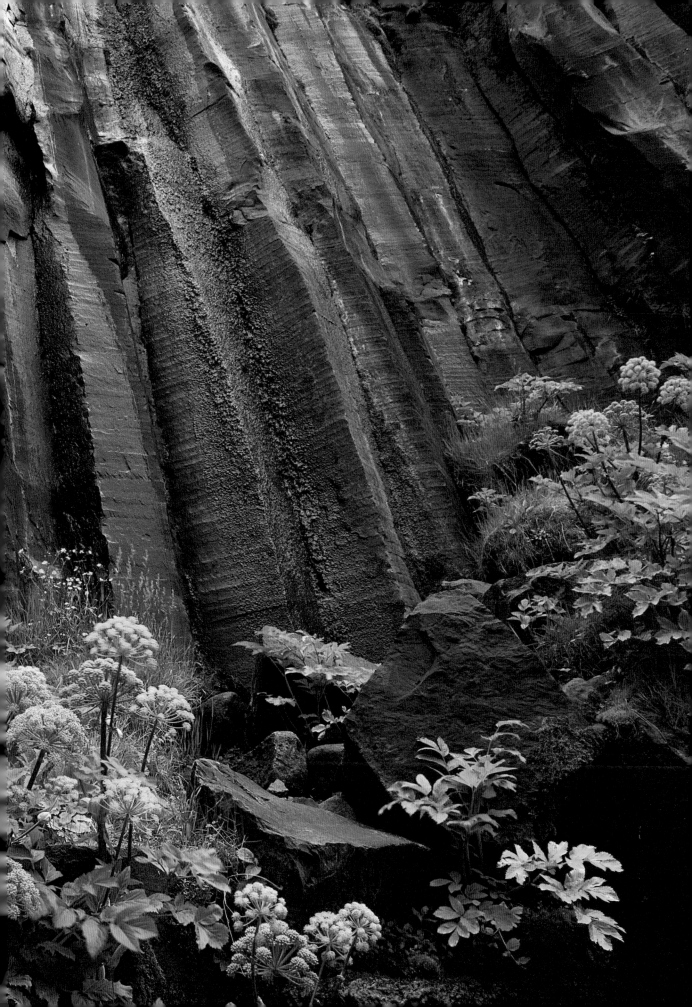

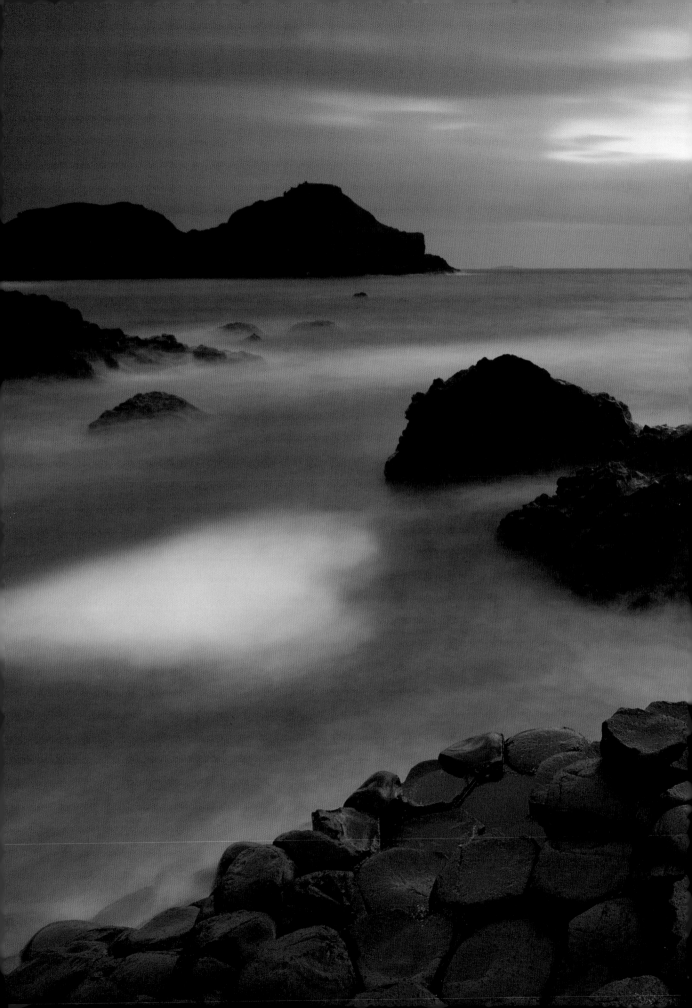

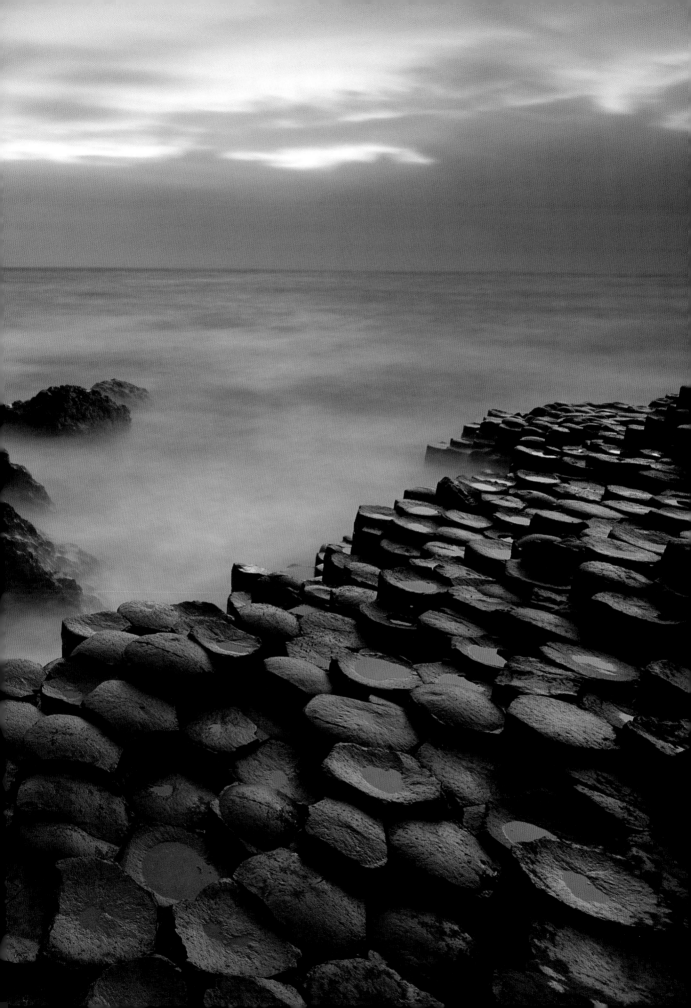

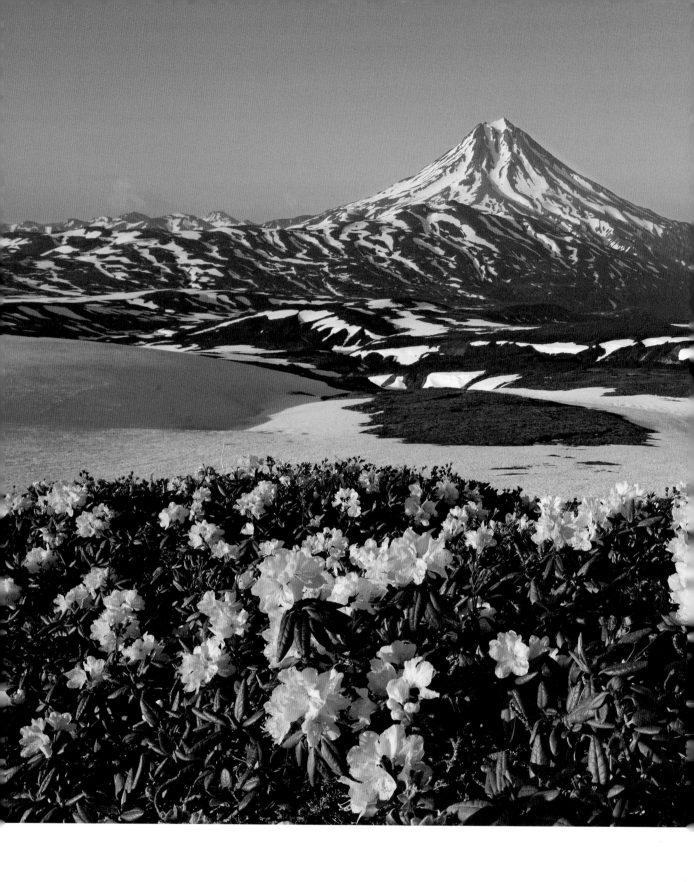

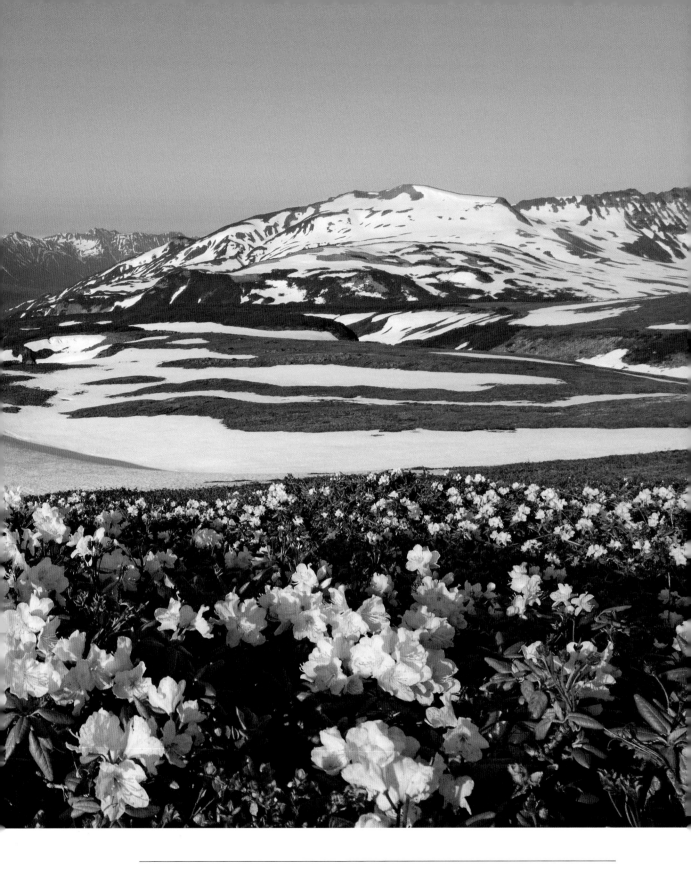

▷ ABOVE The Russian Far East's 'land of fire and ice' is the Kamchatka Peninsula. There are 19 active volcanoes in the Volcanoes of Kamchatka area alone. Here, rhododendrons are in bloom in July, yet the landscape is still covered in ice and snow.

FIRE

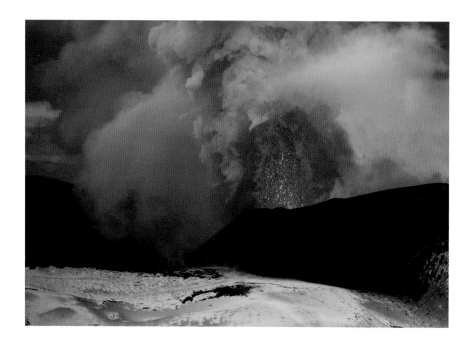

▶ ABOVE and RIGHT A billowing ash plume and fountains of lava erupt from the Plosky Tolbachik
volcano. It is one of a pair of volcanoes on the Kamchatka Peninsula, the other being Ostry Tolbachik.
Plosky means 'flat', for it is a rounded shield volcano, and *ostry* means 'sharp', as it is a cone-shaped
stratovolcano. In 2012, Plosky Tolbachik erupted from two fissures, its basaltic lava flowing 20
kilometres from the volcano. Its fumaroles are rich in minerals, including 100 newly identified ones.

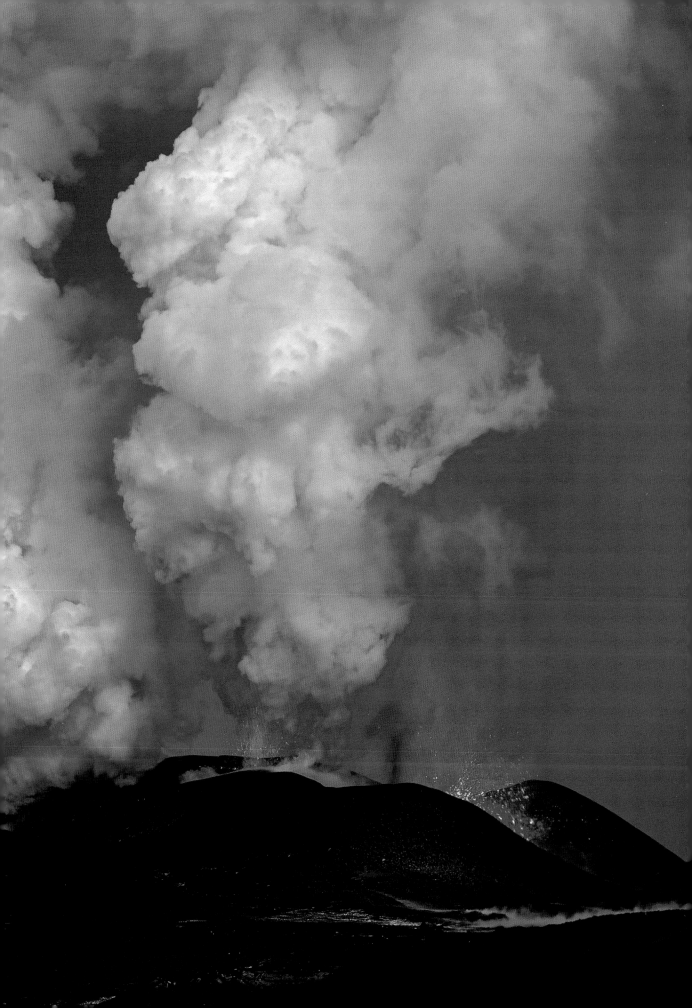

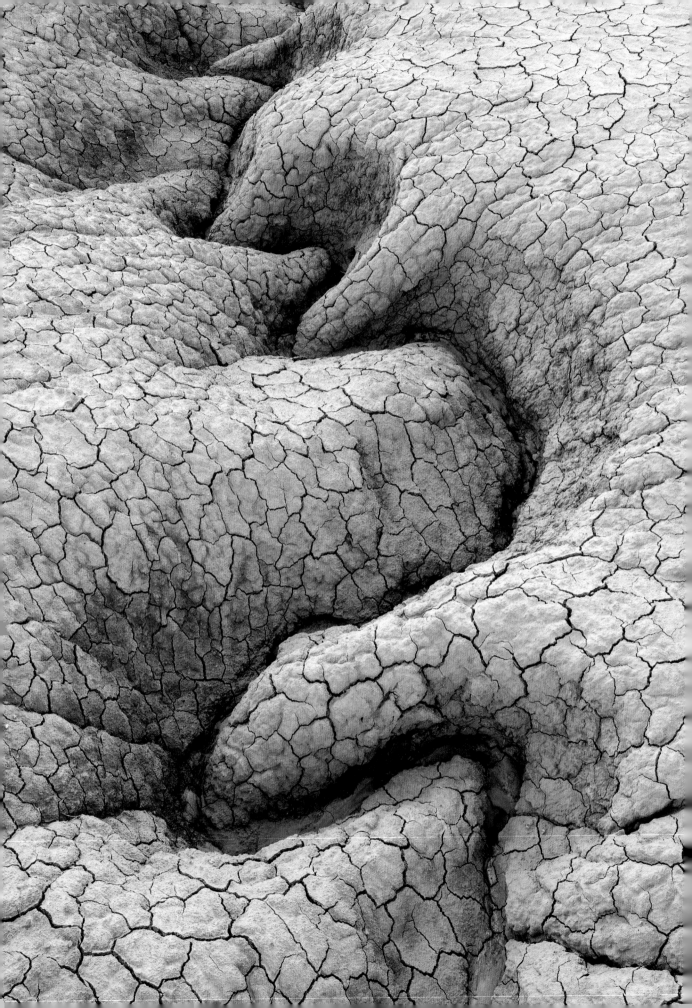

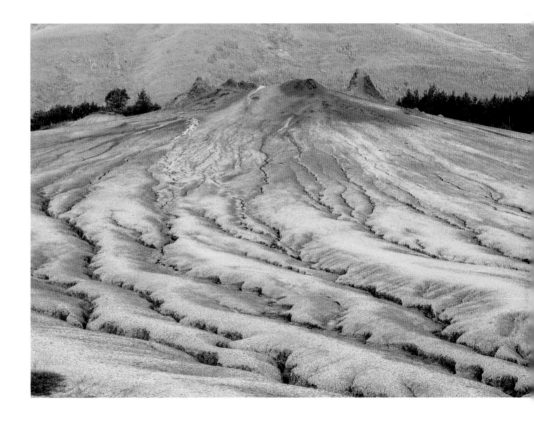

▶ LEFT and ABOVE Like the skin of a scaly reptile, dried mud formations form on the surface of mud volcanoes near Berca, Romania. These structures lie where pressurised natural gases, including methane, helium and nitrogen, push salty water and mud deposits bubbling to the surface. The mud dries to form volcano-like structures typically a few metres high. The gases originate about 3,000 metres below the ground and they are not hot, as they come from within the Earth's crust and not the mantle.

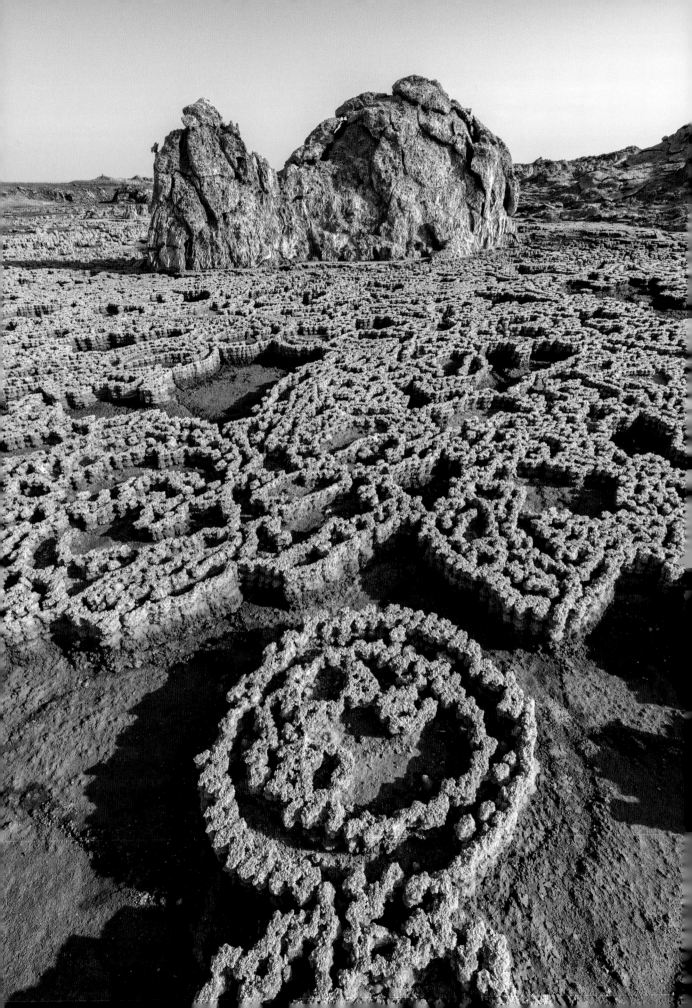

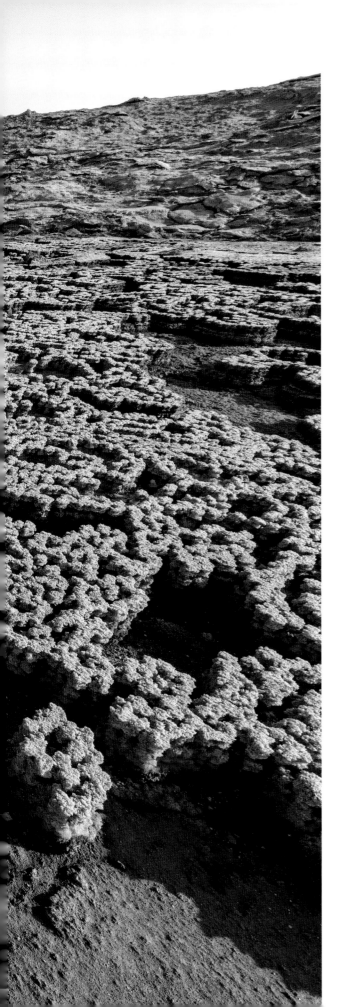

▶ LEFT Like a vast patchwork quilt, a natural
mosaic of salt deposits forms where salty hot
springs have pooled at the surface and then
dried out in the fierce heat of the sun. This
otherworldly landscape is in the Danakil
Depression, Ethiopia. After the intense heat
here during the day, a wind picks up in late
afternoon and swirls about with sand and salt.
It's known as the 'fire wind' because it burns
the face, and is one reason this area is said to
be one of the most inhospitable places on
Earth.

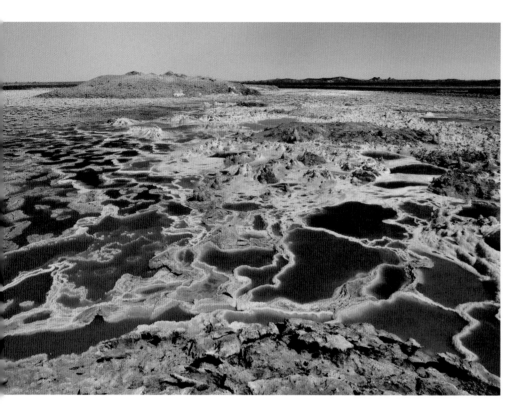

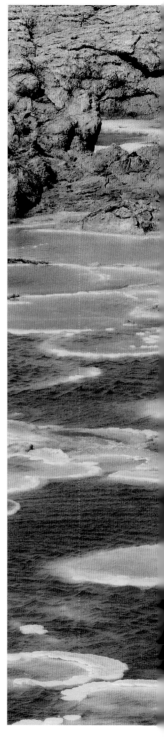

▶ ABOVE and RIGHT The vibrant colours of the hot springs at Lake Karum are due partly to salt-tolerant bacteria that live in the brine. Astrobiologists study these wetter environments of the Danakil Depression, as they might show how life could have arisen on other planets. The lake is also located in the seismically active Afar Triangle area of the East African Rift Valley, where three tectonic plates are slowly pulling apart the Earth's crust. One day, they will be the birthplace of a new ocean.

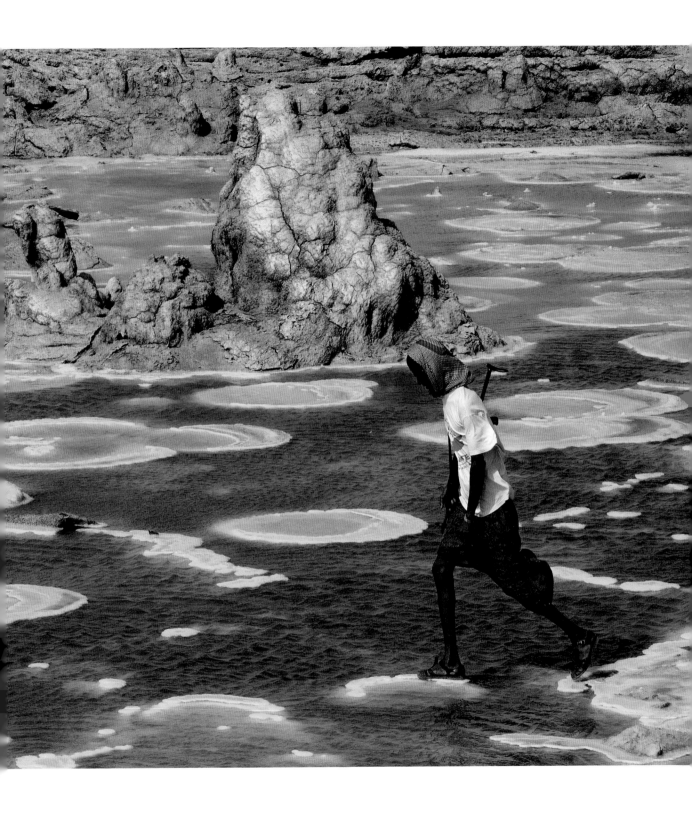

▶ ABOVE This eruption and lava flow on the flanks of the Mount Nyiragongo volcano in the Democratic Republic of Congo is about 10 kilometres from the main summit caldera. It was given the name 'Kimanura' after the area in which the eruption occurred.

▶ RIGHT and 36-37 Mount Nyamuragira is one of Africa's most active shield volcano. It has erupted more than 40 times since 1885, both from the main crater and from its flanks, but even more impressive has been the formation of a lava lake about 500 metres deep. The lake of molten rock is one of only a few in the world. During eruptions, the volcano also releases huge amounts of sulphur dioxide into the atmosphere, and this has been detected as far away as the Amazon rainforest in South America.

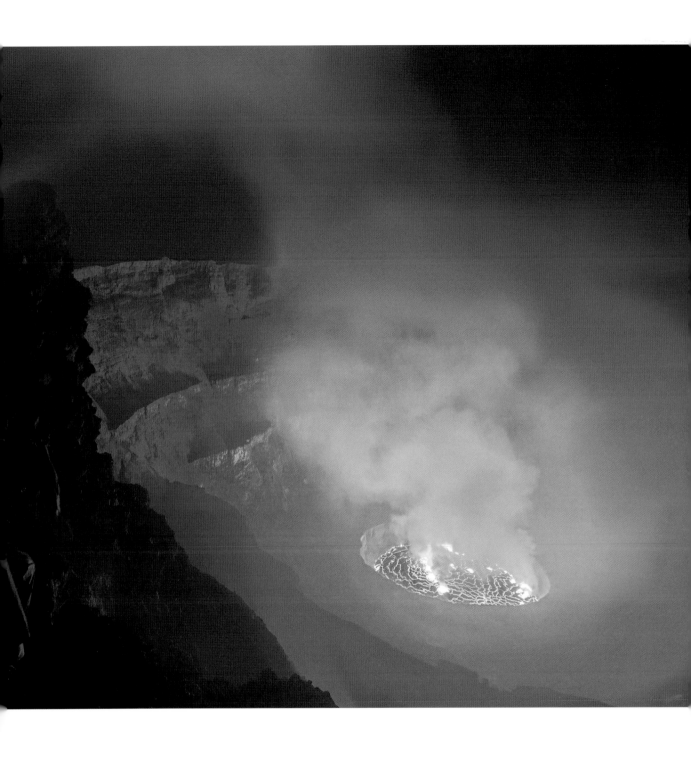

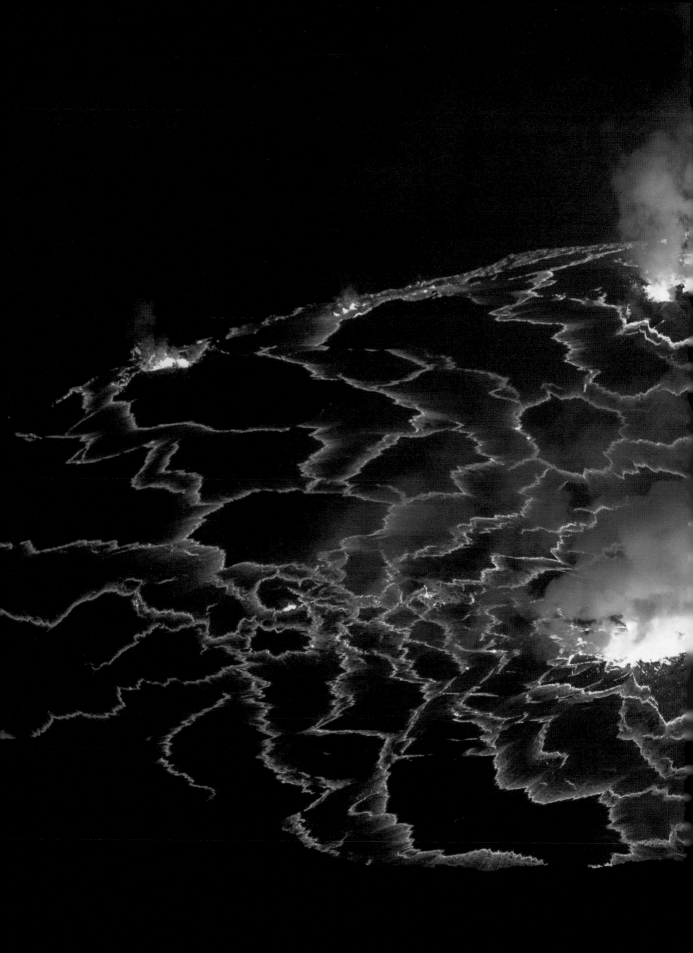

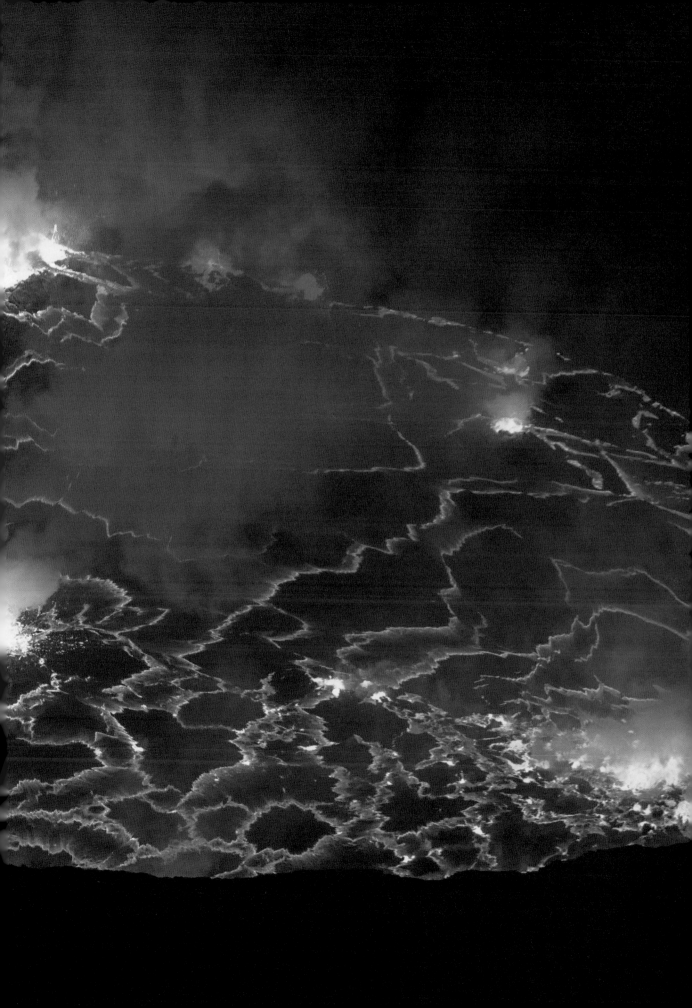

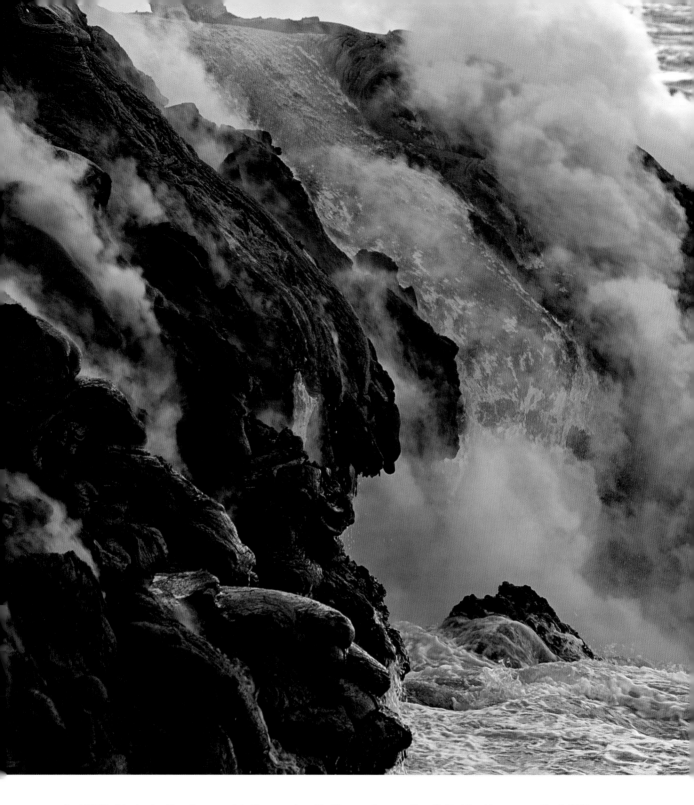

▷ ABOVE A 'pahoehoe' lava flow pours into the ocean from the Kilauea volcano on Hawaii's Big Island from an eruption in 2011. This type of fast-flowing basaltic lava tends to have a smooth or ropy surface, and the flow is narrow and relatively thin.

▷ RIGHT Lava cascades over Hawaii's Kalapana Coast in 2016. By the end of the year, the volcano had produced 4.4 cubic kilometres of lava, covered about 144 square kilometres of land to a thickness of 15 metres, and enlarged the island by 1.8 square kilometres.

▷ 40-41 The active stratovolcano Pico de Fogo volcano on the Cape Verde Islands in the eastern Atlantic erupted in 2014, accompanied by strong earthquakes. Volcanologists thought it was one of the most powerful eruptions the island has ever experienced.

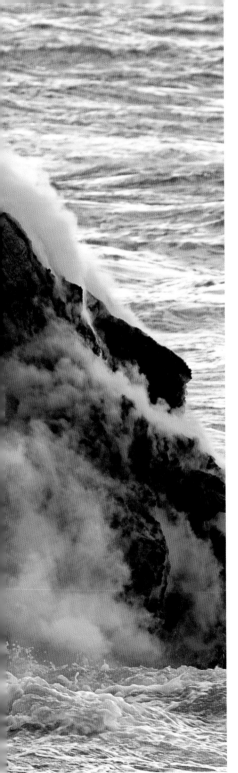
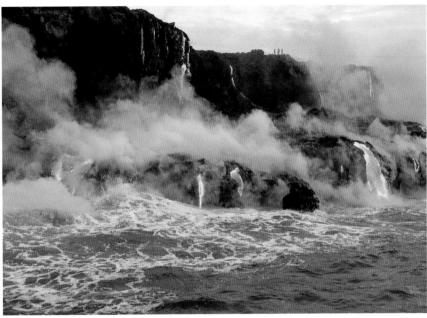

FIRE

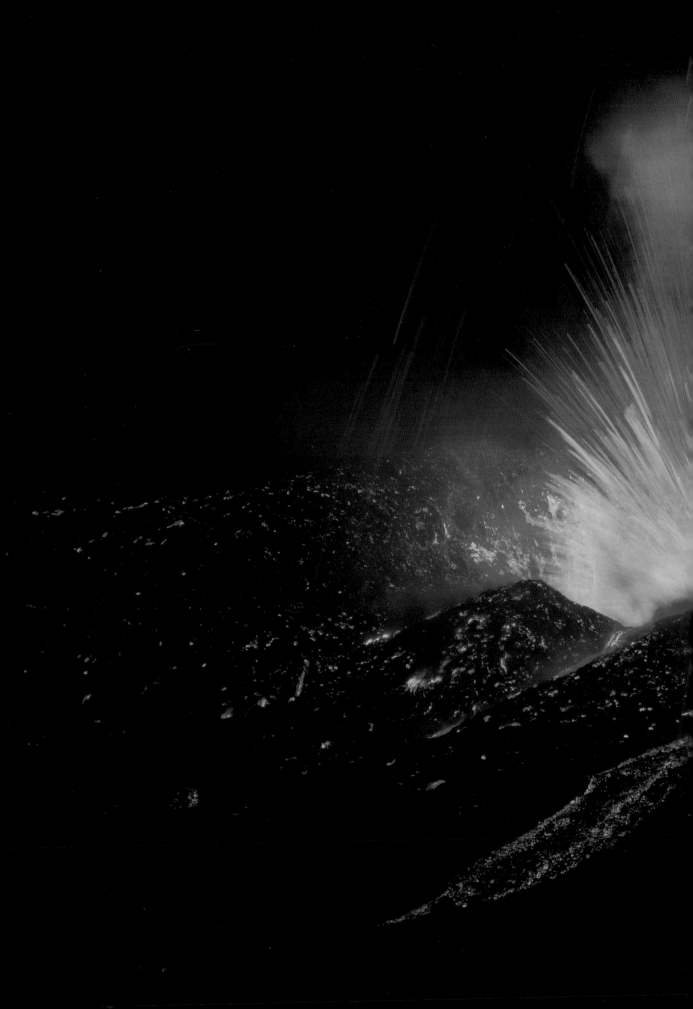

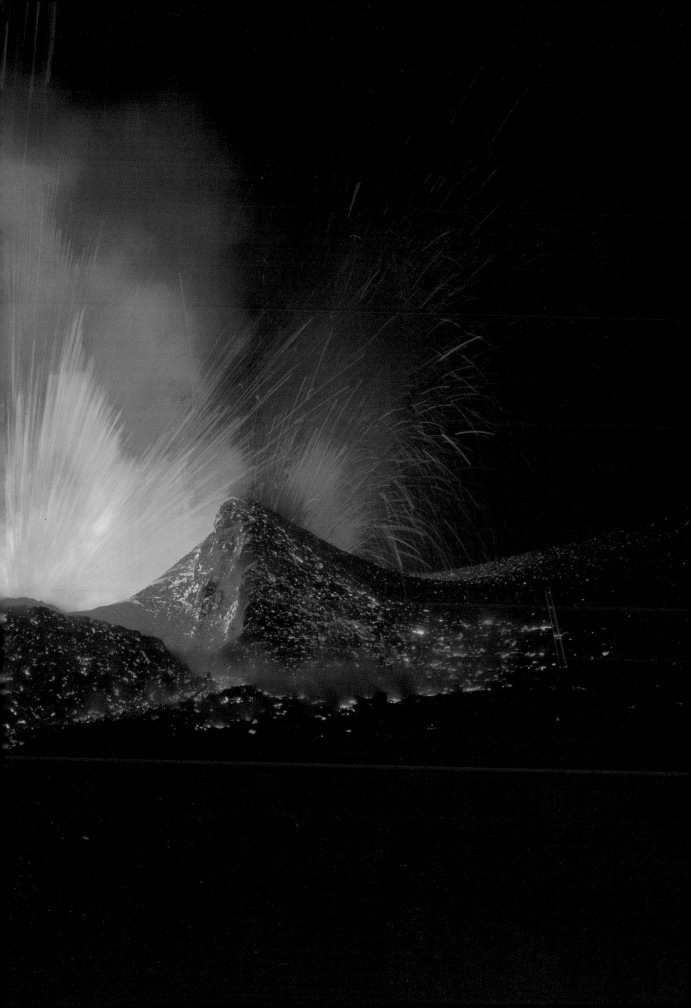

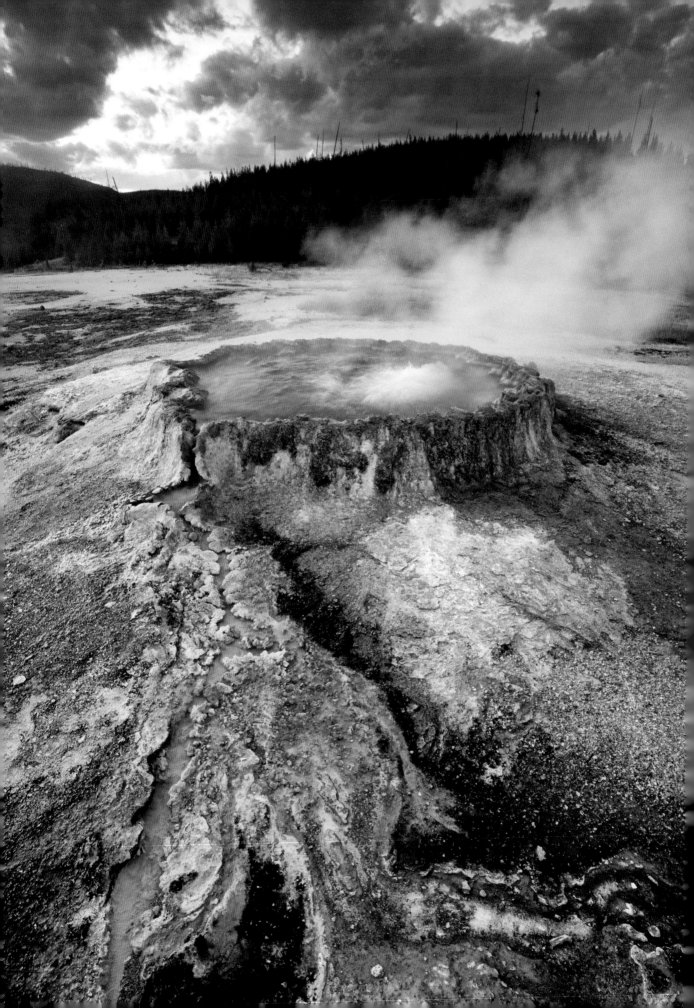

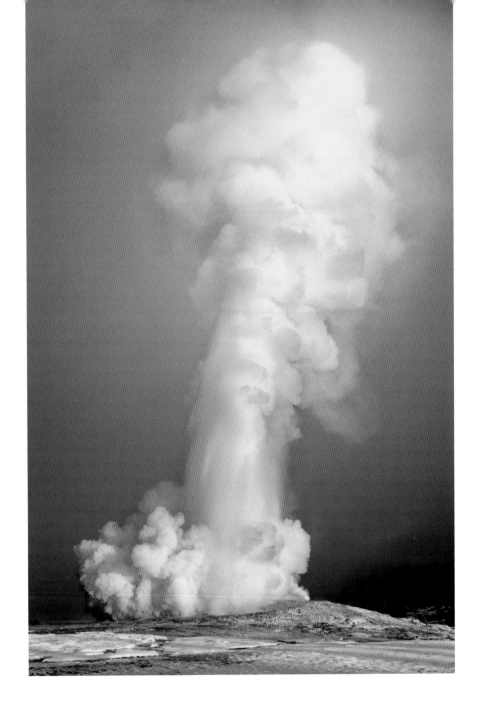

FIRE

▷ LEFT The vibrant colours of hot springs in Yellowstone are caused both by minerals in the warm waters and 'heat-loving' microorganisms. The water can be 30-60°C, with different coloured species of bacteria living in zones at different temperatures.

▷ ABOVE Old Faithful Geyser in Yellowstone National Park, Wyoming shoots out scalding water to a maximum height of 66 metres, and a blast can last for 5 minutes. Eruptions are every 65 or 91 minutes on average, depending on the length of the prior eruption.

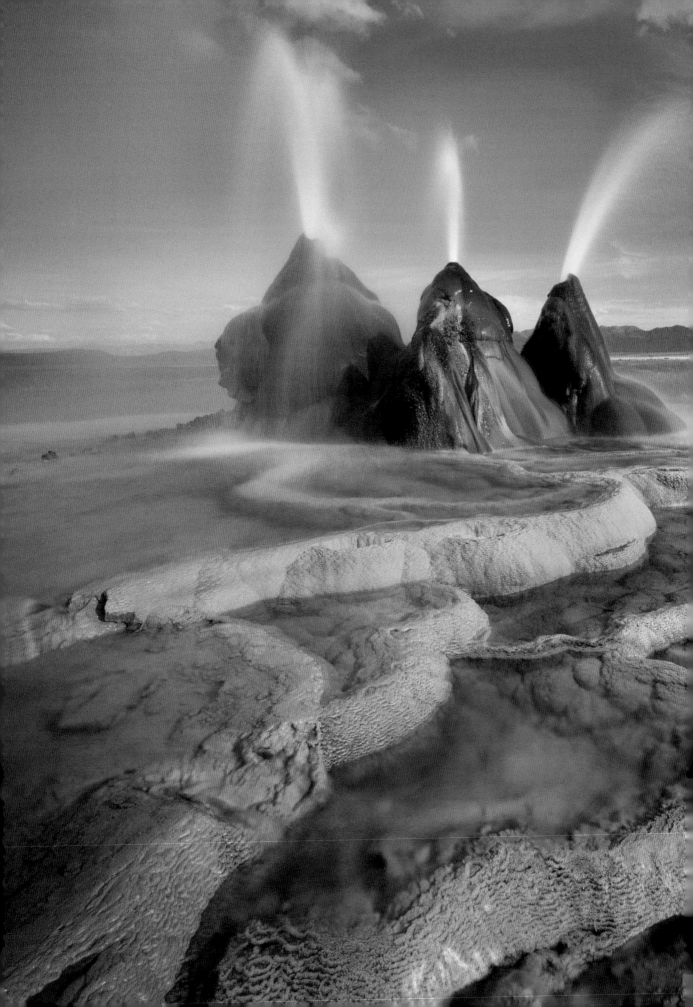

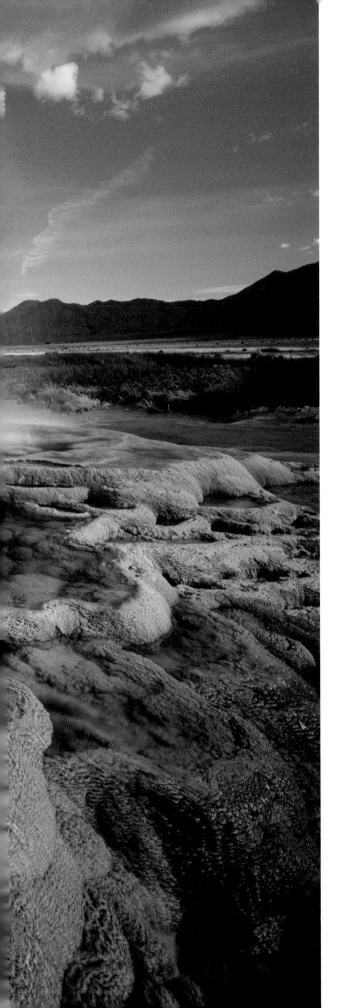

▶ LEFT The Fly Geyser in Nevada is the oddball of geothermal features. For one thing, it is the result of manmade drilling, and for another, its waters contain large quantities of silica, so quartz has formed inside the geyser unusually quickly – less than 60 years. It normally takes 10,000 years. The water spews out constantly, and minerals dissolved in it form travertine terraces and warm pools. Heat-loving bacteria live in the hot water, which colour the rocks brilliant shades of red and green.

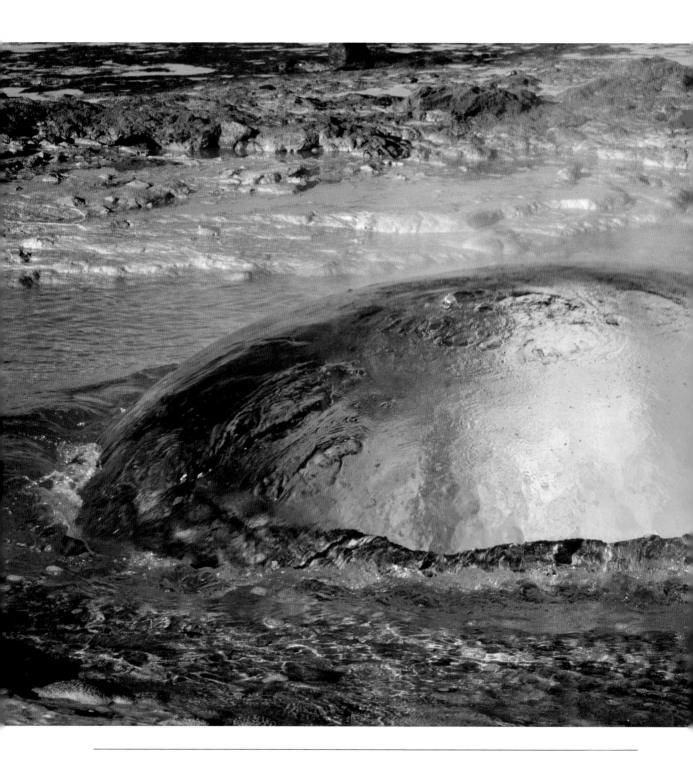

▷ ABOVE Iceland's Strokkur Geyser is found beside the Hvítá River to the east of Reykjavík. The hot water forms into a dome shape just before erupting. There are many other geysers in the area, including the Great Geysir, which gave geysers their name.

▷ RIGHT Strokker Geyser is very reliable. It erupts every 6-10 minutes, sending water 15-20 metres into the air, sometimes even 40 metres. The water comes from the Langjökull glacier, which percolates down and is heated by magma close to the surface.

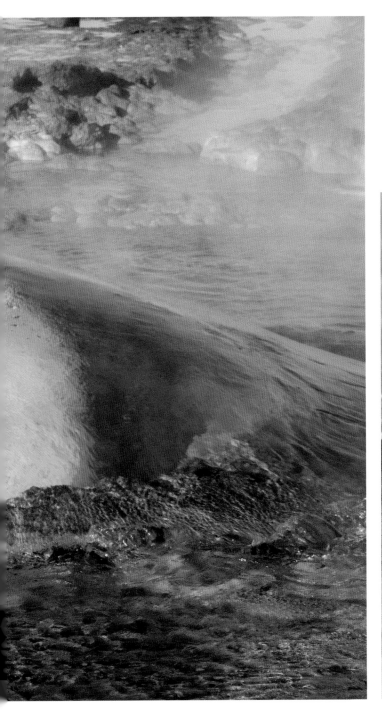
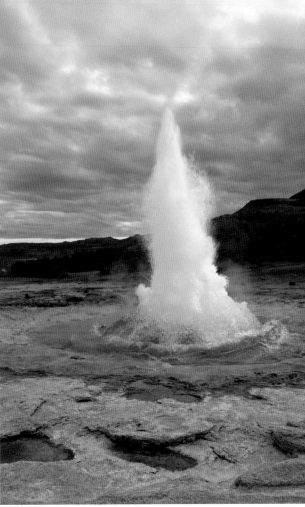

▶ 48-49 In the snowy Wyoming winter, steam rises from the Blue Funnel Spring in West Thumb Geyser Basin close to the shore of Lake Yellowstone. It is well known for its distinctive ring of colour formed by heat-loving bacteria around its outside edge.

▶ 50-51 The natural travertine limestone terraces at Mammoth Hot Springs, Yellowstone, resemble a man-made Roman fountain. The material is similar to stalactites but is formed from weak carbolic acid charged with carbon dioxide rising from a magma chamber.

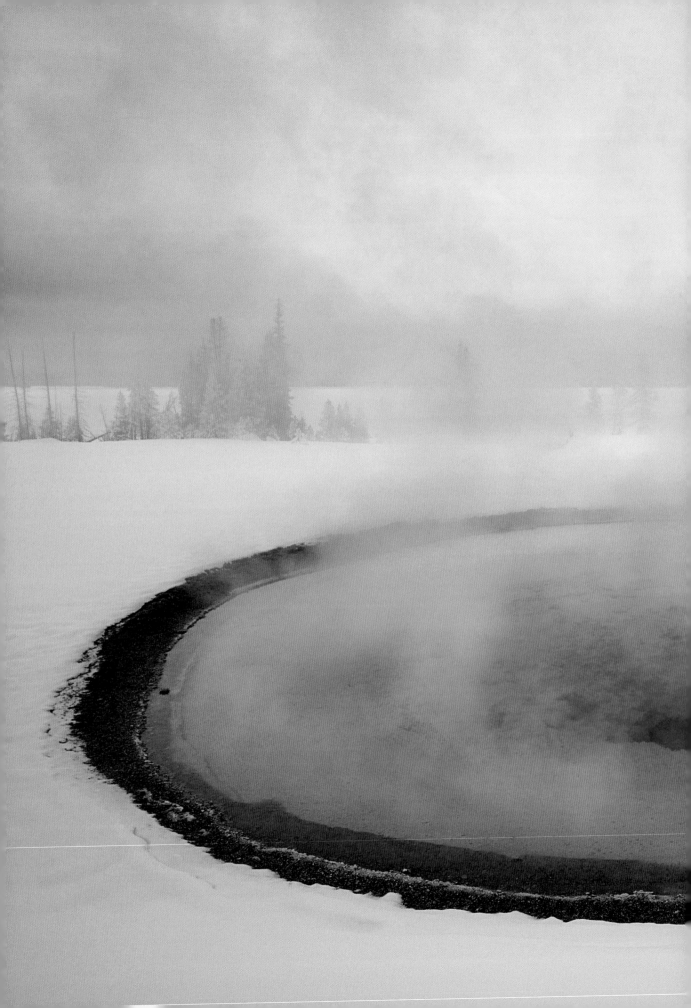

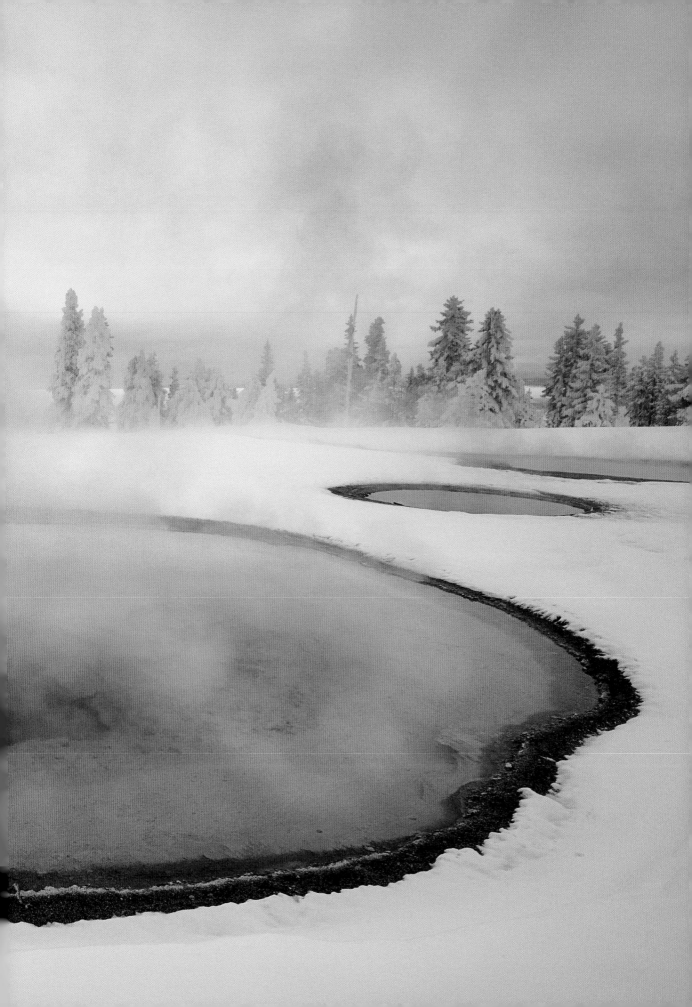

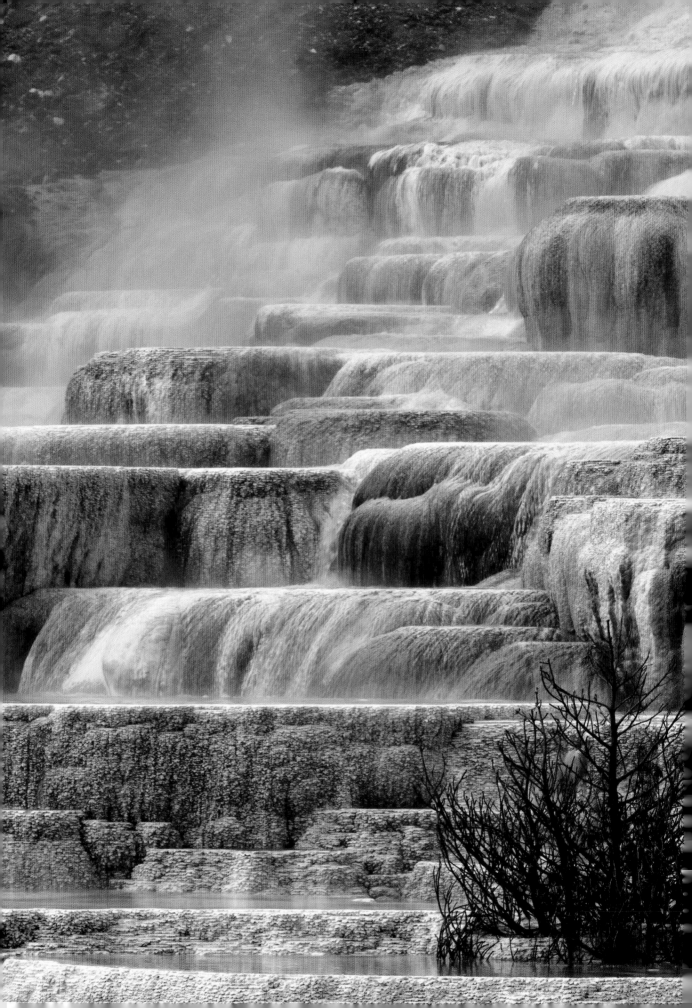

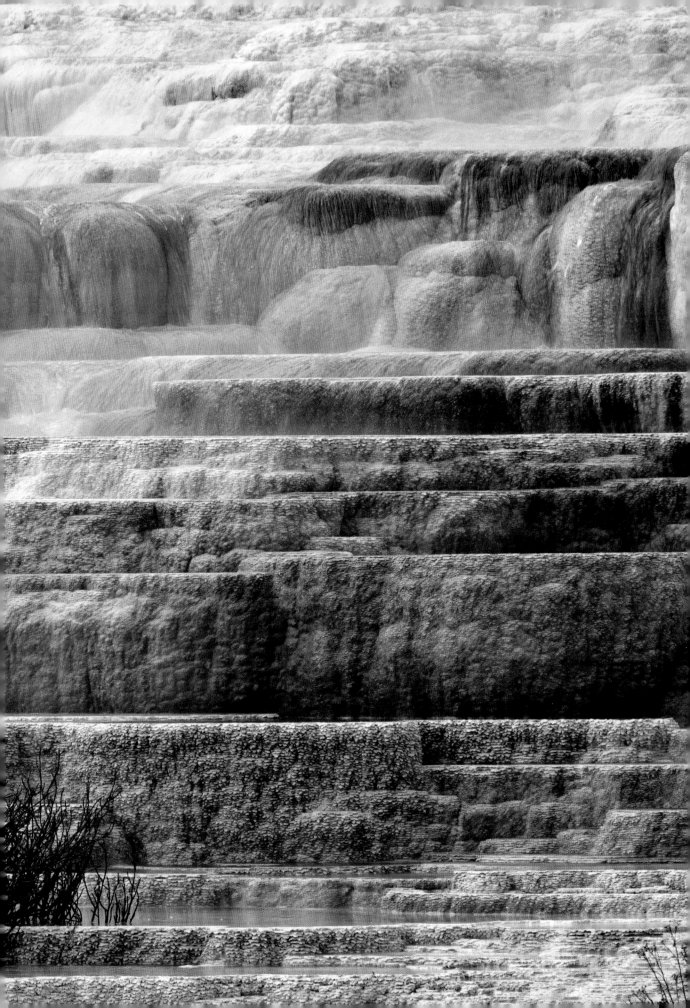

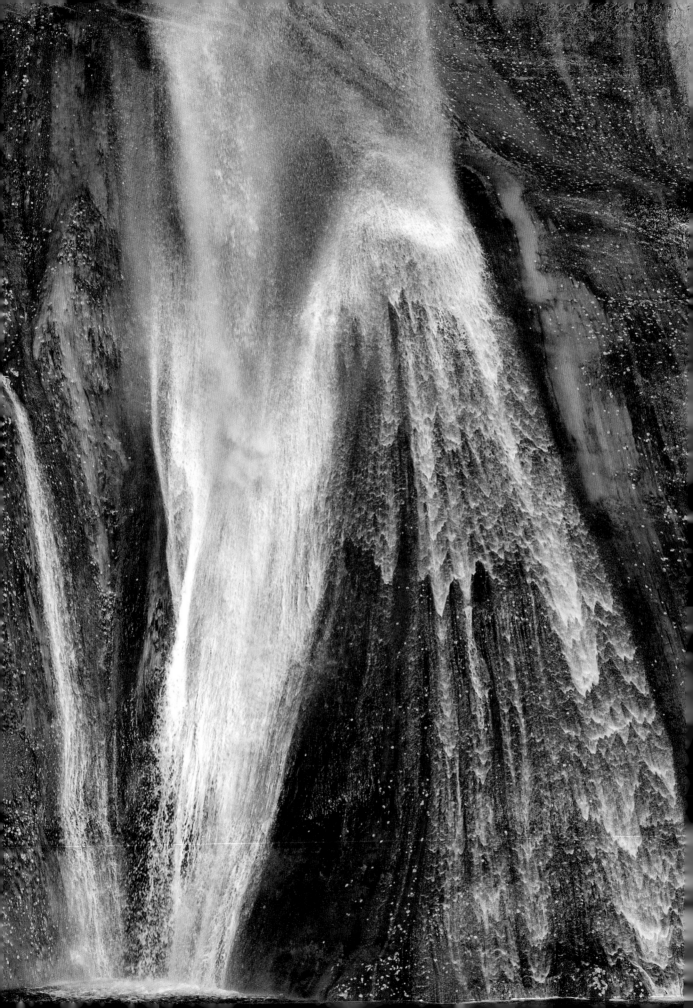

WATER

Mysterious Sculptor in Continuous Movement

Most of the world's water – about 97 per cent – is in the oceans, and it covers about 71 per cent of the Earth's surface. Evaporation turns 0.001% of all the liquid water into the invisible gas water vapour. This rises on warm air currents into the atmosphere, where it cools and condenses into droplets, attaches to dust particles and forms clouds; and the warmer the water, the greater the amount of water vapour and the bigger the clouds. The clouds are carried inland by weather systems, and when the water droplets become too big, they fall as rain, hail, or snow depending on the temperature. This is when water begins to have a lasting impact on the landscape, for water is one of the main agencies of erosion.

Water can wear away the Earth's surface in two ways: it can combine with atmospheric gases to form weak acids that dissolve rocks, and it can physically erode rocks and soil. Right at the beginning of the erosion process, the splash made by falling raindrops can cause particles of dust, sand or soil to move out of the splash zone, forming tiny craters. With enough raindrops, a stream of water might cut through soil, creating a small channel. Many streams flow into rivers and these will cut into the rocks on the riverbed and the land on either side. If they do this over millions of years, some of the most spectacular landscapes on Earth are created.

In the USA, the Colorado River has sliced down through rocks representing two billion years of Earth's history to form the world-famous Grand Canyon in Arizona. The river is thought to have established its course through the many different types of rock about 5-6 million years ago, although the age of the canyon is still hotly debated. At the time, the Colorado Plateau was uplifting, while the Colorado River was eroding, and the process of deepening and widening the canyon continues to this day. Currently, it is 446 kilometres long, with a maximum depth of 1,857 metres. The oldest rocks at the bottom of the cliffs are two-billion-year-old metamorphic schists, while the youngest sedimentary rocks at the rim are 230,000-year-old limestones.

One of the most intriguing and, perhaps, slightly bizarre landforms to be found in a canyon is the 'hoodoo'. It is formed because different rock types erode at different rates. Dolomite, limestone,

▷ LEFT A tributary of the Escalante River feeds Calf Creek Falls. The water drops in two steps: a 27-metre upper tier and a 65-metre lower tier, and it is a surprising watery environment in a desert setting in the Grand Staircase-Escalante National Monument, Utah. The local rocks are streaked with minerals and those behind the falls are coated with green and yellow coloured algae. The falls get their name from the way the area was used as a pen for calves in the late 19th and early 20th centuries.

WATER

and siltstone, for example, are hard, whilst mudstone is soft. The hoodoo — also known as a tent rock, fairy chimney or earth pyramid — is usually composed of at least two rocks, one soft, the other hard, and it is eroded into a tall, thin spire or pillar, its body composed mainly of the softer rock, but with a cap of the harder material. It can be as tall as a human or the height of a ten-storey office block, and one of the best places in the world to see hoodoos is Bryce Canyon National Park in Utah, USA.

Like an army of stone giants, the hoodoos pack into an amphitheatre, where several erosion processes shape them. Primary amongst them is 'frost wedging'. In winter, the water from melting snow drips into crevices in the rock during the day, but then freezes at night. The ice expands and cracks the rock. Gravity does the rest, helped along by the fierce late summer thunderstorms accompanied by torrential rain and stinging hail. Wind is least important here, which is why Bryce Canyon's hoodoos are sharp-edged with jagged tops.

A smaller cousin of the 'canyon' is the 'gorge'. The two terms are often used interchangeably, although Americans prefer 'canyon' and Europeans opt for 'gorge'. There is, however, at least one subtle difference. Although they are both deep valleys with steep sides, the gorge tends to be considerably narrower than a canyon. The Hancock Gorge in the Karijini National Park, Western Australia, for example, is an exceedingly narrow, sheer-sided chasm, where the blood red rocks contrast with the bright green colour of the water. The rocks here are very old, dating back to 2.5 billion years ago, and their red colour is the result of iron oxide that formed when the earliest photosynthetic microorganisms produced the Earth's first oxygen. It oxidised iron in ancient seas, and now it colours the rocks red.

On their way to the sea, rivers not only cut through the rocks to form valleys, canyons and gorges, but also erode the bedrock on the riverbed to create waterfalls. Here, the river tumbles over a vertical drop or a series of drops, and the result can be sensational. Angel Falls in Venezuela is a 'plunge'

waterfall. The water drops vertically, losing contact with the surface of the bedrock on its way down. It is the tallest uninterrupted waterfall in the world, dropping in an 807-metre plunge, before a 300-metre cascade, and another plunge downstream. The falls topple over the edge of a tepui, which means 'house of the gods'. It is an enormous and very obvious block of ancient rock – a mesa – standing clear of the surrounding tropical rainforest. It was the inspiration for Sir Arthur Conan Doyle's The Lost World, in which a relict population of prehistoric animals was isolated from the forest below and still living on the flat top of the mountain.

While 'plunge' is the name given to this type of waterfall, there are several others, and many are equally dramatic. A 'cataract' is a large and powerful waterfall in which great volumes of fast-moving water plunge over a precipice. One of the most impressive is Iguazú Falls on the Argentina-Brazil border. It is the longest waterfall system in the world, with many islands dividing up the river into individual falls. About half the water drops into a long and narrow horseshoe-shaped chasm, the so-called 'Devil's Throat'. Many observers consider these falls to be the most spectacular in the world.

Ruacana Falls in Namibia is a 'segmented' fall, in which there are also separate flows of water. Gullfoss and Dettifoss in Iceland are both 'multi-step' waterfalls, in which there is a series of falls of roughly the same size, each with its own plunge pool, and Calf Creek Falls, Utah is a 'tiered' waterfall where the water falls in distinct steps.

Eventually, all of that water is returned to the sea, completing the water cycle. Indeed, some waterfalls plunge directly into the ocean. Kirkjufellsfoss is the last of three waterfalls on the Kirkjufellsá River on Iceland's west coast, the water pouring into the North Atlantic; and, here in the ocean, the water takes on another life: it turns back on itself and attacks the land.

Land can simply disappear in front of your eyes, when waves slam into cliffs or rock fragments are picked up by the waves and thrown against them, causing them to collapse, but land can also reappear. Small particles of rock are ground against each other and thrown up to form pebble and sandy beaches on the soft rock bays between hard rock promontories. But the most dramatic processes of marine erosion and deposition are those driven by waves during violent storms.

These, like all waves, are generated by the action of the wind. The speed of the wind and the distance it blows across the sea determines the size and strength of the waves. The greater the distance, the bigger the waves, so, on the west coast of the British Isles, with no land

WATER

between Scotland and North America, the waves can be enormous; in fact, the greatest ocean wave ever recorded by a Marine Automatic Weather Station buoy was off the west coast of Scotland in February 2013. Between the peak of one wave and the trough of the next, it measured 19 metres. When waves like this reach the shore, they can be so powerful that they cause the land to explode. As the water crashes into a cliff, the air in crevices is compressed, causing the rocks to shatter. Waves then sweep up the debris and smash it against the rock, causing even greater damage. Over time, the cracks enlarge, and coastal features such as sea caves, arches and stacks are formed.

Tumultuous seas like this batter the west coast of the British Isles and on the Shetland Isles, a remote archipelago to the north of mainland Scotland, the rocks have taken a thorough pounding. On Foula, the most westerly island in the group, wave action has resulted in the formation of columns of rock known as sea stacks. They stand where softer rocks in a promontory have been eroded, leaving behind the harder rock. First, caves were carved out, but when those on opposite sides broke through, a sea arch was formed. If the roof of the arch collapses, a stack will be left standing, but the Gaada Stack, on Foula's north coast, has few years to go yet. It is still a double arch made of old red sandstone, standing about 45 metres tall. One day, though, it will be a single stack, and then disappear altogether.

Further to the north, near the village of Vík í Myrdal on the south coast of Iceland, the Reynisdranger sea stacks are tough basalt pillars that have resisted the power of the ocean. They are close to Reynisfjara's famous black sand beaches, a location for the Game of Thrones fantasy drama. In the real world, though, this is a place where the roaring Atlantic crashes in, sudden shifts in the tide producing especially strong rip currents. Notorious 'sneaker waves' sweep up the shore when you least expect them and push far further up the beach than you might think, catching the unwary off guard. Never turn your back on the sea!

▷ RIGHT The Green River is a tributary of the mighty Colorado River. They have both carved deep canyons into the Colorado Plateau. Their confluence in the Canyonlands National Park, Utah is a striking prelude to the famous Grand Canyon downstream.

▷ 58-59 Gullfoss, meaning 'golden falls', is Iceland's most spectacular waterfall. In a dramatic display of nature's power, the waters of the Hvítá River tumble down a three-step staircase, turn sharply, and then plunge into the Gullfossgjúfur Canyon.

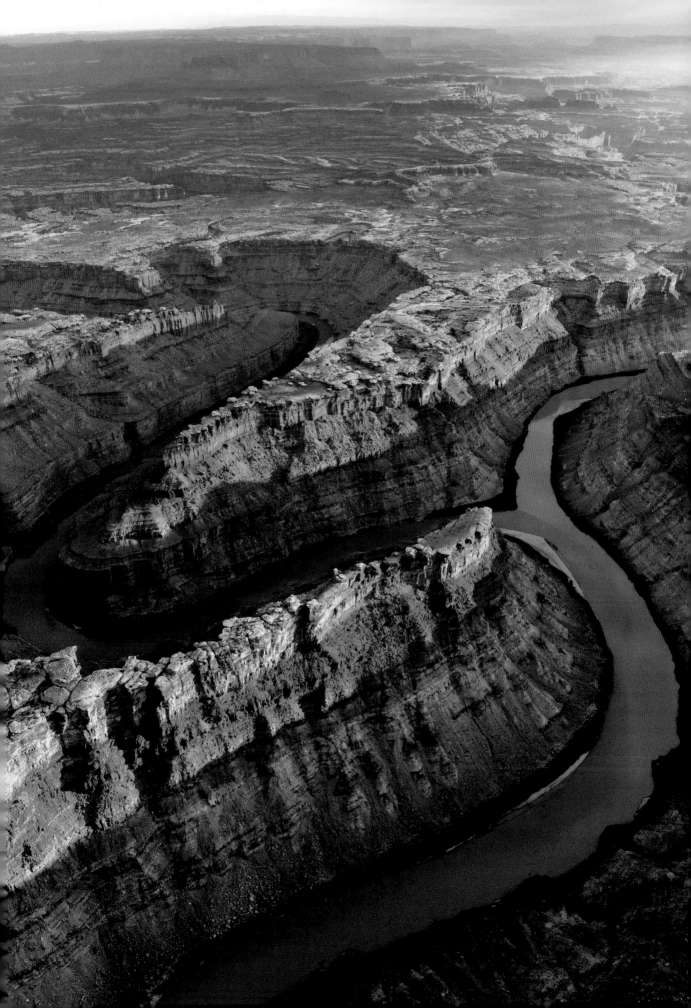

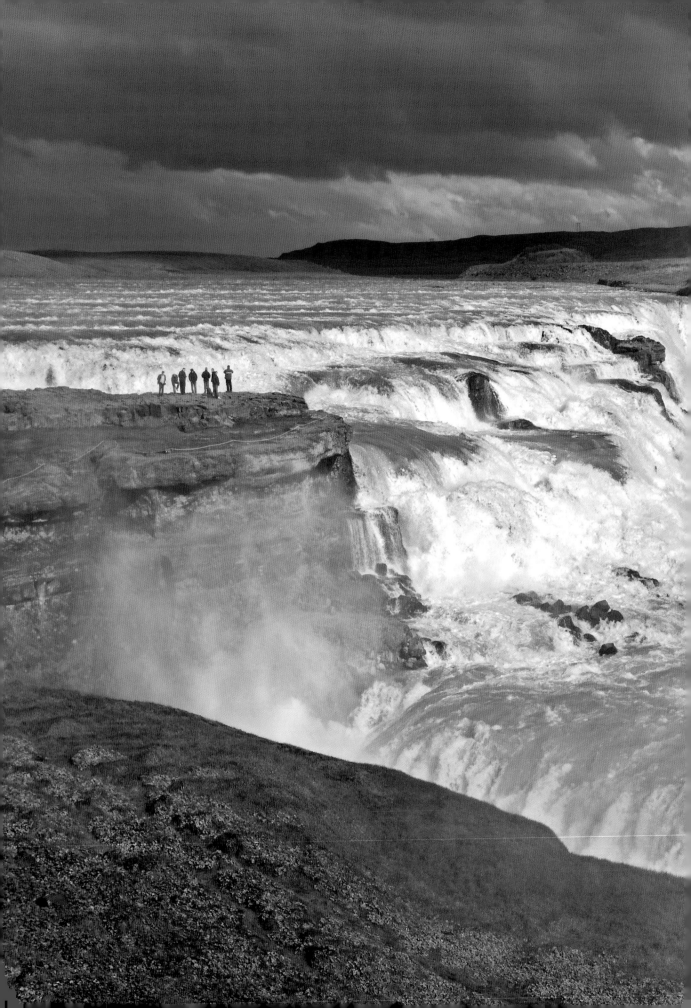

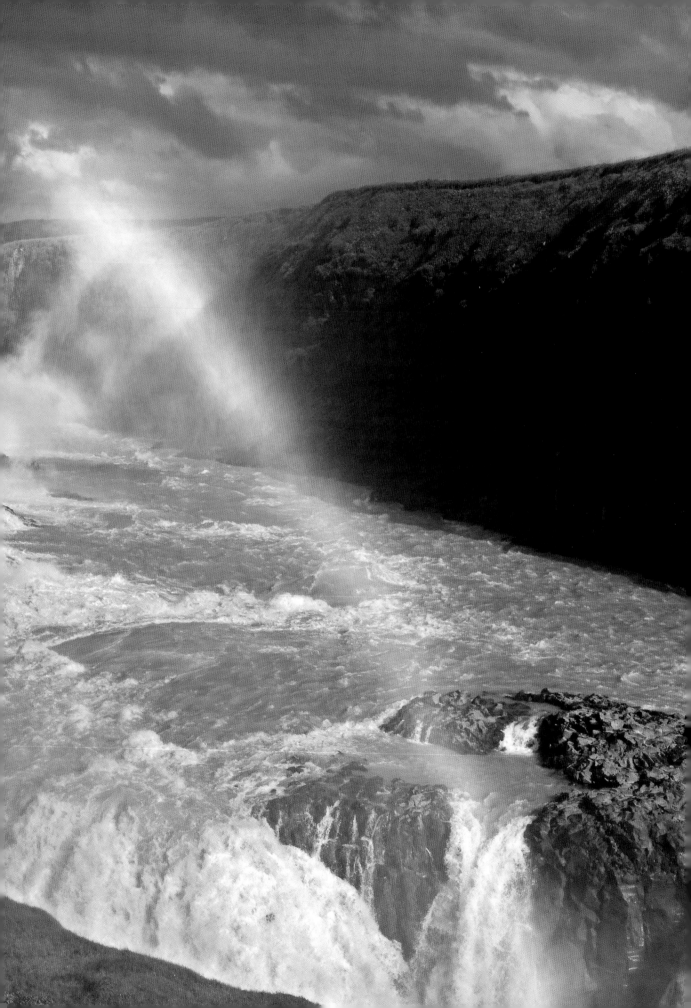

WATER

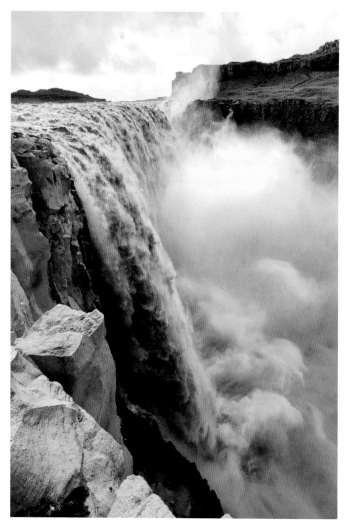

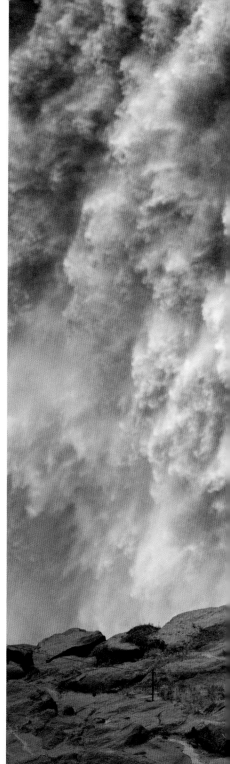

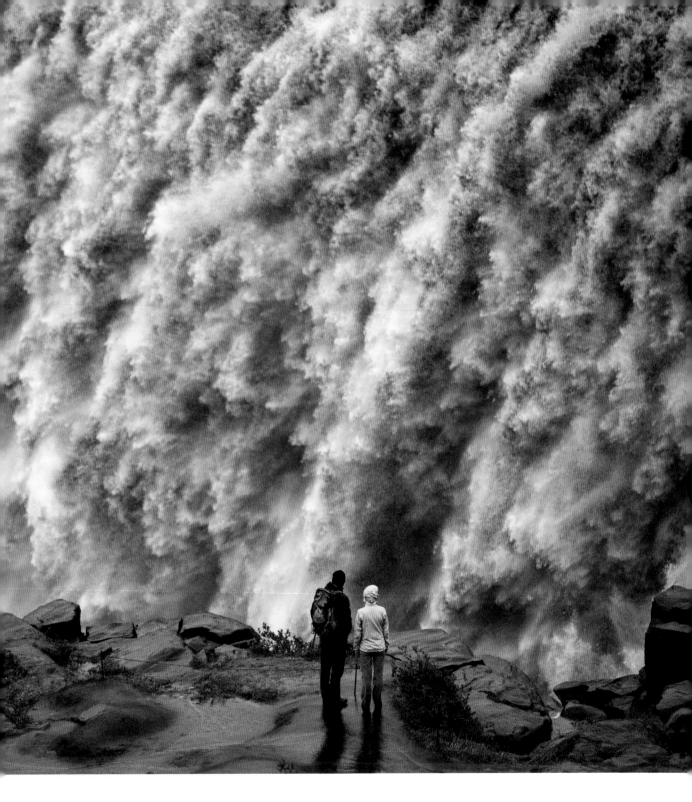

▷ LEFT and RIGHT Northern Iceland's Dettifoss is thought to be the most powerful waterfall in Europe. The river flows from the Vatnajökull glacier, the largest in Europe, and is greyish white because of the sediments it carries. The falls themselves are 100 metres wide, with a drop of 45 metres. They appeared in the 2012 feature film *Prometheus*, the stark and dramatic scenery forming an alien landscape, and sites nearby represented lands 'North of the Wall' in the TV series *Game of Thrones*.

▷ 62-63 The Kirkjufellfoss waterfall, or 'church mountain falls', drops into the sea on the desolate Snaefellsness Peninsula. Not far from the falls on the west coast of the island, the sheer cliffs of Kirkjufell are Iceland's most photographed mountain.

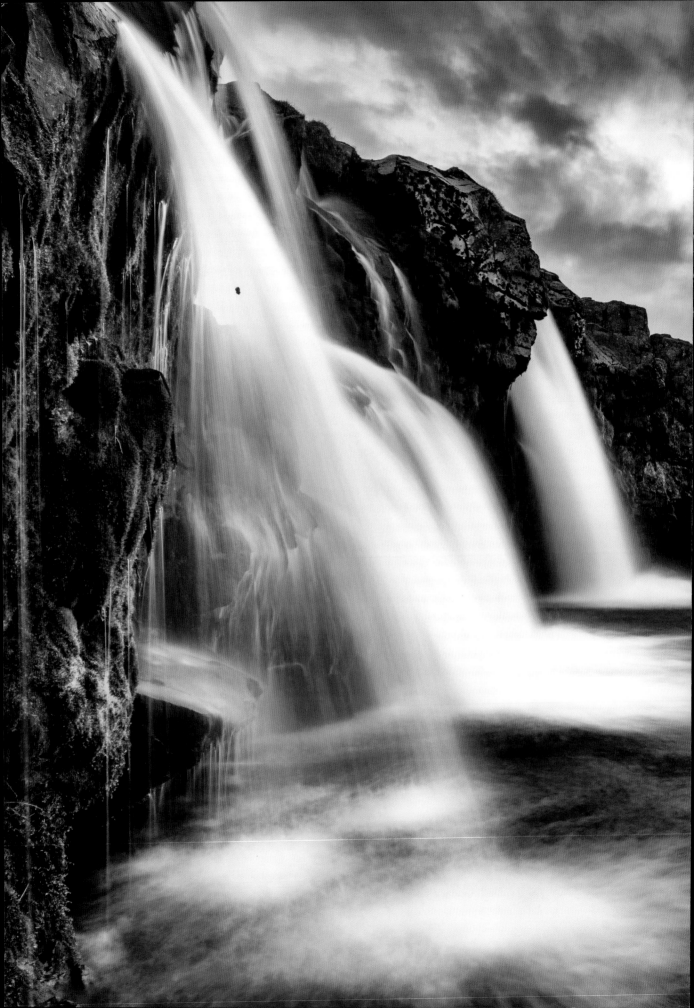

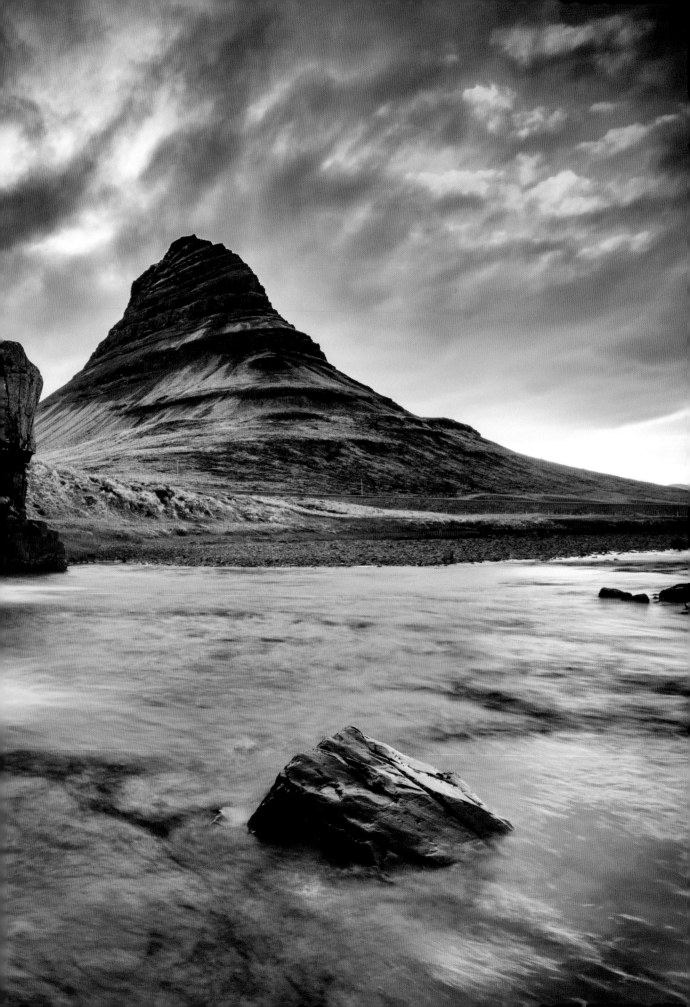

WATER

▶ RIGHT Backlit by the setting sun, the towering Reynisdrangar sea stacks are made of volcanic basalt and eroded slowly by the sea. According to legend, the stacks were formed when trolls dragged a ship to the land, but it turned into needles of rock.

▶ 66-67 In winter, parts of the Godafoss waterfall, the 'waterfall of the gods', turns into an icy curtain. Icelandic history reveals that when the country turned from Norse Gods to Christianity, a priest threw idols of the Old Gods into the waterfall.

▶ 68-69 The sky is reflected in a small pool in marble bedrock in Láhko National Park, Norway. The park is known for its water-eroded caves, swallow holes and alpine karst landscapes, where rivers simply vanish underground, before reappearing downstream.

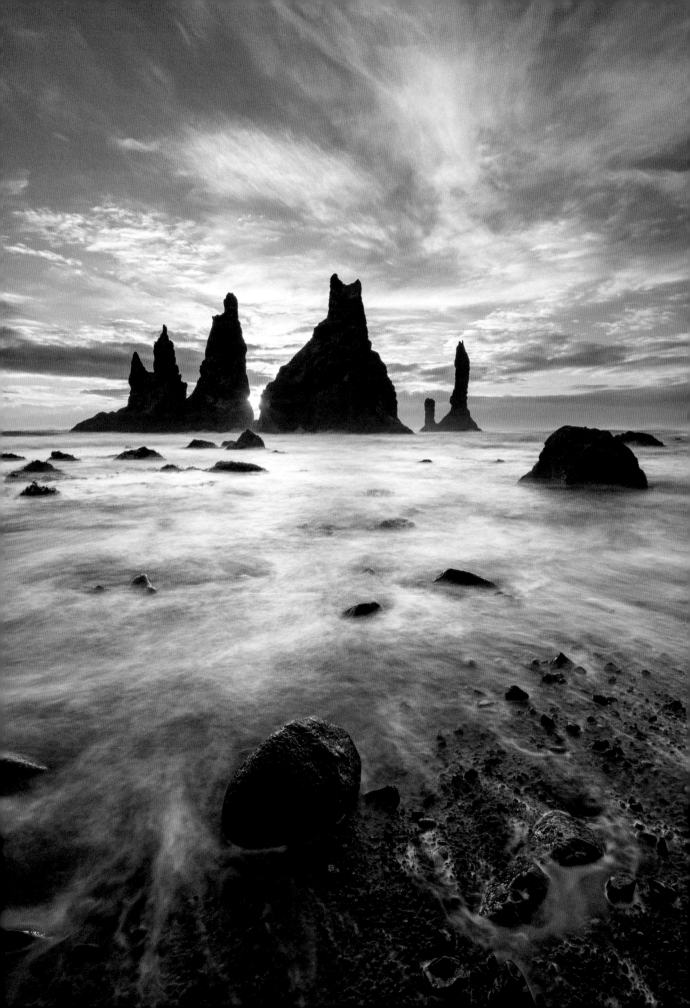

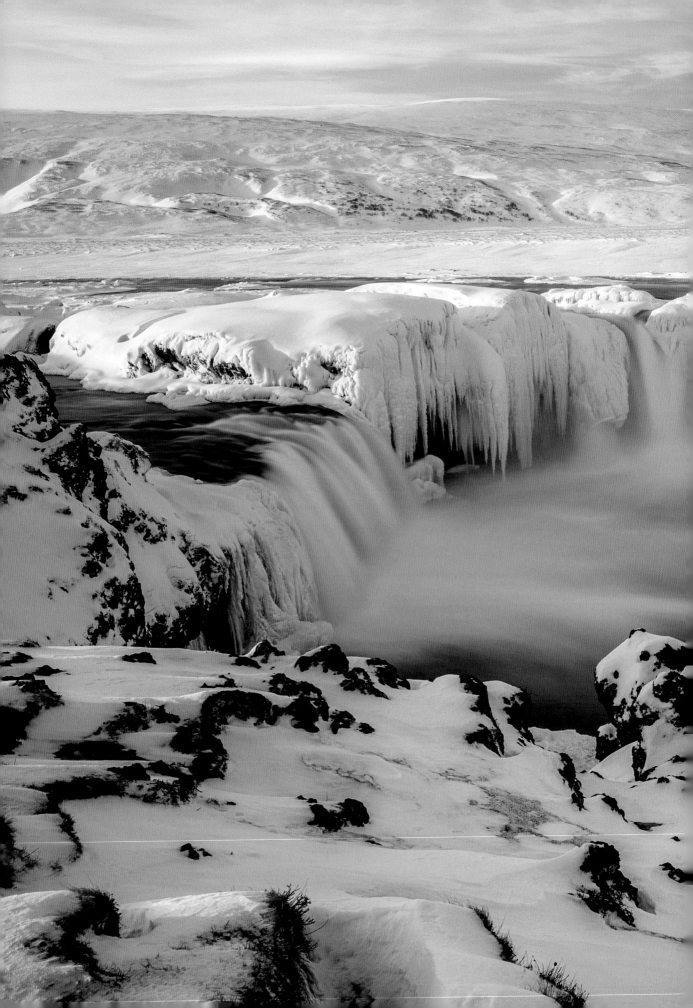

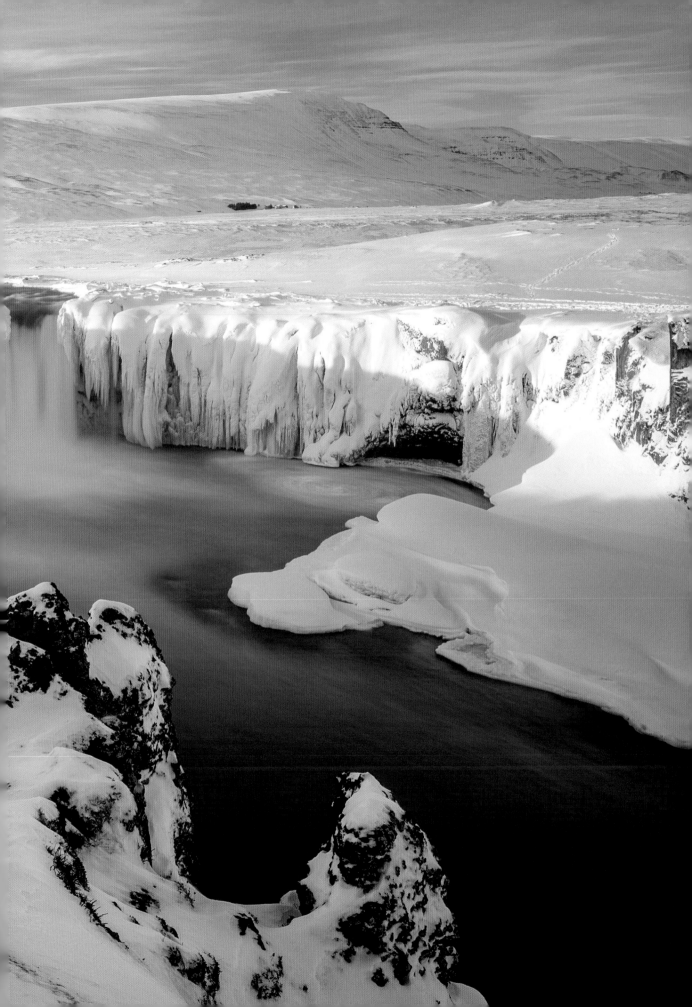

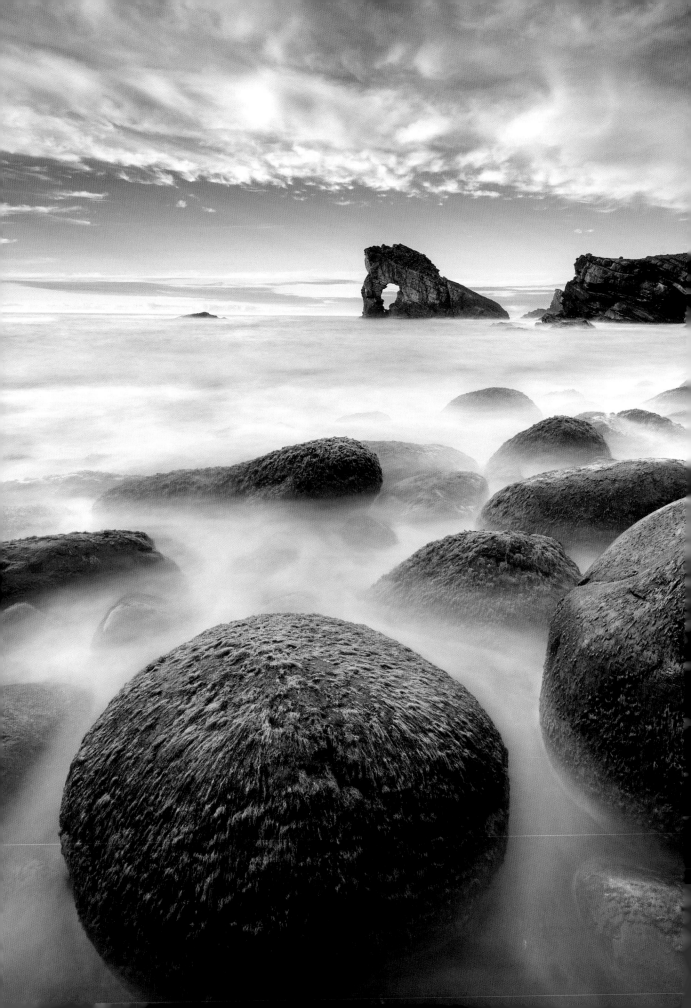

▶ LEFT and 72-73 Seaweed-covered boulders, worn smooth and round by the action of the waves, are scattered randomly on a beach near Gaada Stack. The stack is a natural arch off the coast of Foula, or 'bird island', so named because its cliffs are home to millions of nesting seabirds. Foula is one of Britain's remotest inhabited islands and the westernmost island in the Shetland archipelago of Scotland. Just 38 people live here permanently, their ranks swollen in summer by birdwatchers and hikers.

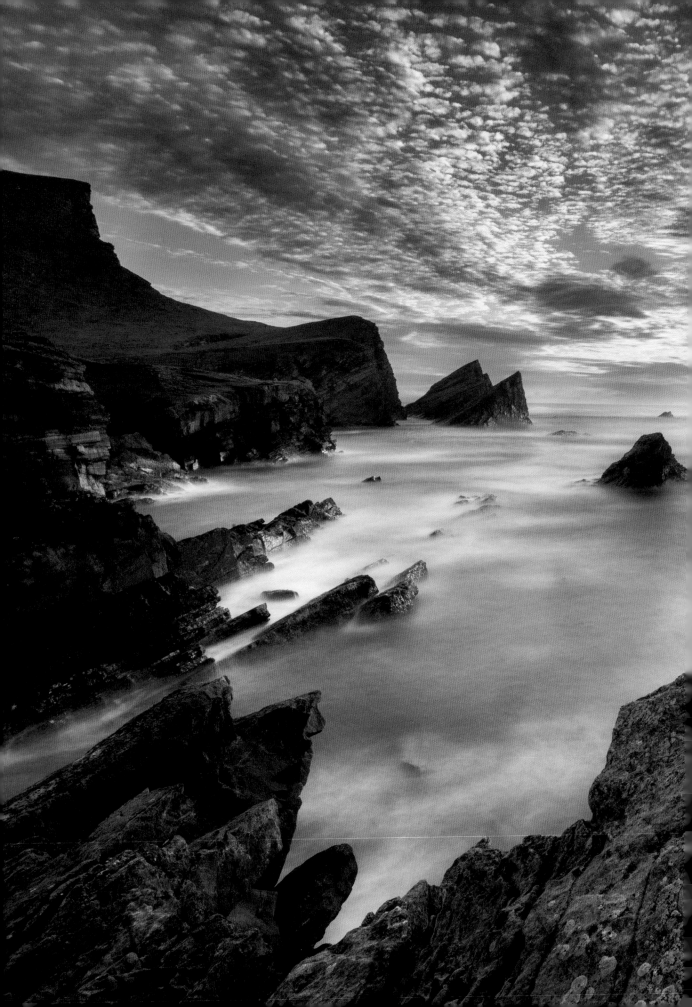

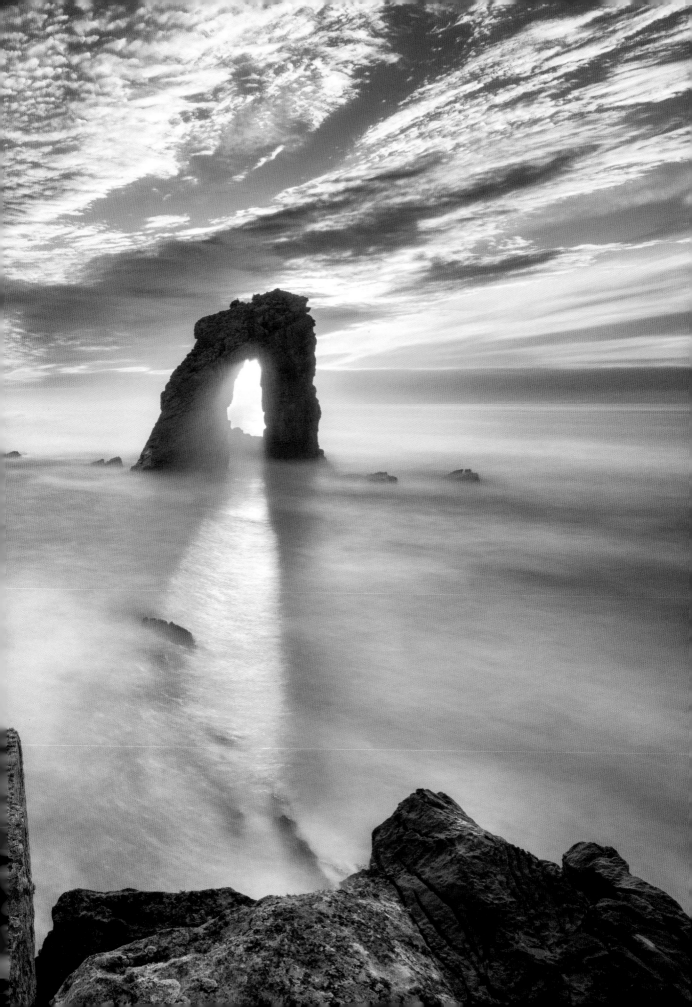

WATER

▶ RIGHT A platform of rock is exposed at low
tide in Kimmeridge Bay on Dorset's Jurassic
Coast, southern England. The sea has eroded
the softer mudstones and shales, leaving the
harder limestone as a rock pavement
crisscrossed by cracks and crevices.

▶ 76-77 Alternating strata of hard and soft
rocks have been thrust vertically and then
eroded by the sea at Barrika Beach on Spain's
Bay of Biscay coast. The soft rocks have worn
away, so rows of hard rocks project like the
scales on a crocodile's back.

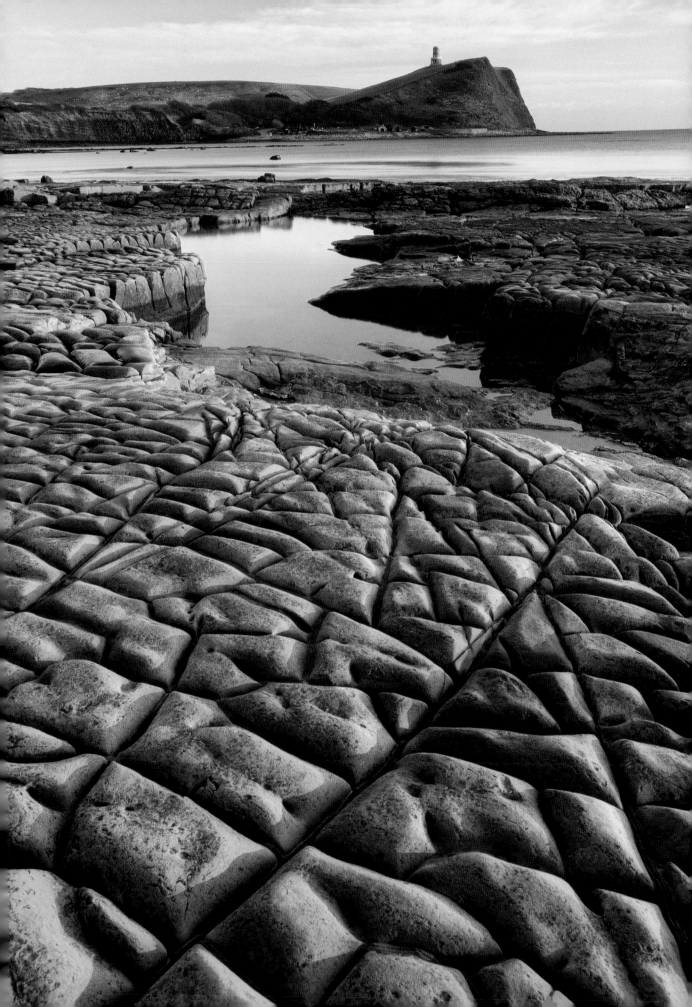

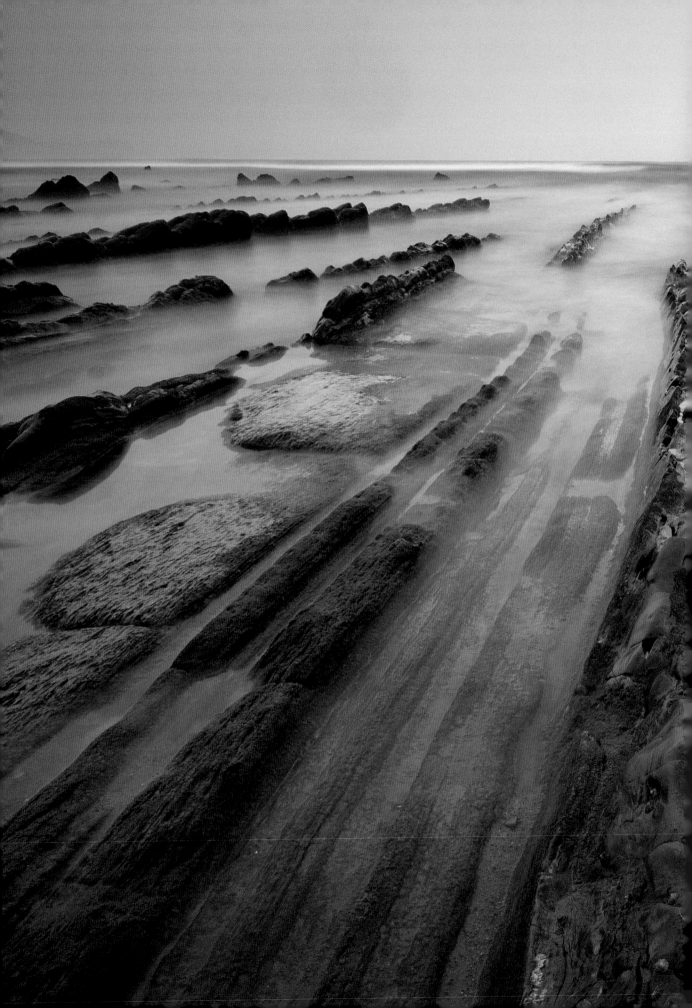

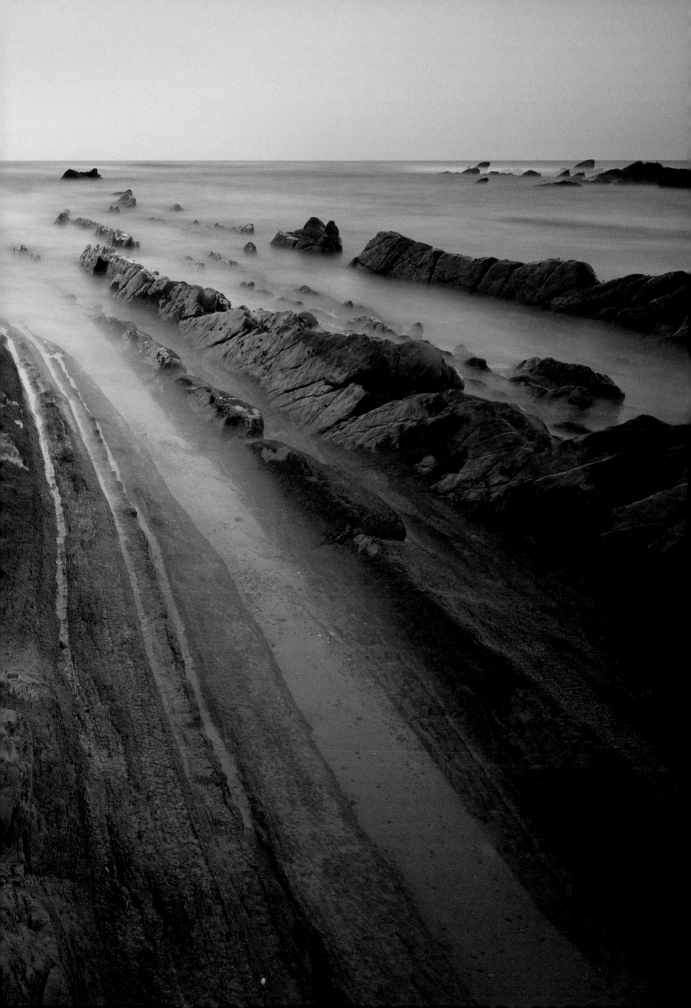

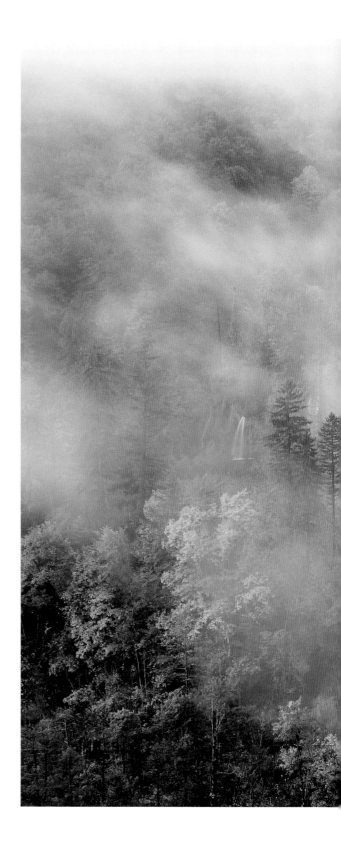

▷ RIGHT A misty dawn at the fairytale Plitvice Lakes National Park in Croatia. The 16 lakes are arranged in a cascade, each separated by a natural dam of travertine. The water moves from one lake to the next by flowing gently over delicate waterfalls.

▷ 80-81 Ethiopia's Sof Omar Cave is possibly the longest in Africa. It has been carved out of the rocks by the action of the Weyib River, creating a series of vaulted chambers and natural underground arches that resemble Gaudí's cathedral in Barcelona.

▷ 82-83 The Kunene River plunges 120 metres over the Ruacana Falls in northern Namibia. The falls are at their best when water is released from Angola's Calueque Dam, 20 kilometres upstream. They are said to rival the Victoria Falls for pure spectacle.

▷ 84-85 The razor-sharp limestone pinnacles in Madagascar's Tsingy de Bemaraha National Park were formed when the limestone was thrust up and exposed to torrential and rain, creating a stone forest. *Tsingy* means 'a place where you cannot walk barefoot'.

▷ 86-87 South Africa's Blyde River Canyon is one of the world's largest canyons. The river has sliced down through sandstone rocks, and its deep, precipitous cliffs are cloaked in subtropical vegetation, making it the world's greatest 'green canyon'.

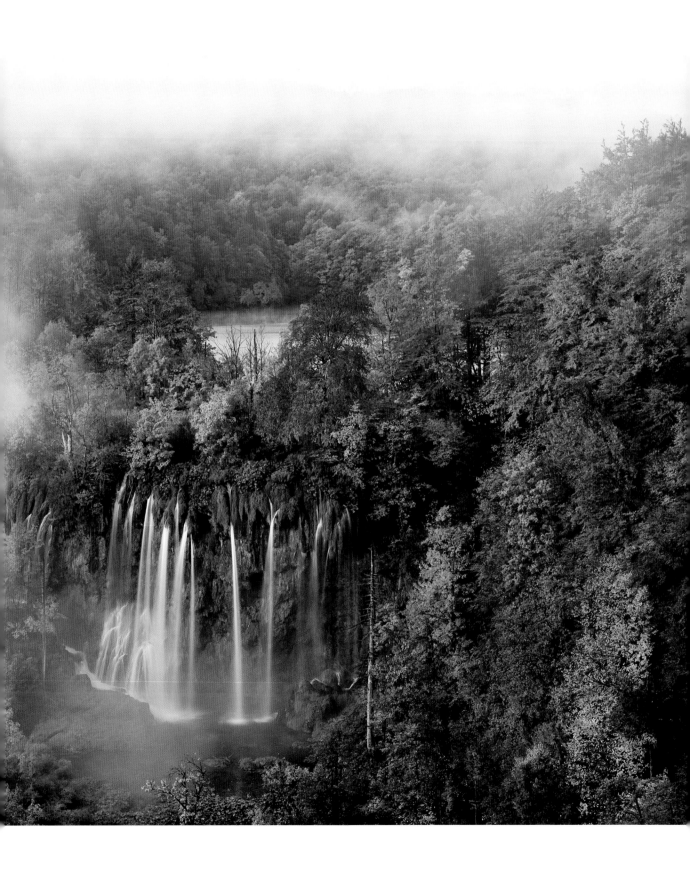

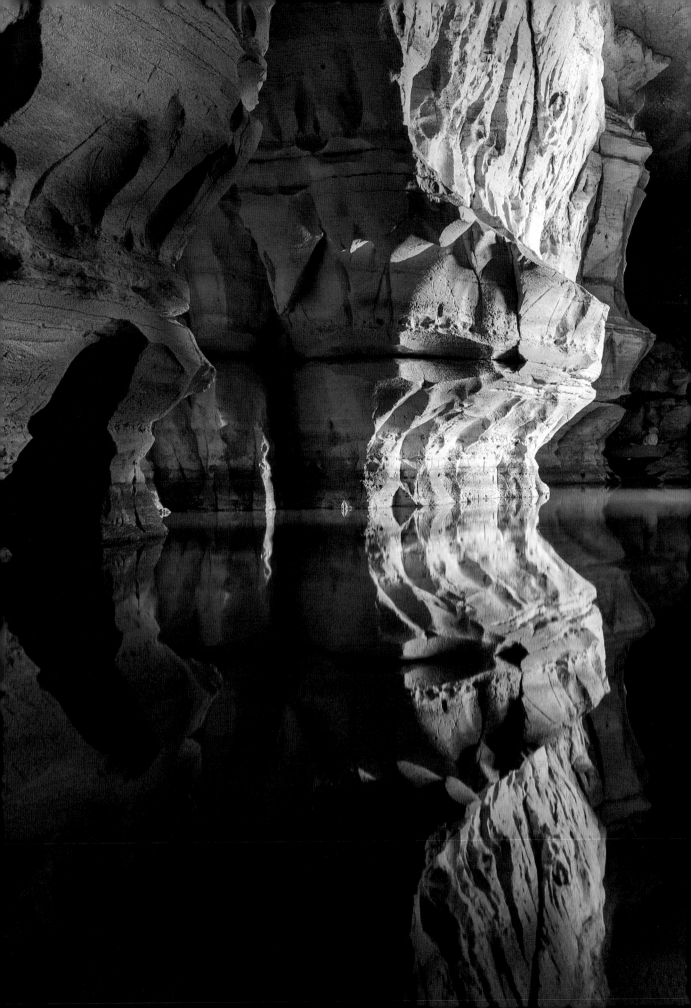

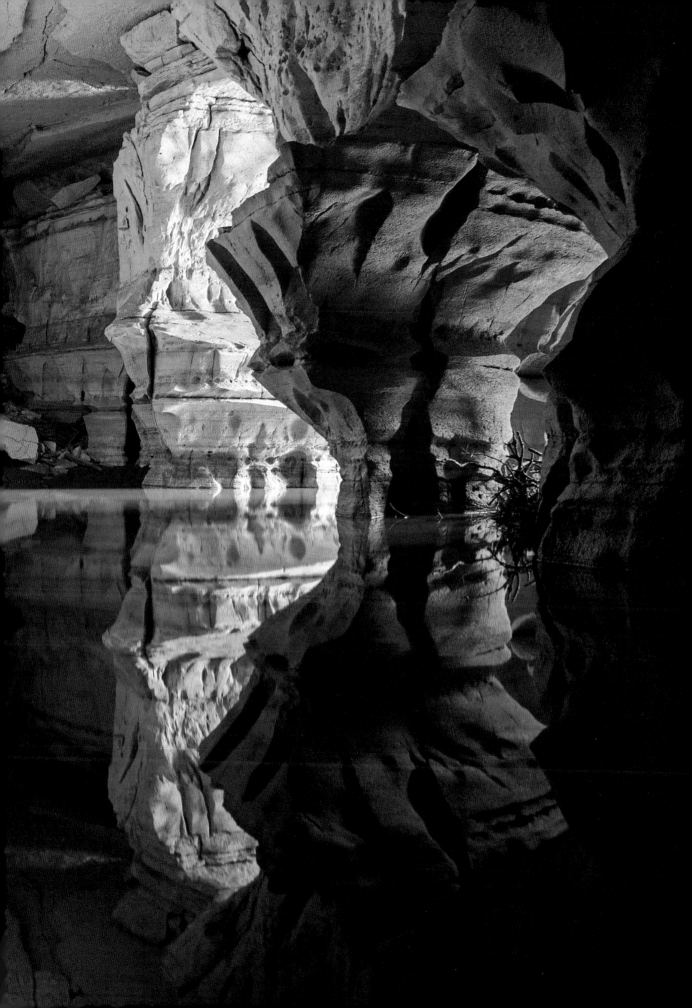

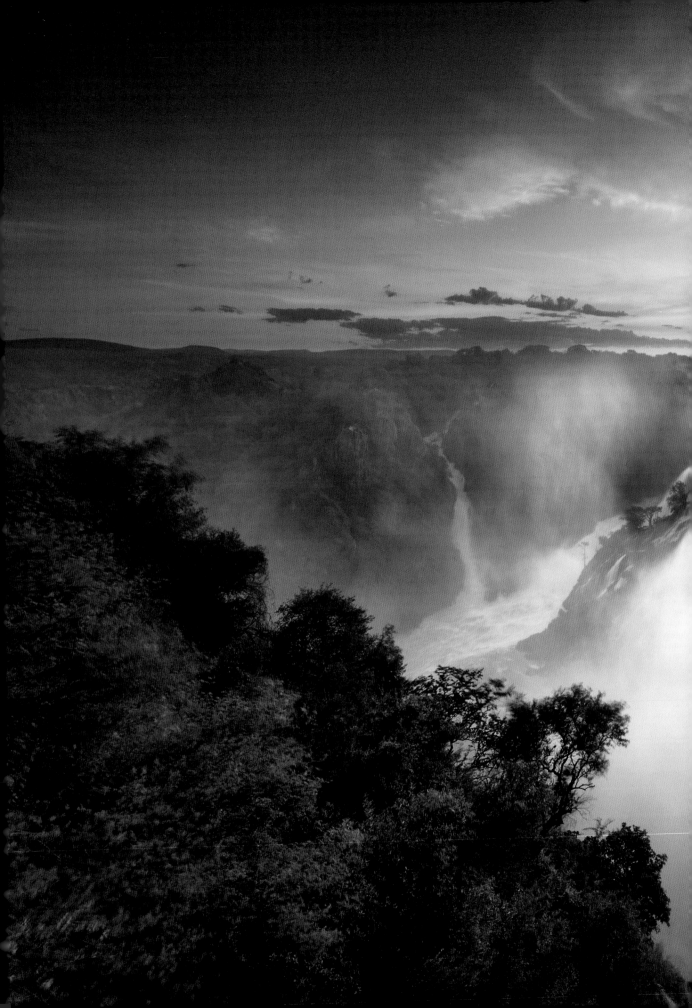

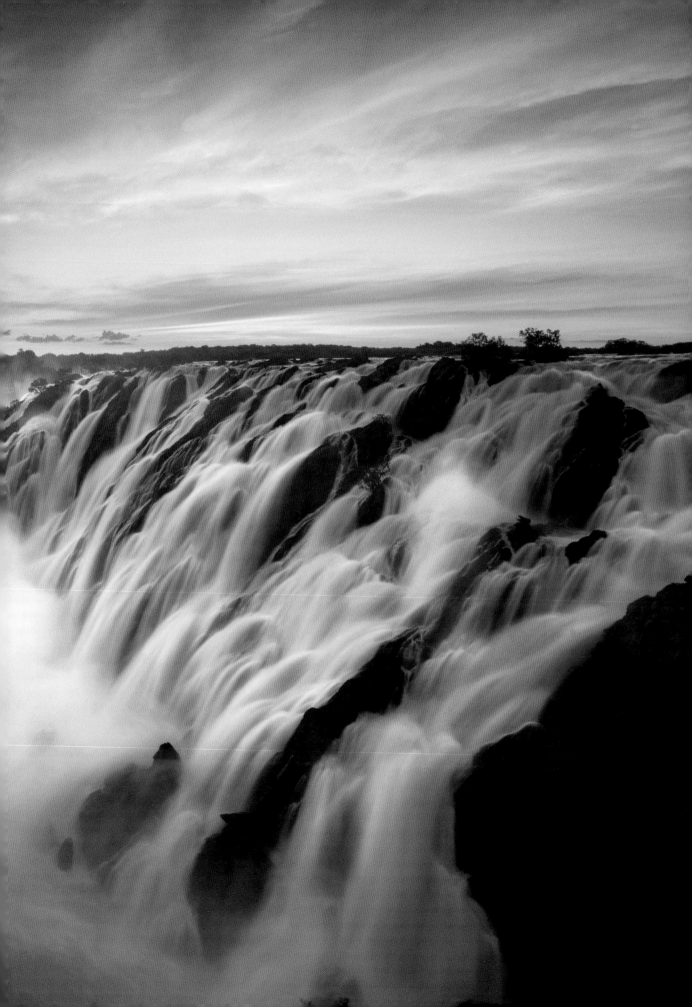

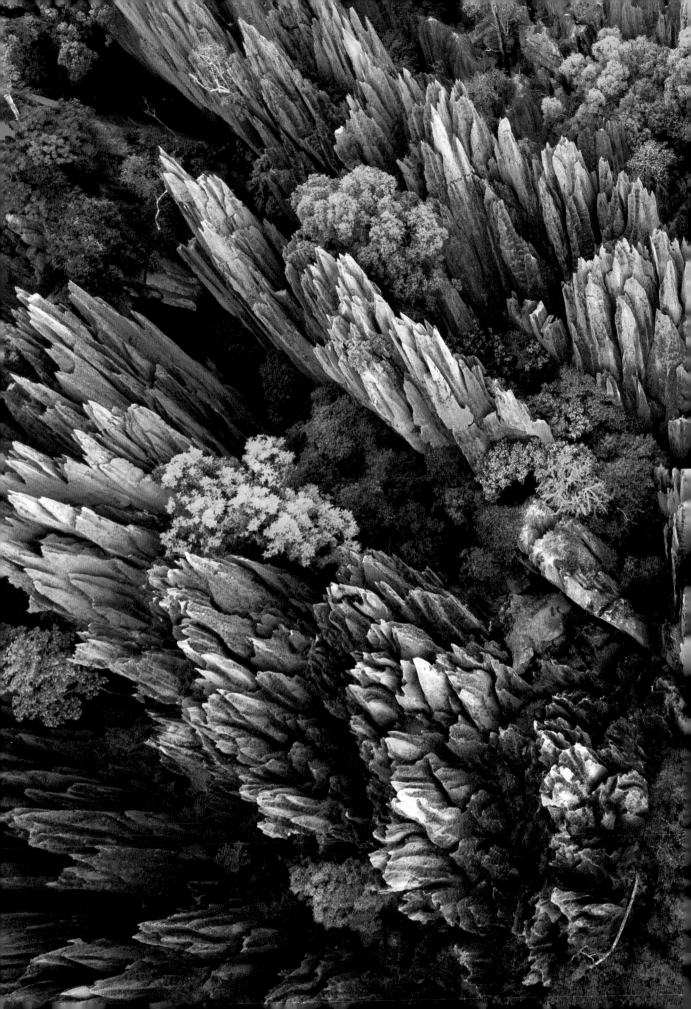

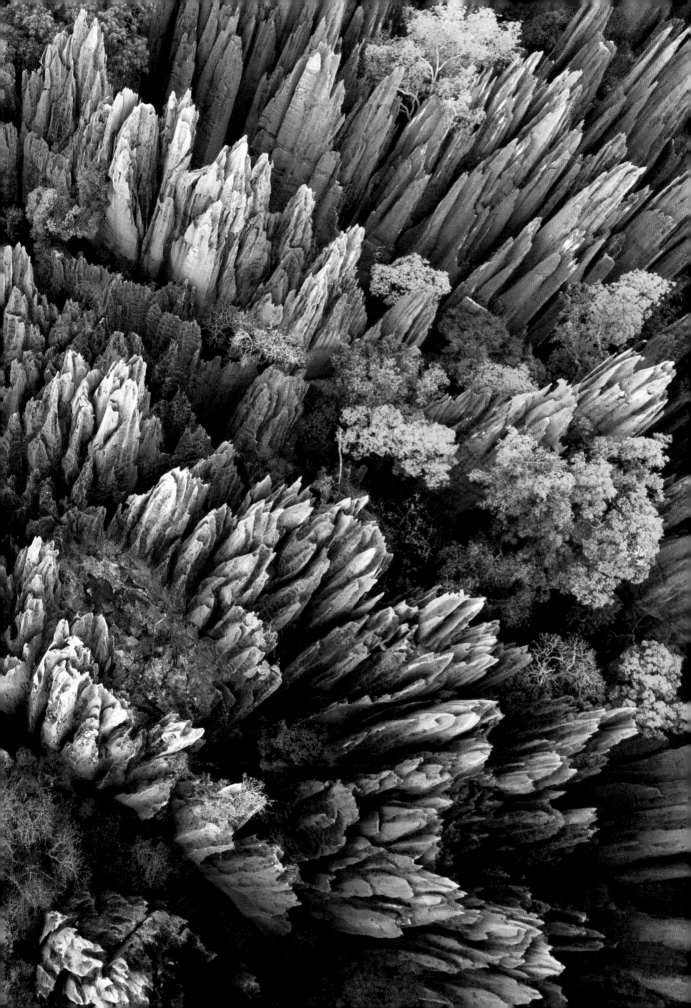

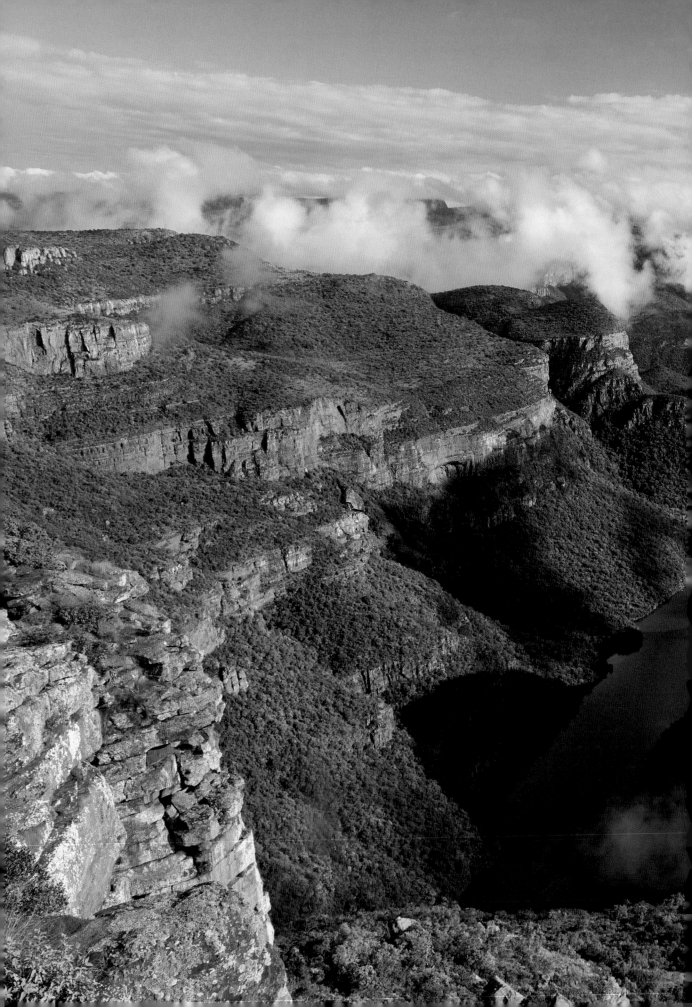

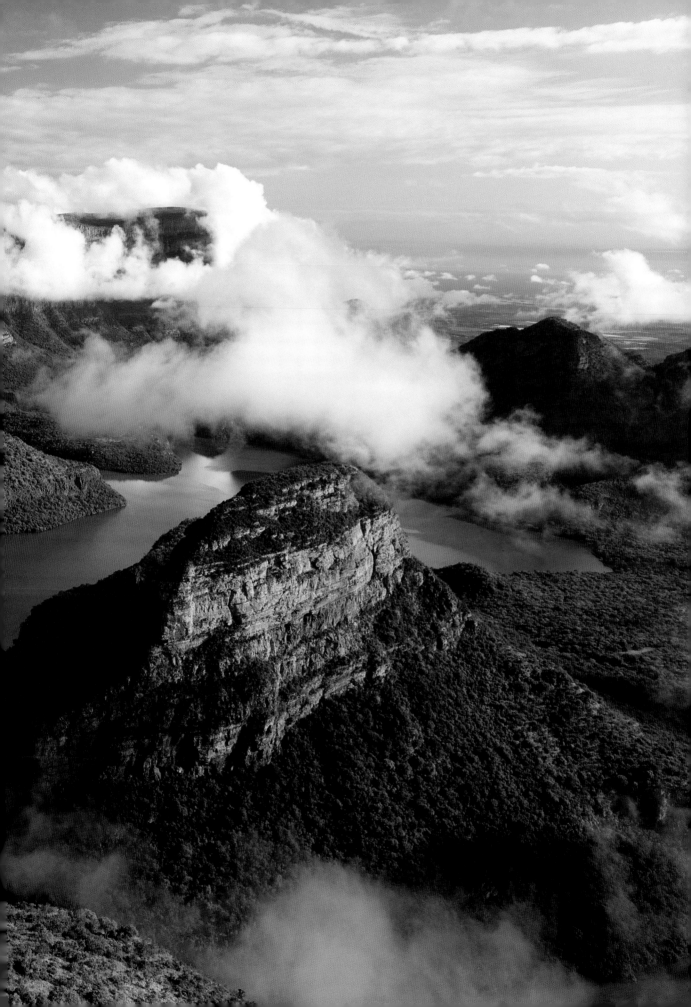

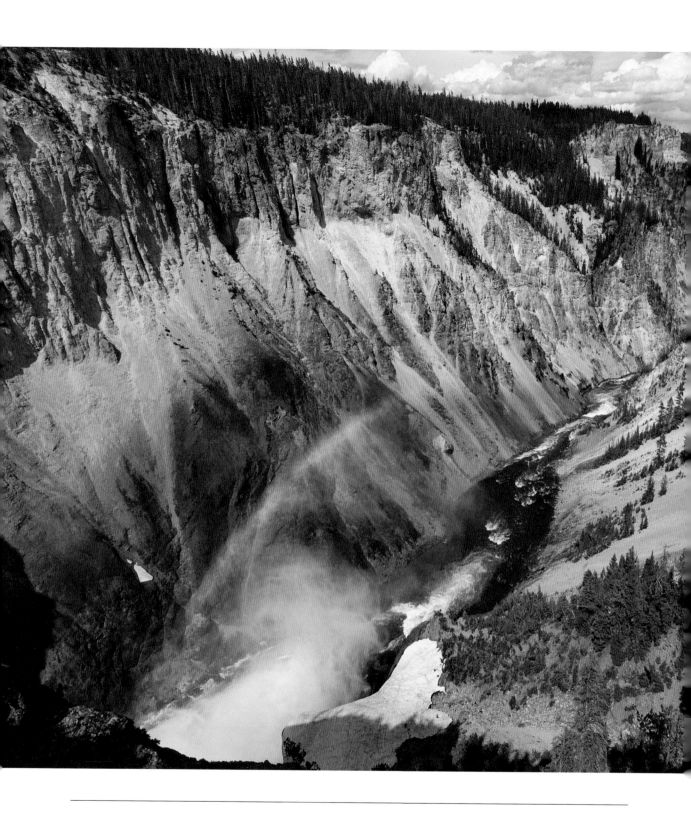

▶ ABOVE and RIGHT Conifer trees cling to the steep walls of the Grand Canyon of Yellowstone. The area below the Lower Falls was once a geyser basin, and the heat made the rocks softer, like baking a potato, and therefore they were more easily eroded. The process was accelerated after the last Ice Age, when ice dams burst and caused flash floods to barrel down the valley, sweeping the rocks away. The canyon's V-shaped profile indicates it was formed by river erosion rather than by glaciation.

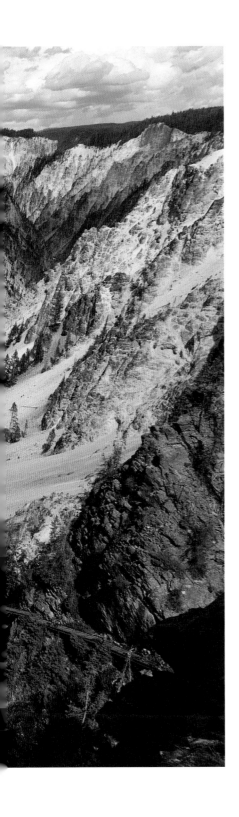

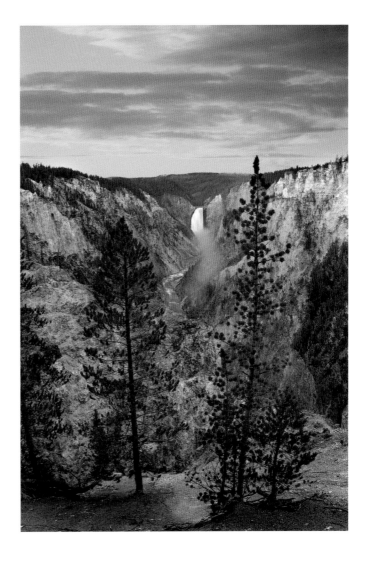

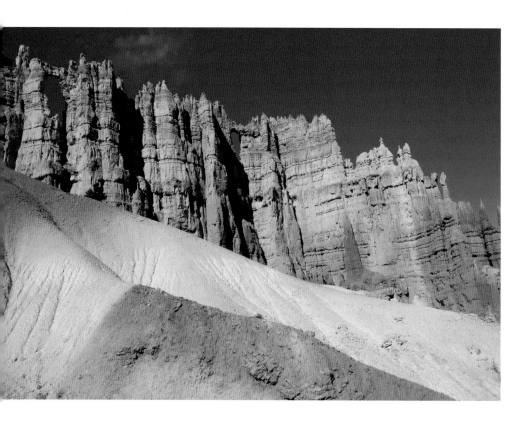

▶ ABOVE 'Wall of Windows' in Bryce Canyon National Park, Utah, is a series of arches and hoodoos along a slim ridge that has been weathered by frost, water and wind on the rim of the canyon.

▶ RIGHT Row upon row of hoodoos line the walls of Bryce Canyon. Their bodies are made from soft rocks and the hard caps are dolomite limestone, which contains magnesium so is particularly resistant to weathering. The tall, thin ones are up to 45 metres tall, but there are also short ones the height of a person.

▶ 92-93 Like a great army of giants, hoodoos pack into the horseshoe-shaped Amphitheatre carved out of Bryce Canyon. Some have been given nicknames like 'Queen Victoria', 'Chessmen' and 'Thor's Hammer'. In the setting sun, they all glow a glorious deep red.

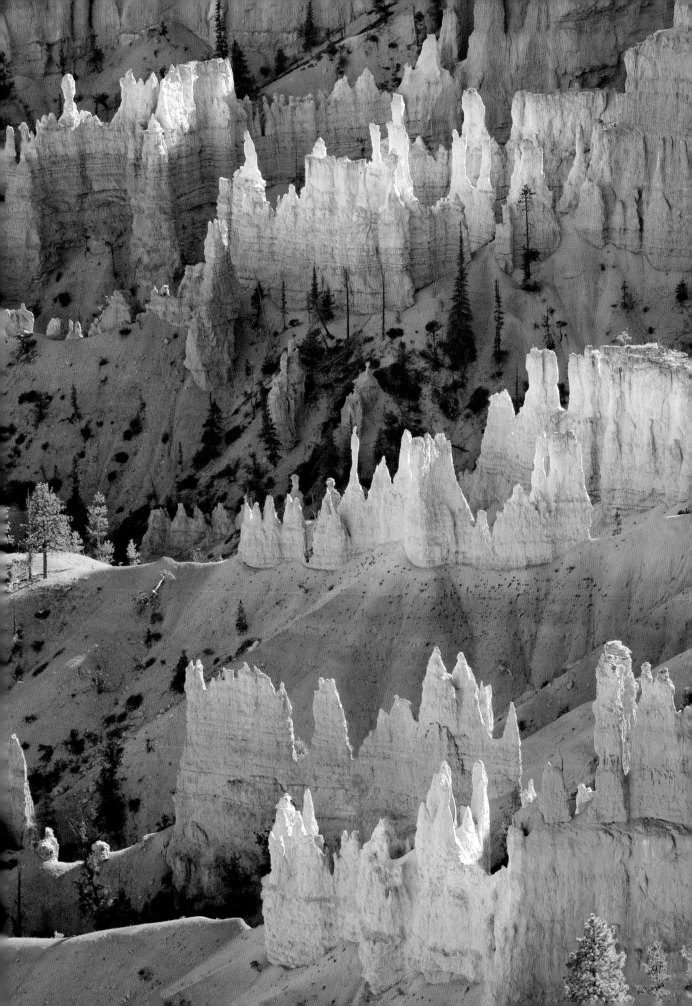

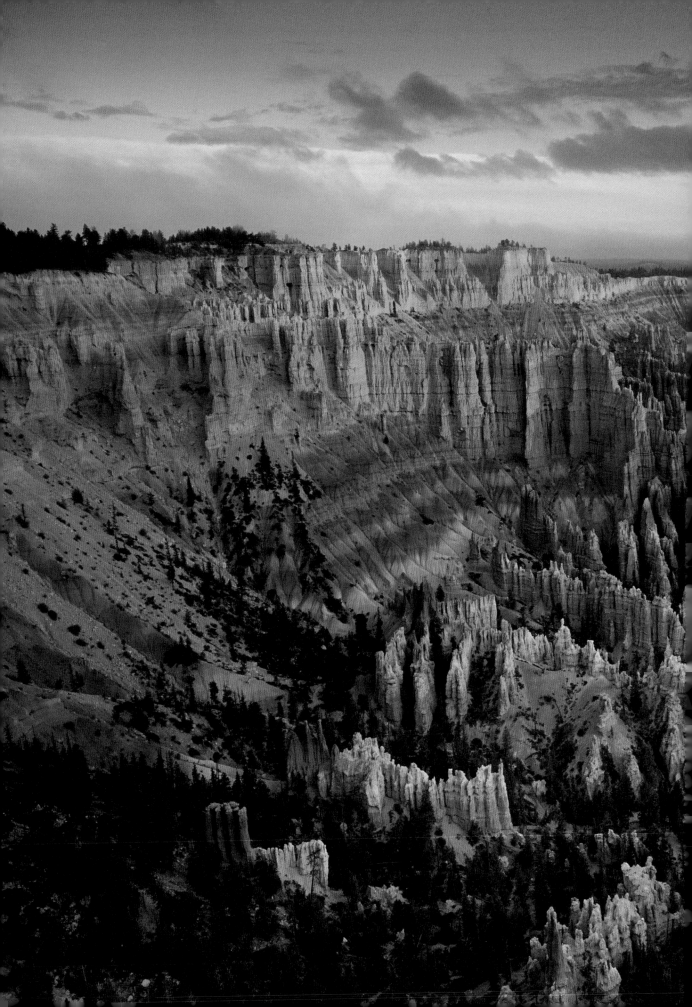

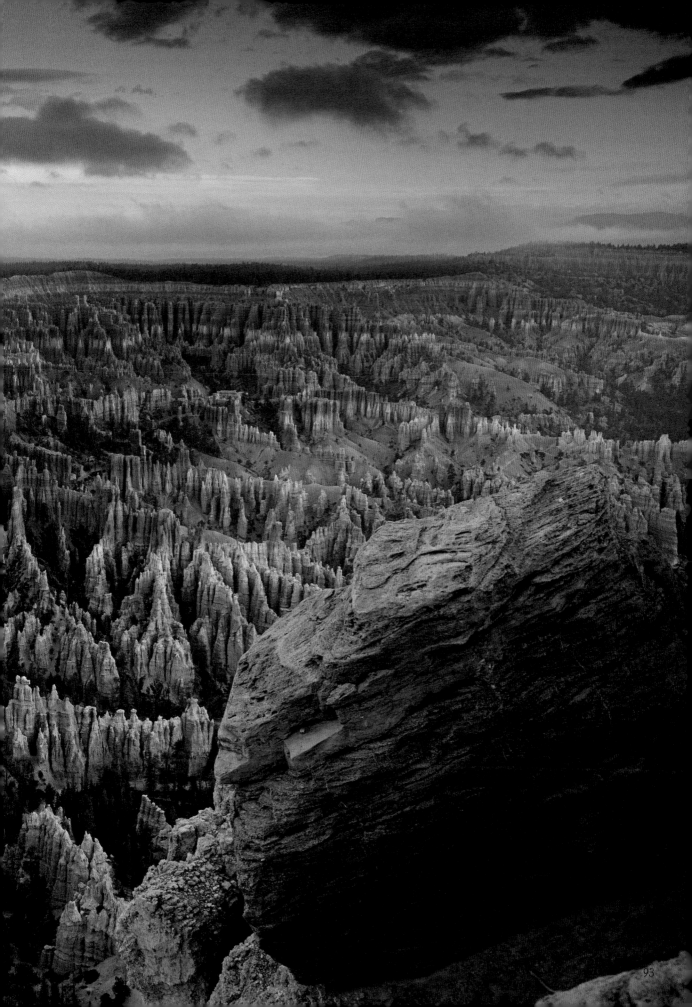

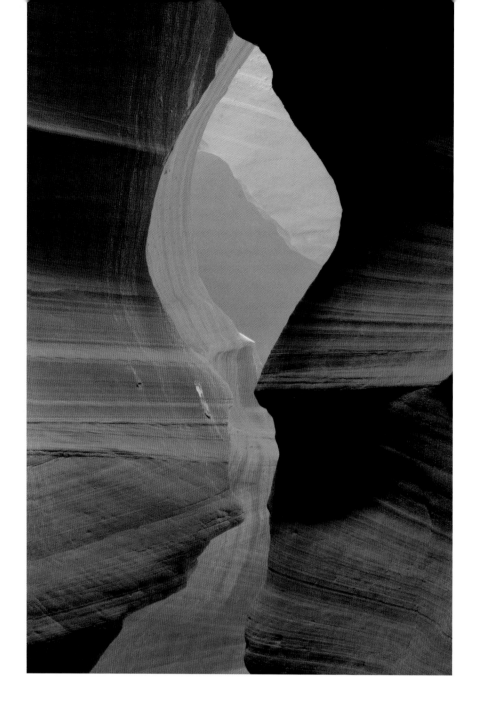

▷ ABOVE 'The Candle' is a rock formation in the upper part of Antelope Canyon, near Page, Southwest Arizona. This slot canyon, with its 40-metre-high walls, is in two sections: the upper and the lower. Shafts of direct sunlight illuminate the upper section, known as 'The Crack', but only for half the year. They appear on March 20 and disappear on October 7!

▷ RIGHT and 96-97 The lower section of Antelope Canyon is known appropriately as 'The Corkscrew'. The rock has been eroded smooth and the passageways contorted into spiral rock arches by flash floods, wind and rain. The water accelerates through the slot canyon, picking up speed in the narrow passageways. Antelope Canyon lies within the lands of the LeChee Chapter of the Navajo Nation.

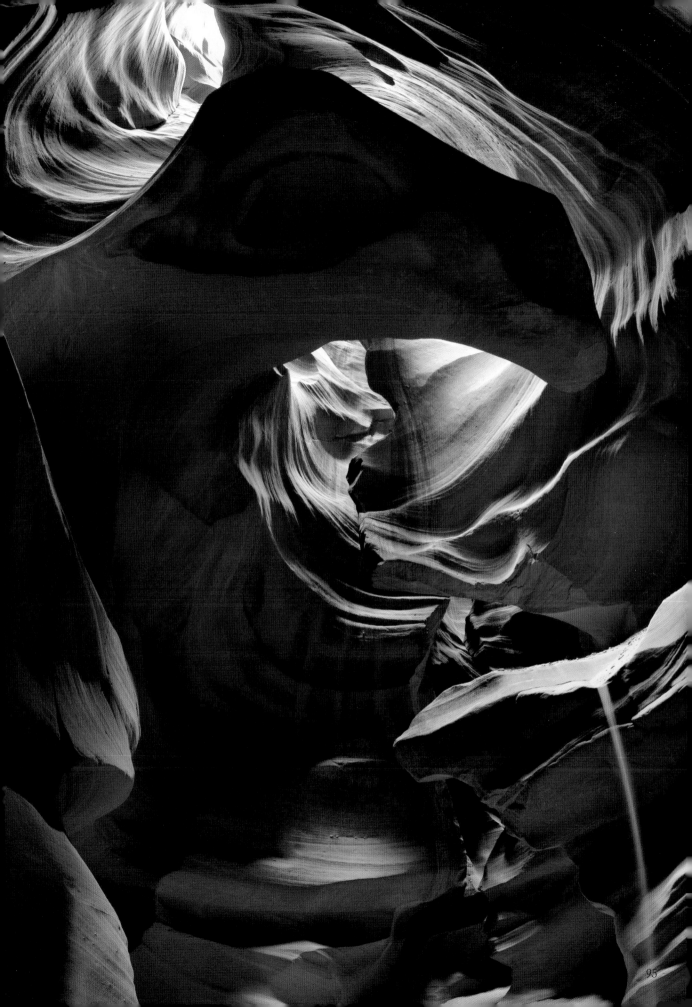

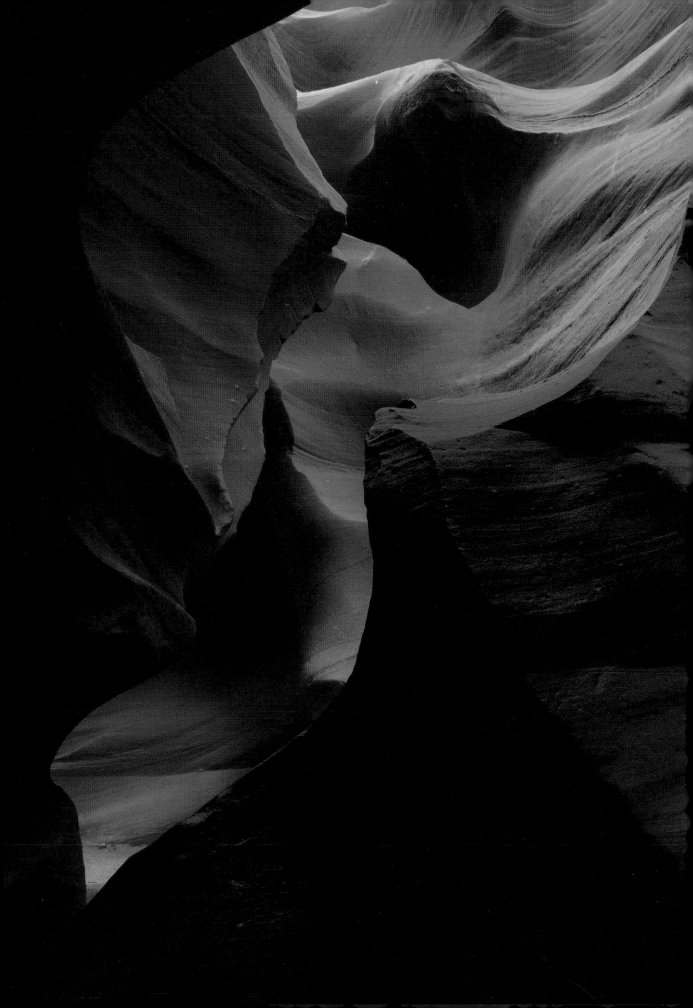

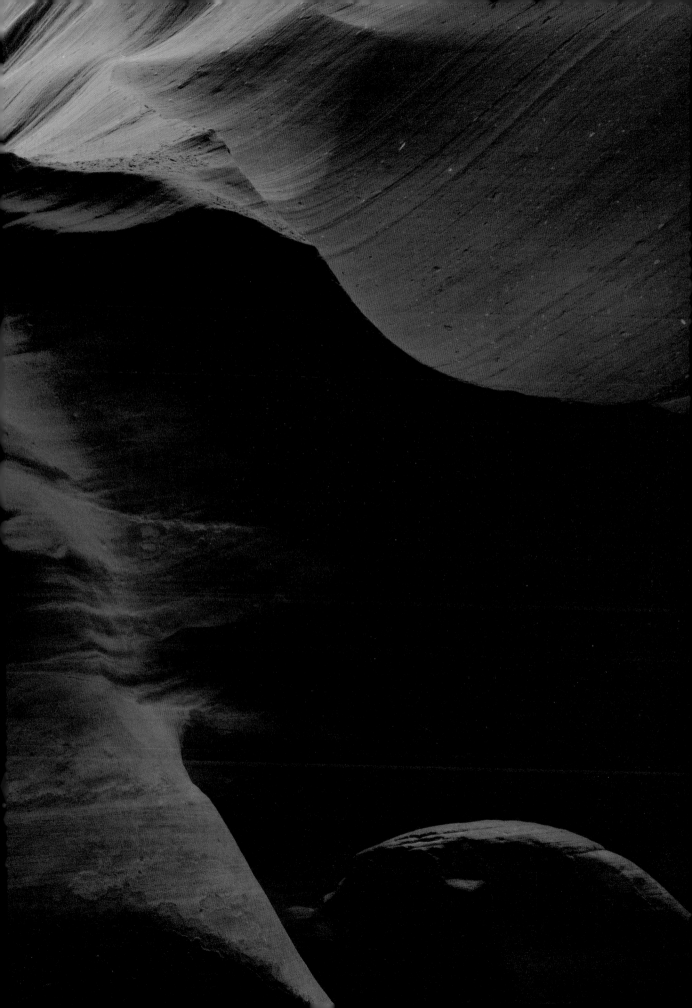

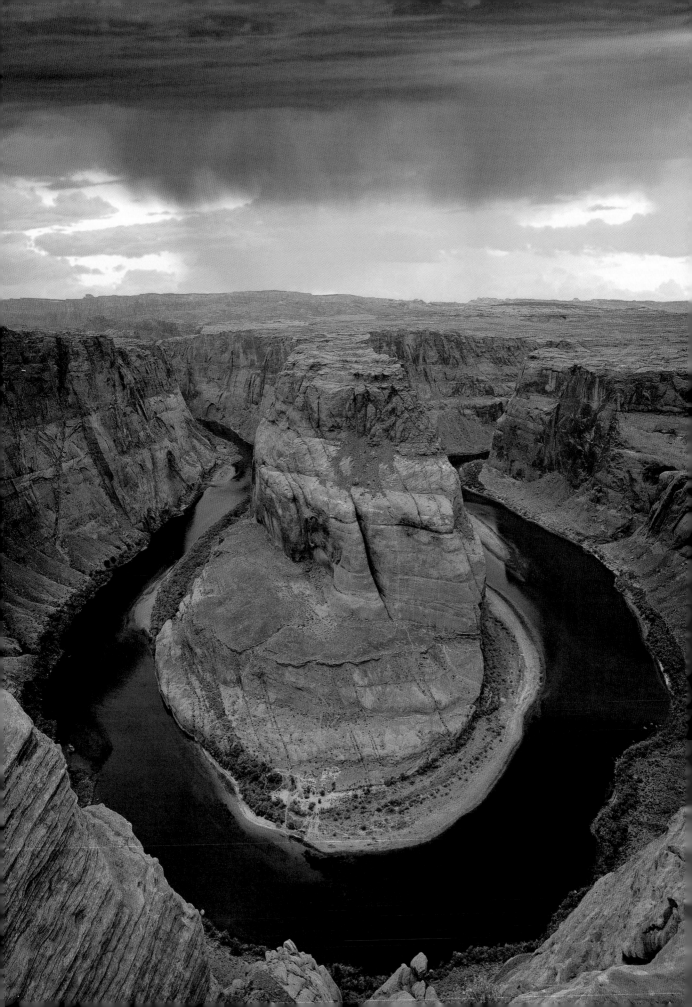

LEFT Storm clouds gather over Horseshoe
Bend in Arizona. The canyon is a deeply incised
meander of the emerald-green coloured
Colorado River, and close to the Grand Canyon
National Park. Its walls contain minerals, such
as platinum and garnet.

100-101 Viewed from the high desert of Dead
Horse Point, the Canyonlands National Park
and the gooseneck-like shape of the Colorado
River are spectacular. The vertical cliffs and
deep canyons have been eroded over millions
of years by water, wind and ice.

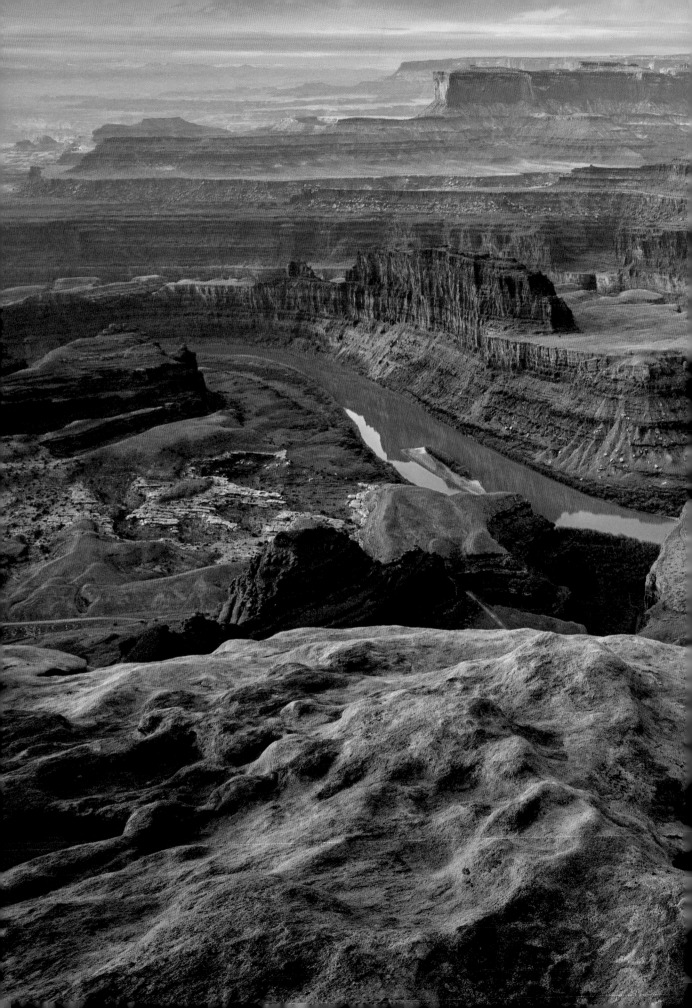

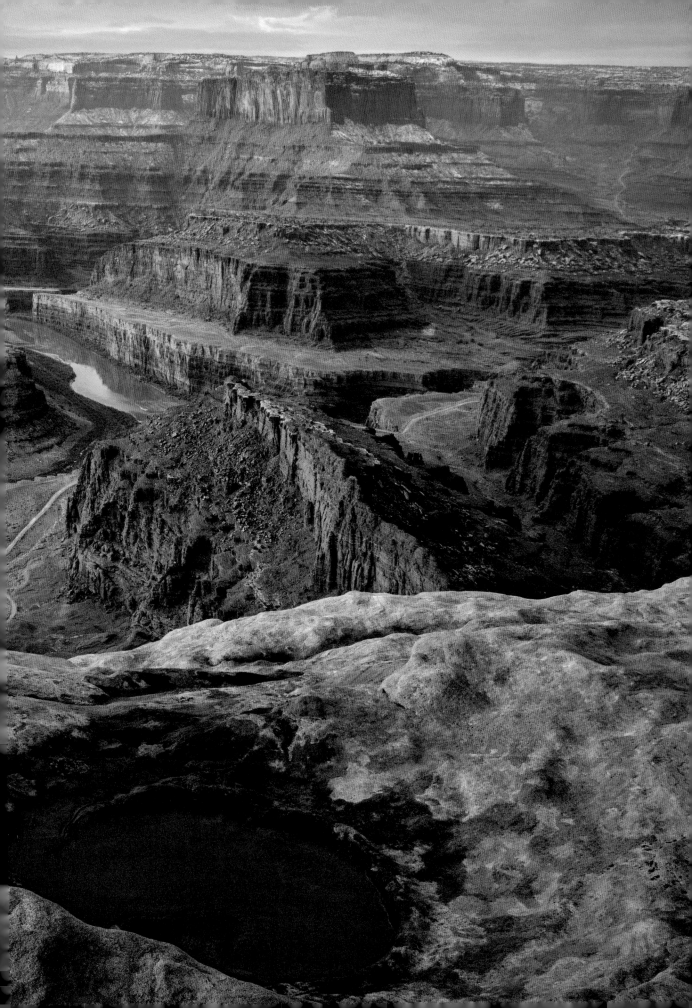

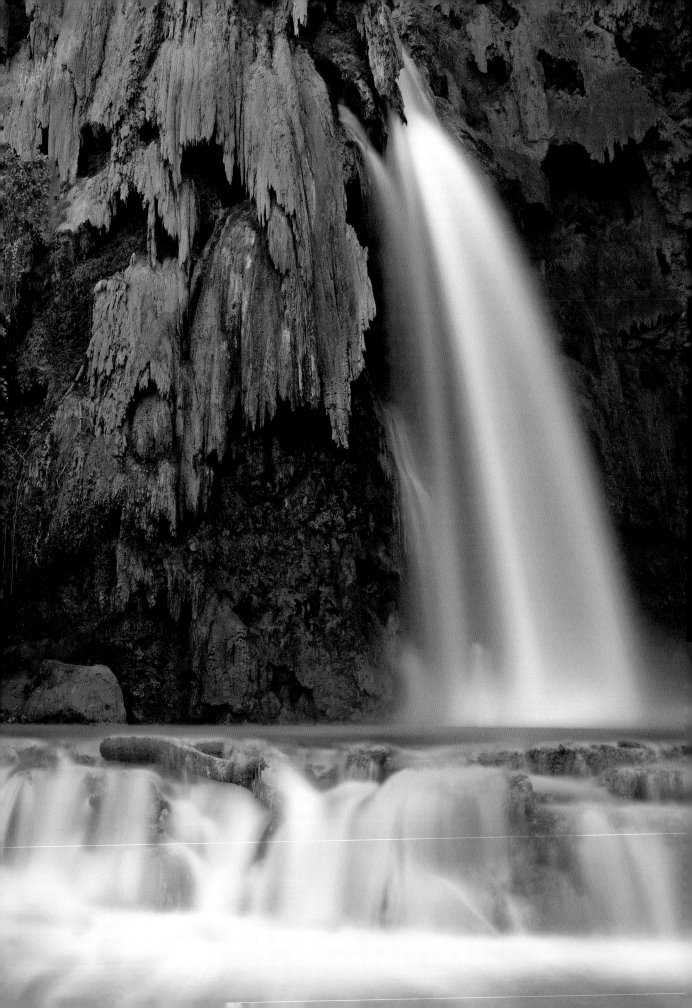

WATER

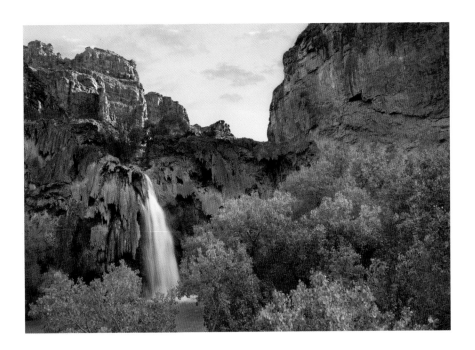

▶ LEFT and ABOVE Havasu Falls pours over a 30-metre-high cliff into a pool in Havasu Canyon. Swimmers can find a natural alcove behind the falling water. Flowing through the canyon is Havasu Creek, a tributary of the Colorado River. Its heavy load of calcium carbonate means the creek is lined with limestone, which reflects sunlight and gives the water a striking turquoise colour. The Havasupai, the smallest North American Indian nation, who live nearby, are the 'people of the blue-green waters'.

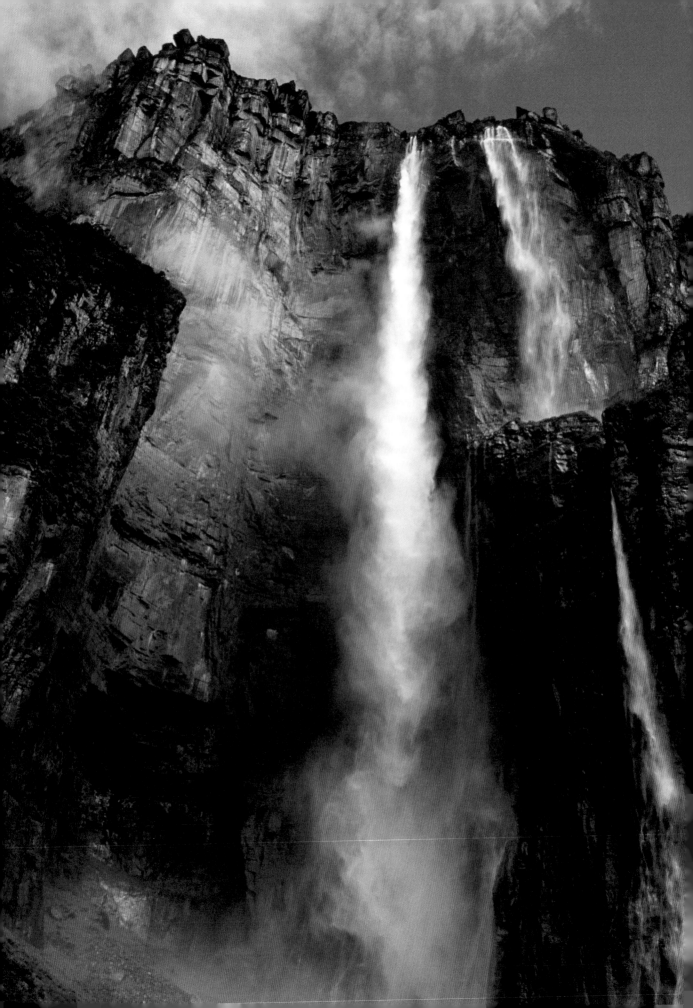

WATER

▶ LEFT The breathtaking Angel Falls, in
Venezuela's Canaima National Park, has the
greatest uninterrupted drop of any waterfall
in the world. The water pours over the edge
of the ancient Auyán *tepui*, and plunges
807 metres from a height of 979 metres.

▶ 106-107 Iguazú Falls, on the border between
Argentina and Brazil, is where the Iguazú River
plunges over the edge of the Paraná Plateau –
the world's largest waterfall system. Great
dusky swifts nest behind the water, where they
are safe from predators.

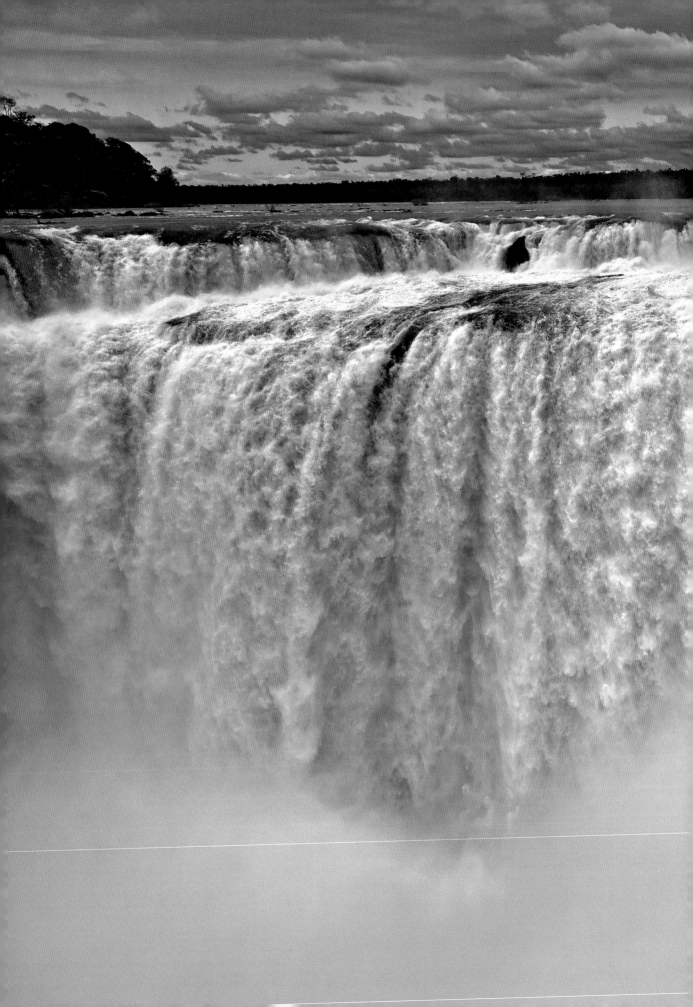

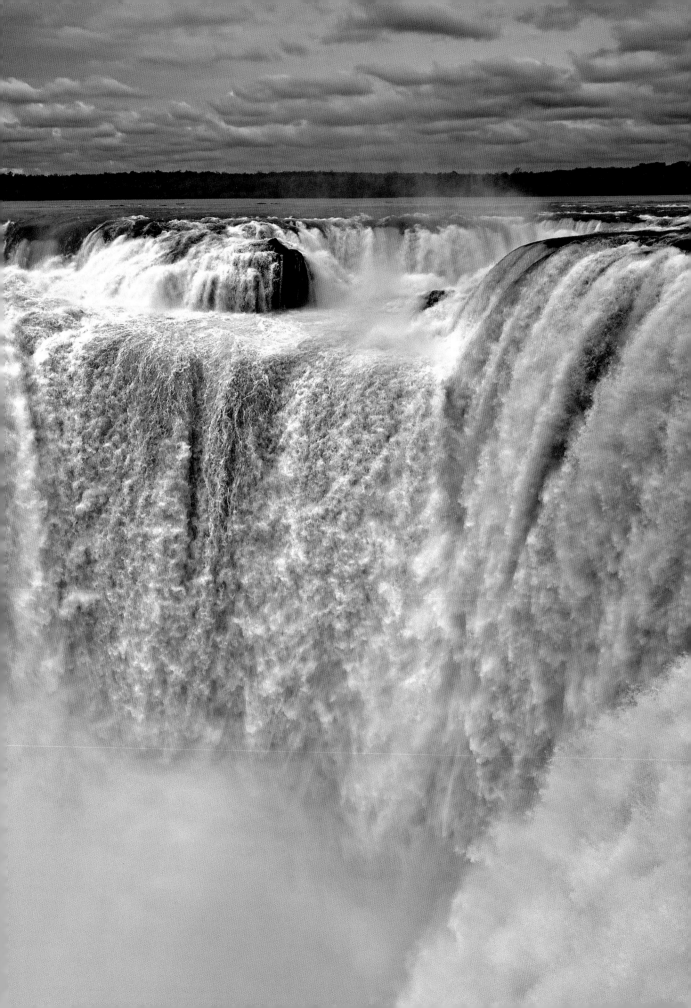

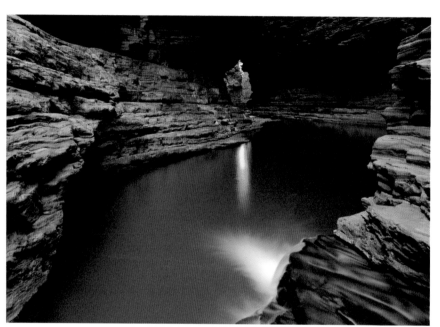

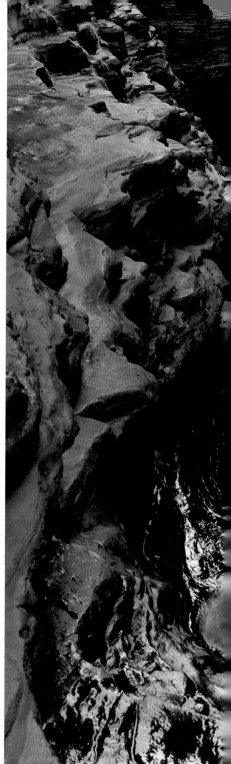

WATER

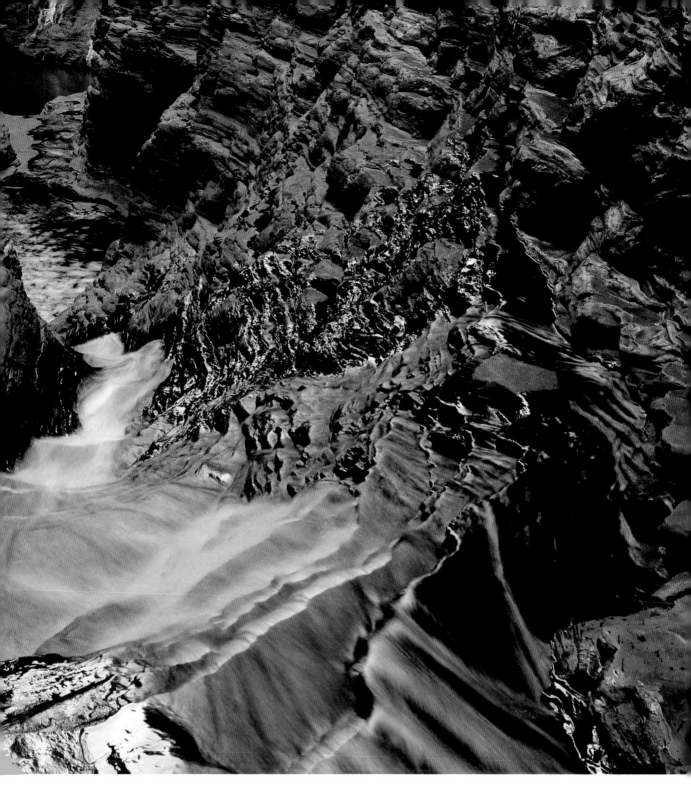

▷ LEFT Karijini National Park, in The Pilbara region of northwest Australia, has narrow gorges and beautiful plunge pools that are unlike anything elsewhere in the world. 'Kermit's Pool' in Hancock Gorge is named for its bright green water.

▷ ABOVE 'Reagan's Pool' is named for Jimmy Regan, who lost his life in a flash flood while attempting to rescue a trapped tourist. It is a series of cascades and pools that are so dangerous, hikers are advised not to go any further without an experienced guide.

▷ 110-111 Moeraki Boulders in New Zealand are large, spherical rocks made of mud, silt, and clay, cemented by calcite. They were formed on the floor of an ancient sea, and then covered with mud that became mudstone. Coastal erosion has broken them free.

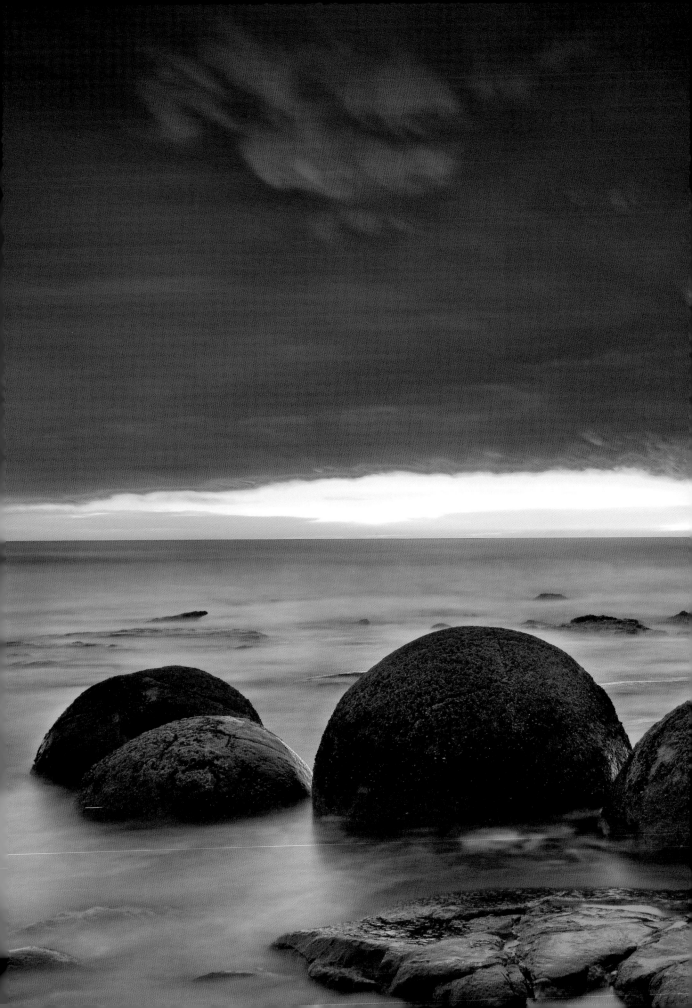

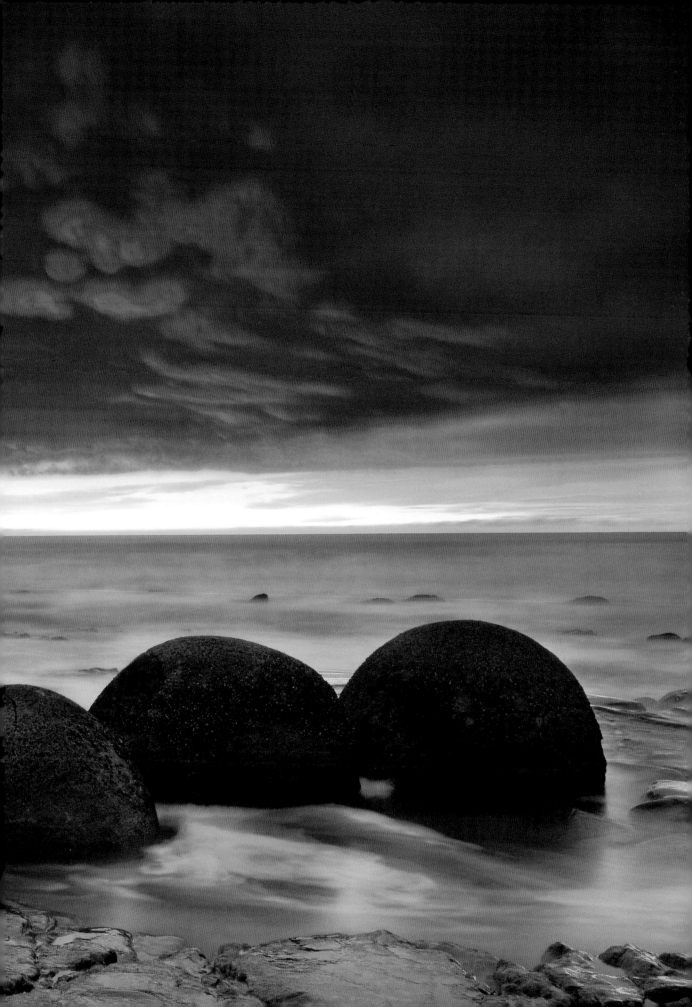

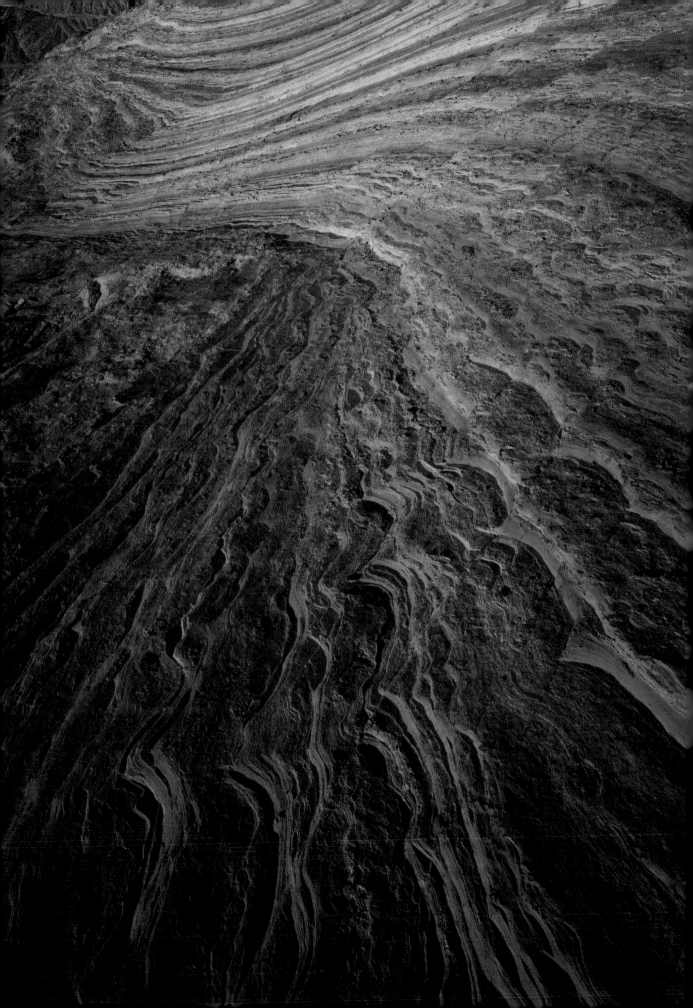

WIND

Invisible and Unpredictable Designer of the Ages

Wind is a perceptible movement of the air, but generally not until it is so strong that it turns our umbrella inside out or knocks us over are we really aware of it at all; and like the other agencies of erosion and deposition, it shapes a great many landscapes on the surface of the Earth.

Winds have always been important to us. Ancient seafarers in their sailing ships recognised them by their vigour and latitude, with names like the 'roaring forties', 'furious fifties', 'screaming sixties' and the 'doldrums'. Artists such as Cezanne and Van Gogh lived in Provence in the south of France, where the cold, dry, northwesterly winds of the mistral made for clear skies and vibrant colours. Weather forecasters know winds for their direction, strength and duration: short bursts of high-speed winds are gusts, which, if they last for a minute or more, become squalls, while winds of longer duration are described by their average strength – breeze, gale, storm force and hurricane.

Whatever their names, these winds can pick up and move dust and sand, and, in a process similar to sandblasting, fling it at rock surfaces, wearing them down until they become as smooth and rounded as the 'Giant Marbles' in Joshua Tree National Park, California, or the ragged 'fins' of Gold Butte, Nevada. How the particles behave depends on their size. Large particles roll along the ground, smaller particles are lifted into the air and bounce along, and the very small dust-like particles are lifted by the wind and carried over long distances. They all lead to wind-eroded landforms, which are especially prevalent in hot, dry desert landscapes like those in the American Southwest.

One of the most spectacular is 'The Wave' at Coyote Buttes in the Vermillion Cliffs National Monument, Arizona. Like a sweeping multicoloured skateboard park, it is composed of bands of red, white, pink and yellow sandstone. They are the rock layers that were once windblown sand, but now look like the contours on a topographical map, only writ large. Fast-flowing water carved out the original chutes, but they have dried up and the wind has taken over, skimming the surface as if somebody has taken an enormous sheet of sandpaper and smoothed and rounded the rocks. It is such a charismatic site that many people try to visit, but the rock formation is so delicate that

▶ LEFT On the high desert of the Colorado Plateau in Arizona, petrified sand dunes create a striped pattern that is more obvious as the sun sets and shadows are longer. It's been called the 'red rock country', because the main rock is red sandstone.

WIND

the authorities issue only a handful of permits per day to prevent this stunningly beautiful landform from being destroyed by trampling feet.

While the wind is secondary to the shaping of The Wave, on the other side of the Pacific an equally iconic landmark has the wind taking centre stage. In the Pilbara region of Western Australia are some of the world's oldest rocks. They were created 3.4 billion years ago and contain traces of the earliest forms of life. In amongst them is an extraordinary landscape with thousands of weathered limestone pillars standing in yellow desert sand. They are 'The Pinnacles'. Some are the size of tombstones, others are up to 3.5 metres tall, and how they came to form is the subject of intense scientific discussion. Most scientists agree that things started with sand dunes made from the ground-up shells of marine creatures, but they cannot agree on how the limestone formed. One theory is that trees once grew amongst the dunes, and calcium accumulated in and around their roots. When the trees died, the conduits, where their roots had been, filled with carbonate materials, which turned into limestone. The dunes were then blown away, leaving the root casts standing as limestone sentinels.

Dunes and dust storms occur because the wind not only erodes, but also carries and deposits vast quantities of material from one place to another. If rain should pass through a desert, for example, the air temperature drops substantially and the cooler, denser air drops to the ground, where it is deflected forwards. In the turbulence, dust is swept up and into the atmosphere, creating dust storms that can travel right across the globe.

The wind also picks up and transports larger sand-sized particles and these are deposited, and then build into dunes. Dunes are formed when accumulations of sand are blown into mounds or ridges. They generally have a gentle slope on the windward side, and often an avalanche-like slope or 'slipface' on the lee side. Sand is blown along the upwind side and gathers on

the crest. When the accumulation becomes unstable, it slides down the slip face, so grain by grain, the dune moves downwind and across the Earth's surface. There are several types of sand dune, depending on the direction of the prevailing wind. One of the most common is the 'barchan' dune, which is a fast-moving, crescent-shaped dune formed when the wind blows consistently from the same direction, but there are several others, and one type of dune can turn into a monster.

In the Namib Desert, on the Atlantic coast of southwest Africa, there are some of the highest sand dunes in the world, and the biggest are to be found around Sossusvlei in the Namib-Naukluft National Park. Sossus means 'gathering place of water' in the Nama language, and vlei is Afrikaans for 'shallow lake'. The words refer to the times when water accumulates in the shallow pan between the dunes, but recently it has been invariably dry. The dunes now surround and tower over the parched pan.

The sand was carried originally by the wind from the Atlantic coast, but as it blows from all directions, the sand has not moved very far for thousands of years. It is this multidirectional pattern of the wind that created the 'star' dune. As it moves horizontally very little, the sand has

had time to accumulate in one place, so these star dunes become exceptionally big. Most are over 200 metres, their sand various shades of pink, orange and red, colours due to iron oxide coating the sand grains. The older the dune, the deeper the red, and the most ancient are close to 5 million years old.

In the Sossusvlei area, the tallest dune is 'Big Daddy', about 325 metres high. From the top, climbers can see an ocean of sand reaching to the coast over 80 kilometres away and look down on a hauntingly beautiful vlei.

Deadvlei is another clay pan. Its name means 'dead lake', and it was formed when the Tsauchab River flooded, forming shallow pools about 600-700 years ago. Camelthorn trees grew in and around the pools, but the river was cut off from the area by the sand dunes. The pools dried up, and the trees died, but they have not rotted because it is so dry. Their blackened skeletons can now be seen stark against the bleached white pan and towering, deep red dunes.

Sand dunes from ancient times are preserved if other sediments such as volcanic ash or lava are laid on top. The dunes are compressed and turn into stone. Banded and striated patterns of petrified sand dunes appear at the surface when

the overlying sediment is worn away, and these can be seen at sites on the Colorado Plateau, such as Vermillion Cliffs in Arizona.

Petrified forests form in a similar way. Ancient trees are buried in sediments, but they do not decay because of a lack of oxygen and an absence of the microorganisms that break down dead tissue. Groundwater, rich in minerals and other dissolved solids, percolates down through the sediments, and the original plant material is replaced by silica, calcite, pyrite and even opal. When the surrounding sediment is eroded, the fossil tree trunk and its branches can be so well preserved that the bark and vascular tissues can be seen clearly, and even the structure of its cells.

One of the most famous localities for fossil trees is the Petrified Forest National Park in Arizona. About 225 million years ago, during the late Triassic epoch when dinosaurs were beginning to have an impact, North America was closer to the Equator. The park was an area of lowland with a tropical climate and rainforests. Some of the trees were 60 metres tall and their trunks 3 metres in diameter, but a deluge of tropical rainstorms caused rivers to flood, and they washed mud and other sediments into the lowland sites. The trees were buried, and volcanic eruptions covered everything in thick layers of ash, the rapid burial preventing the trees from decaying. Silica leached out of the ash and replaced the plant tissues with minerals like quartz, while iron, manganese and other trace minerals gave the petrified wood a variety of colours. Then, about 60 million years ago, major earth movements caused the area, part of the Colorado Plateau, to be uplifted and the rocks exposed to increased erosion. The sediments containing the fossils were worn away by wind and water, leaving the petrified tree trunks and branches littering the park. In some places, there are 'pedestal logs', where a fossil tree is still perched on a plinth of the soft sedimentary rock. It will gradually erode, slowly lowering the log to the ground.

The park also has an abundance of other fossils, including ferns, cycads, and ginkgoes, and giant reptiles such as crocodile-shaped phytosaurs and early dinosaurs. All things considered, the Petrified Forest National Park is a remarkable place, all down to the magical processes of chemistry and the natural geological agencies of erosion.

▶ RIGHT Coyote Buttes in Utah and Arizona is a place to see Jurassic sandstone, its striped colours due to iron oxide pigments woven into geological features like 'The Wave', not on the shore, but a striking stone wave following the contours of the land.

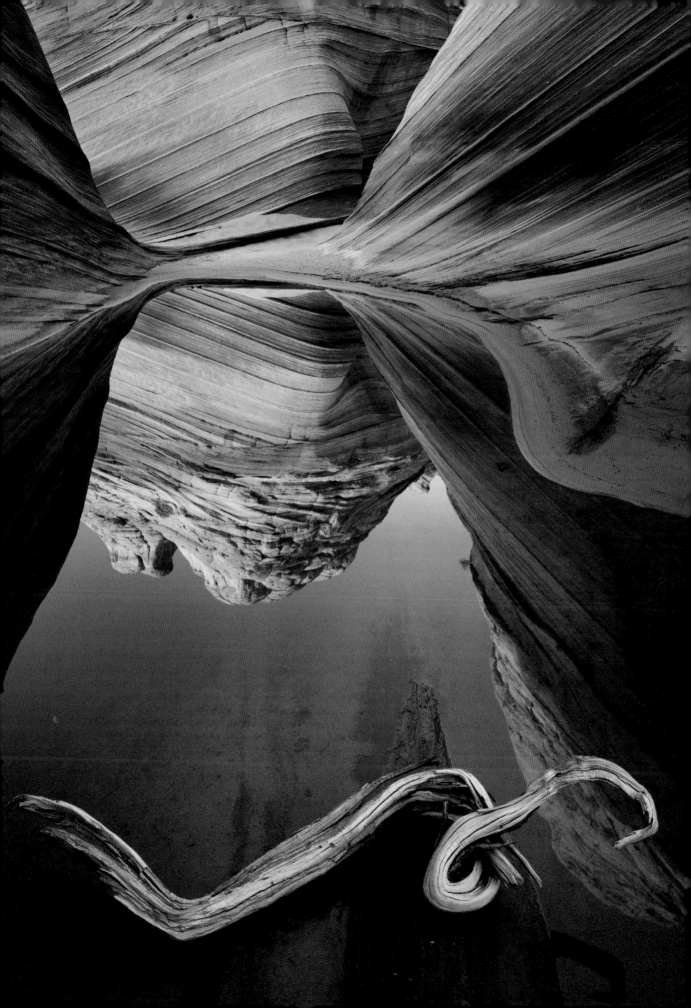

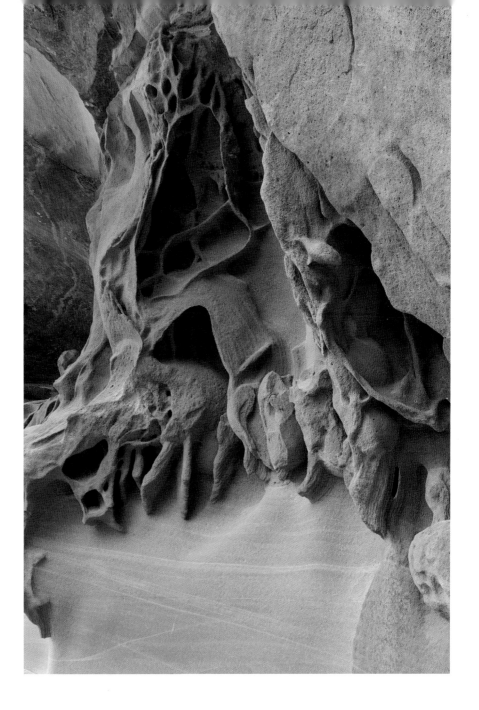

▷ LEFT, ABOVE and 120-121 The fiery sandstone cliffs at Jaizkibel Beach in Spain's Basque Country
have been etched by the wind, rain, and the sea to create elaborately eroded rocks in exquisite detail.
The small mountain, just 547 metres high, is on the Bay of Biscay coast, and is the first summit of the
Pyrenees when travelling eastwards. The border with France is barely 5 kilometres away. The
sandstone of which the mountain is made is a sedimentary rock composed mainly of sand-sized
grains of minerals or small rock fragments cemented together. Its colour can be yellow, brown, white,
black, or in these photographs, a vibrant red, due to the presence of iron oxide as an impurity, the
colour enhanced by the rays of the setting sun.

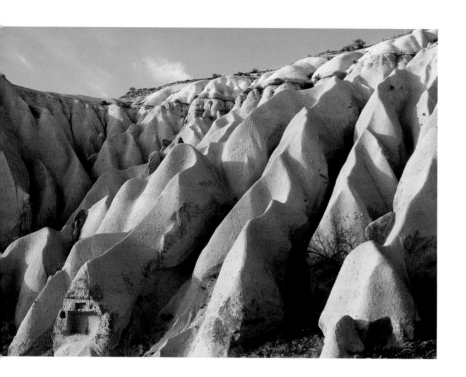
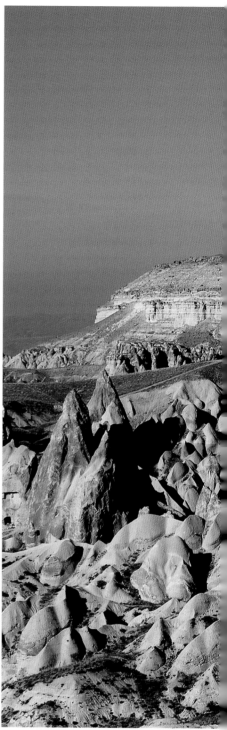

WIND

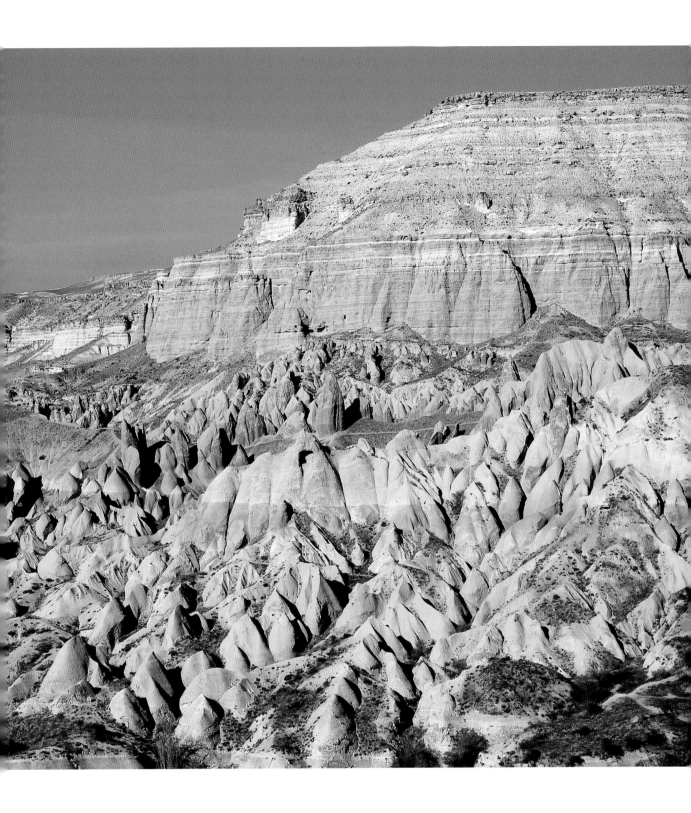

▶ LEFT and ABOVE Honeycombed hills and rock pillars are what the Göreme National Park in the Cappadocia region of Turkey is famous for. The minaret-like rock formations a part of an otherworldly landscape composed of a porous tuff, known as ignimbrite, which was ejected from volcanoes that erupted 3-9 million years ago. It was then overlain with basaltic lava, which provides the protective caps for the columns and spires. People have also carved out houses, castles and churches from the soft rocks.

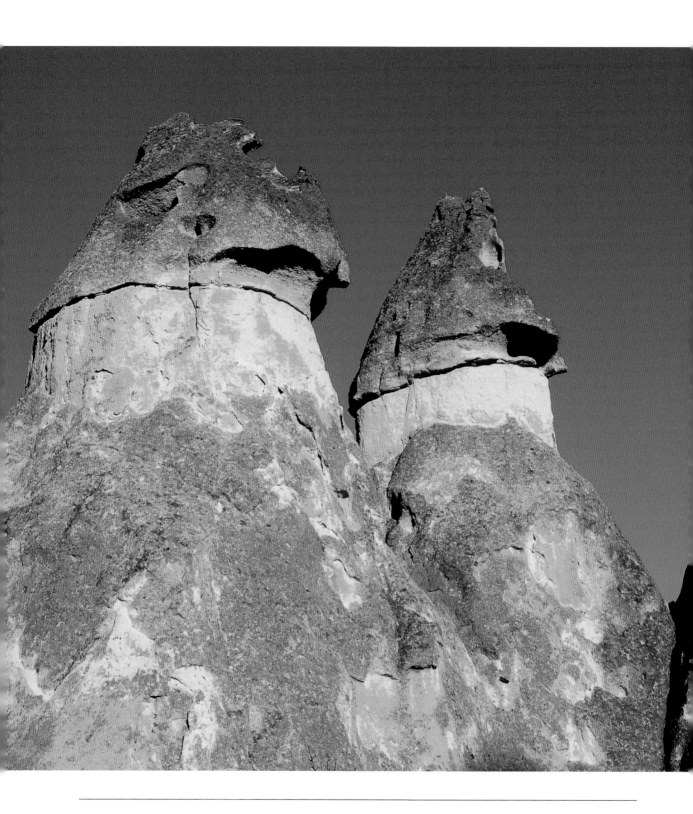

▷ ABOVE and RIGHT The hoodoos in Cappadocia are called 'fairy chimneys', and they are set in a fairytale landscape. It is as if a witch had cast a spell and people had been turned to stone. The reality is equally beguiling. The chimneys were formed after the softer tuff was gradually eroded away, leaving great spires and columns, some 40 metres tall. Each is protected by a mushroom-shaped cap of the harder basalt, which erodes more slowly. It is undoubtedly one of the most magical places on Earth.

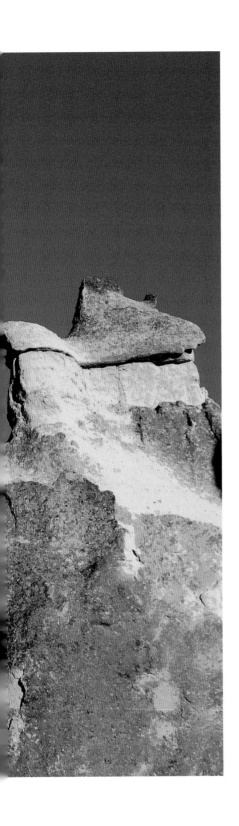
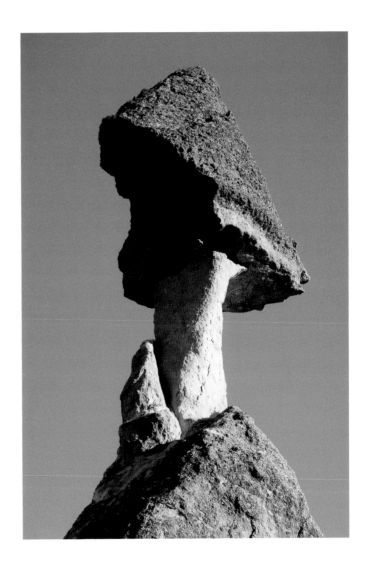

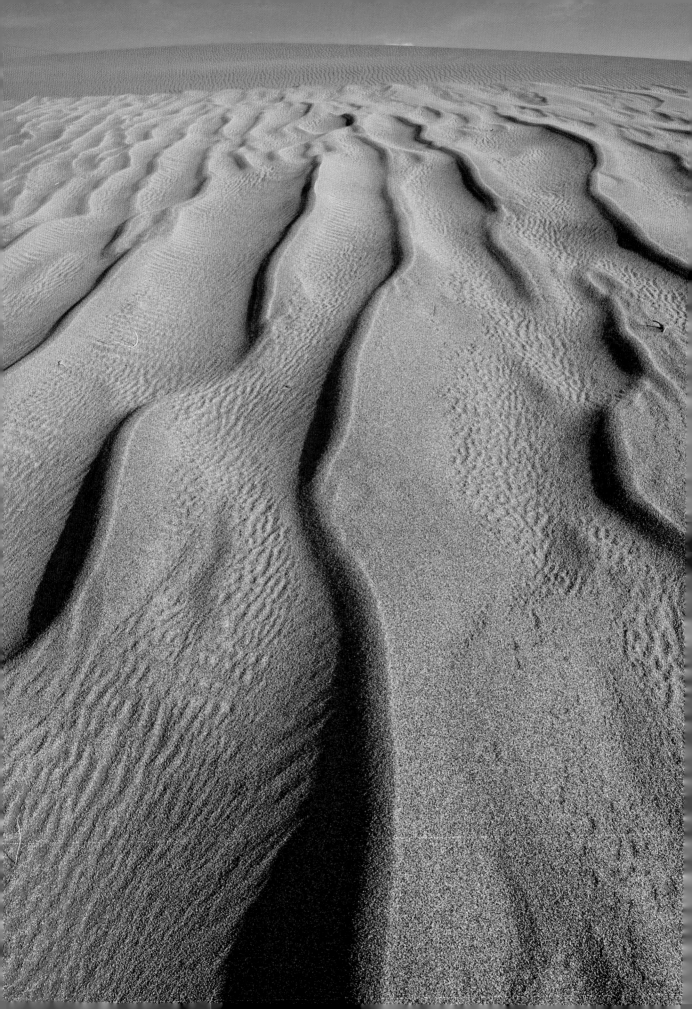

WIND

▶ LEFT Ripple-like sand patterns, caused by the wind and the moisture from fogs, are etched into the sand of some of the world's highest dunes near Sossusvlei, in the Namib-Naukluft National Park, Namibia. Many of the dunes are more than 200 metres high, the biggest being 'Big Daddy', with a record height of 325 metres. The reddish colour of the dunes is due to the presence of high concentrations of iron oxide. The oldest dunes, up to five million years old, have a more intense colour than the younger ones.

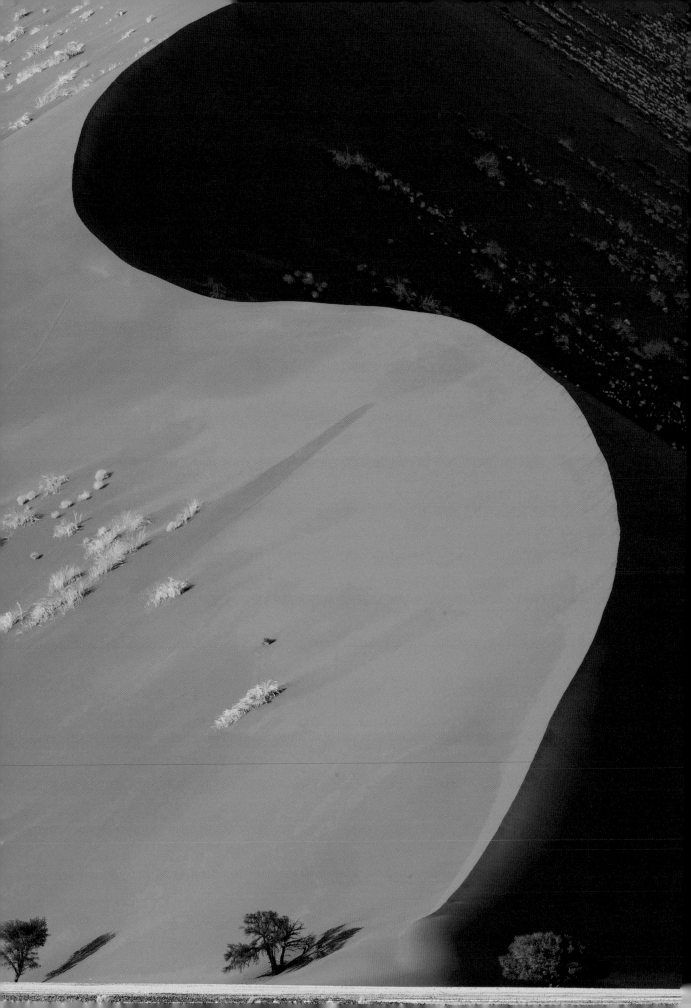

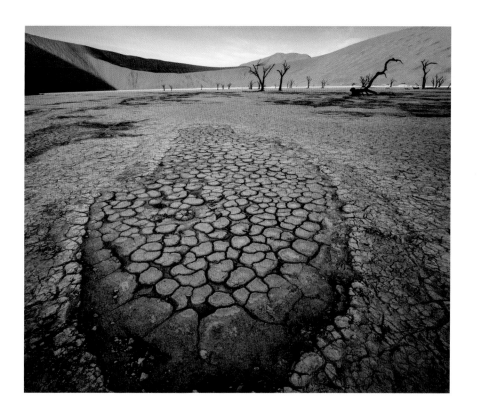

▶ LEFT The sweeping curve of a red sand dune at Sossusveli in the Namib Desert is dotted with acacia trees and other vegetation. The water for them to grow comes from fogs that drift in each morning from the Atlantic Ocean.

▶ ABOVE The blackened skeletons of dead camelthorn trees, some more than 700 years old, stand in the desiccated white clay pan at Deadvlei, Namibia. It was once a shallow pool in which the trees grew, but it dried up, and is surrounded now by sand dunes.

▶ 130-131 The rugged beauty of eroded buttes and pinnacles dominates the Badlands National Park in South Dakota. Sandstone and shale, containing many fossils, are interspersed with pale volcanic ash beds and reddish-brown layers of fossils soils.

▶ 132-133 The 'Giant Marbles' formation in the Joshua Tree National Park, California is the result of volcanic rocks splitting and minerals in the cracks turning to clay. The soft clay was eroded by wind and water, leaving behind the blocks of harder rock.

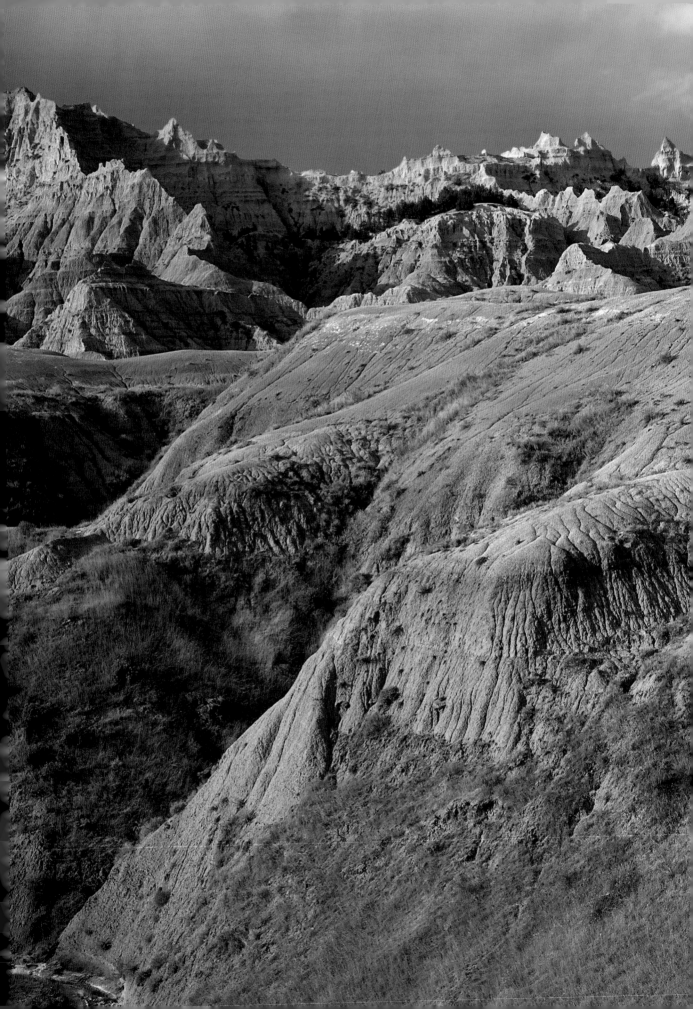

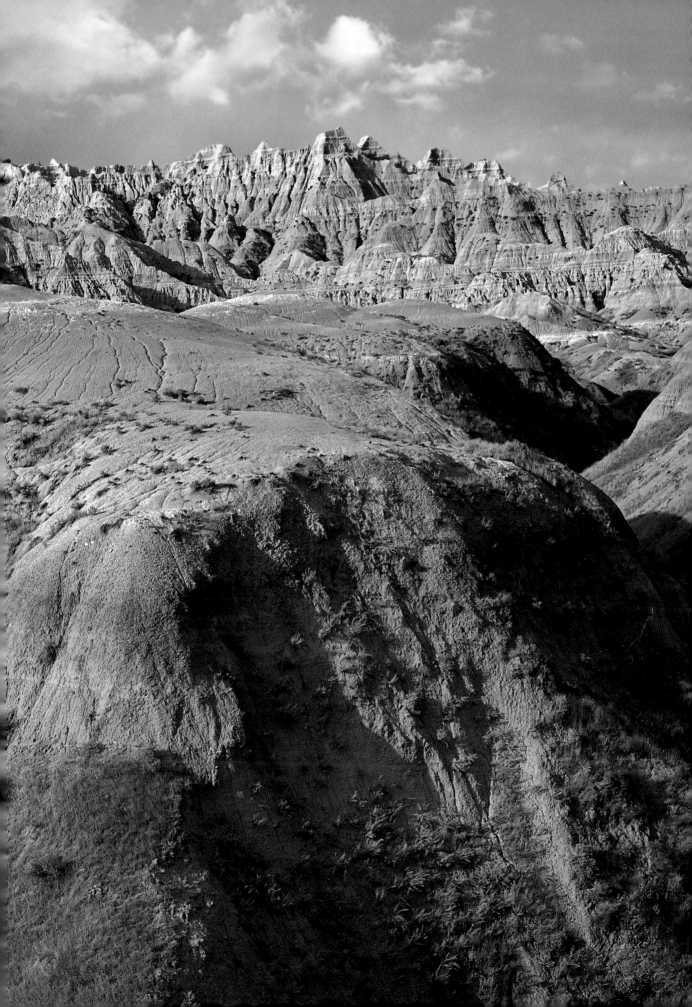

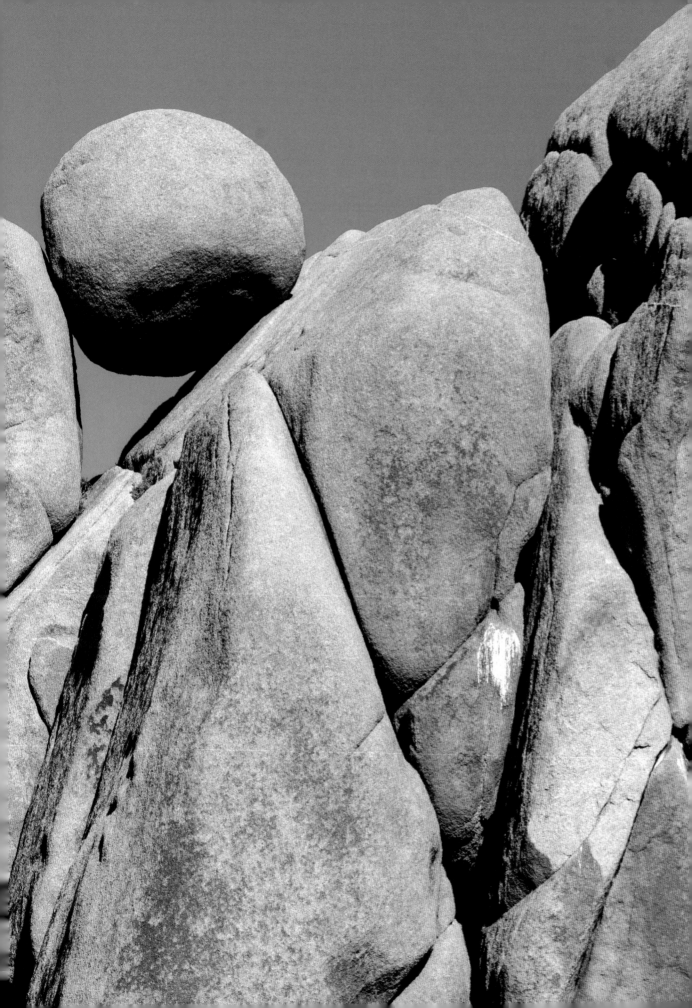

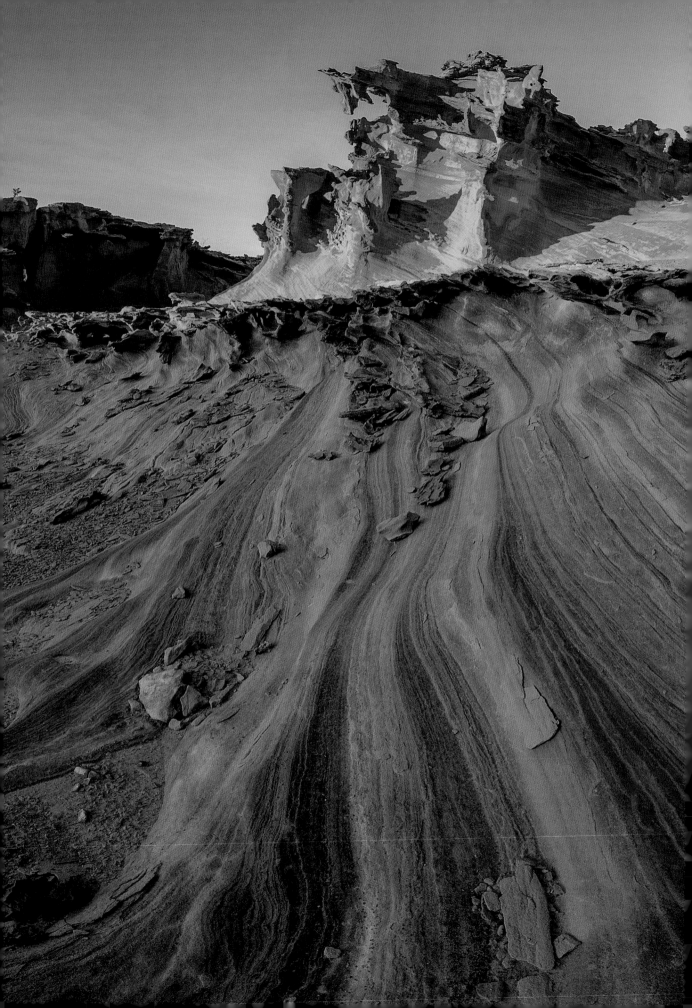

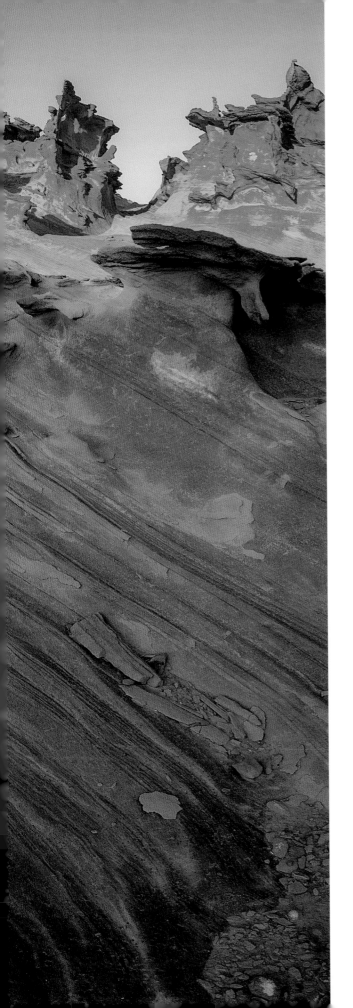

▷ LEFT 'Hobgoblin's Playground' at the Gold
Butte National Monument, California, is
composed of red sandstone rocks that have
been chiselled into bizarre but delicate fin-like
rock formations, so the area has also become
known as 'Little Finland'.

▷ 136-137 Red, pink and white desert cliffs and
fluted sandstone buttes, some appearing to
sag like melting blocks of Neapolitan ice cream,
feature in Red Rock Canyon State Park. The
park is at the southern tip of the Sierra Nevada
in California.

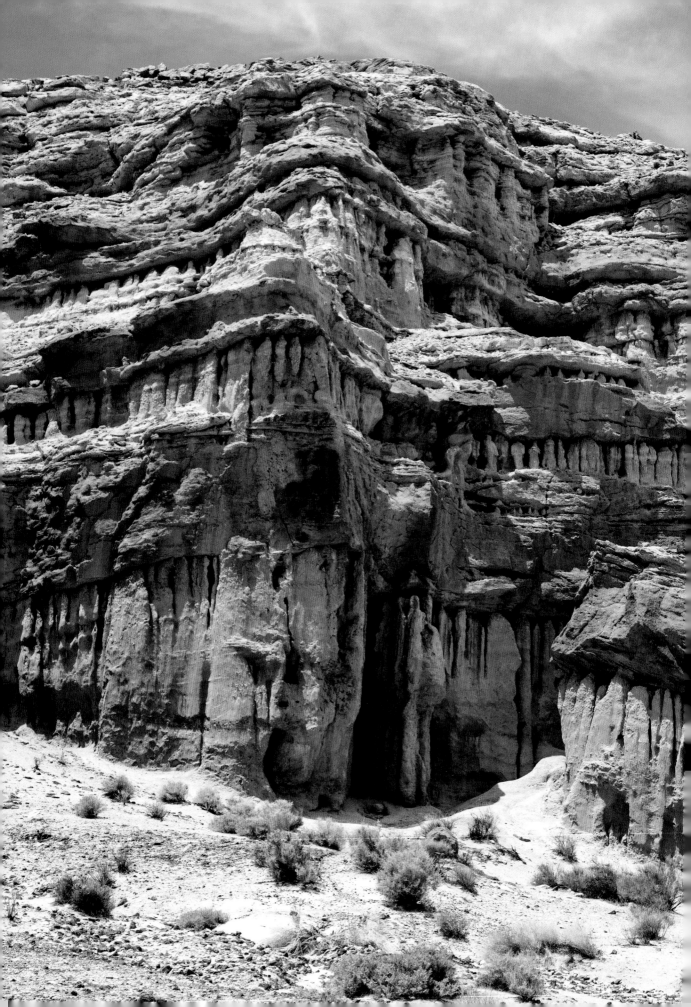

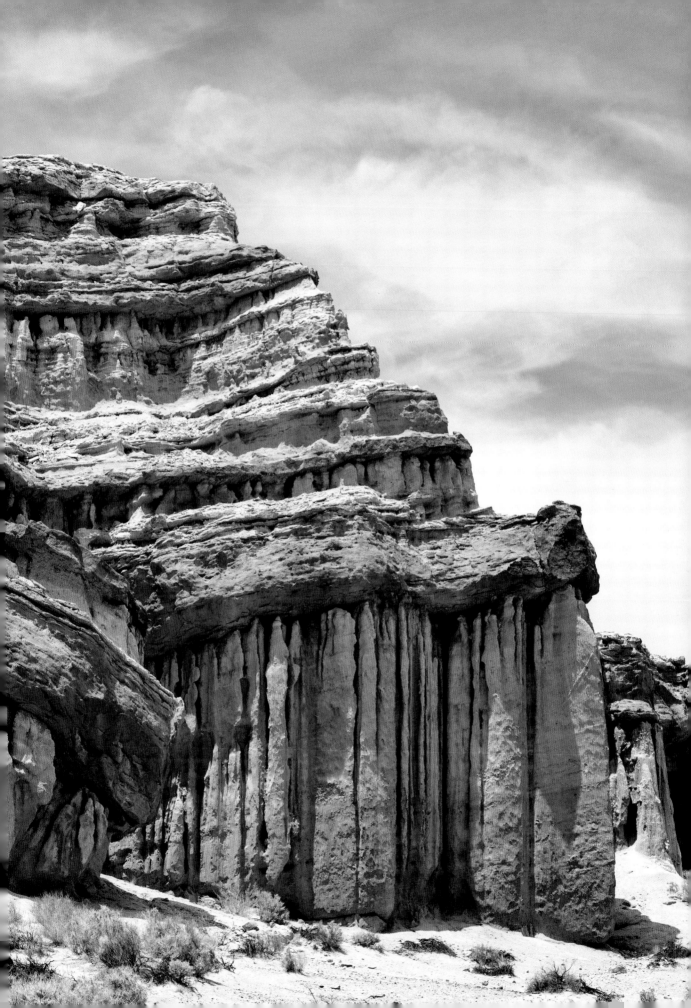

▷ RIGHT Groves of ghost-like Wahweap hoodoos occupy the grey sandstone slopes at the edge of the sun-scorched Grand Staircase-Escalante National Monument, Utah. These eerie rock formations are composed of two types of sedimentary rocks. The white body is of 160-million-year-old, soft Entrada sandstone, the same as the cliffs, and the harder dark cap can be of 100-million-year-old Dakota sandstone or a purple-coloured conglomerate. Some hoodoos are tall and tapering; others are short and squat.

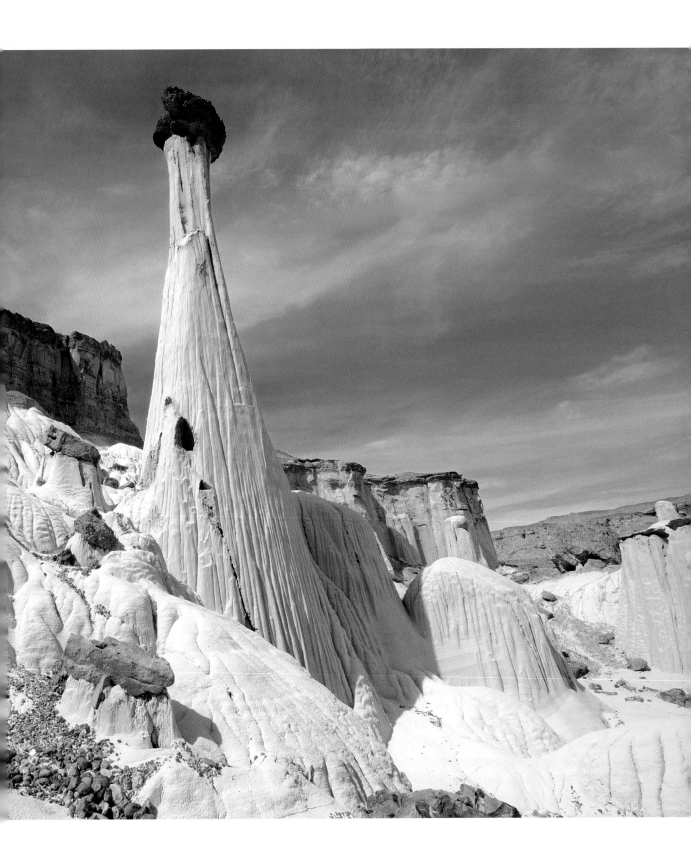

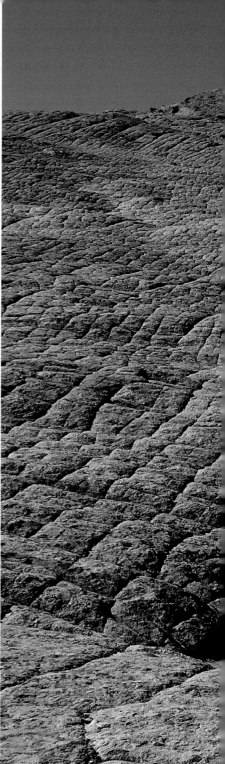

WIND

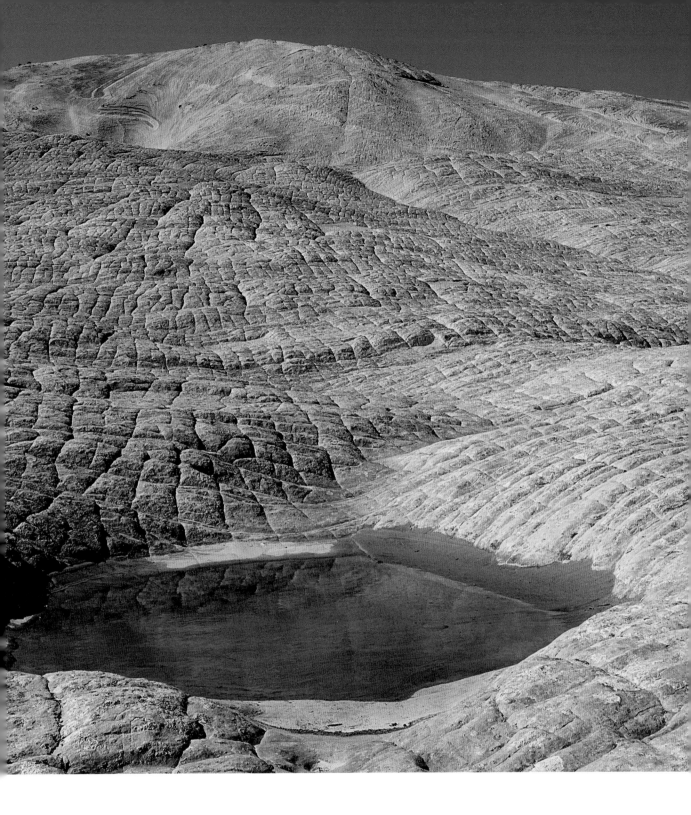

▶ LEFT The 'Devils Garden' has hoodoos, arches and other rock formations made from Jurassic sandstone, estimated to be about 166 million years old. Down the eons, many weathering processes have worn them down, including sandblasting by wind-blown sand.

▶ ABOVE Yellow Rock, Utah is a dome-shaped monolith made of Navajo sandstone. It is entirely devoid of vegetation. Yellow is the main colour, but there are straight and wavy bands of red, pink and white, and criss-cross patterns of ridges and cracks.

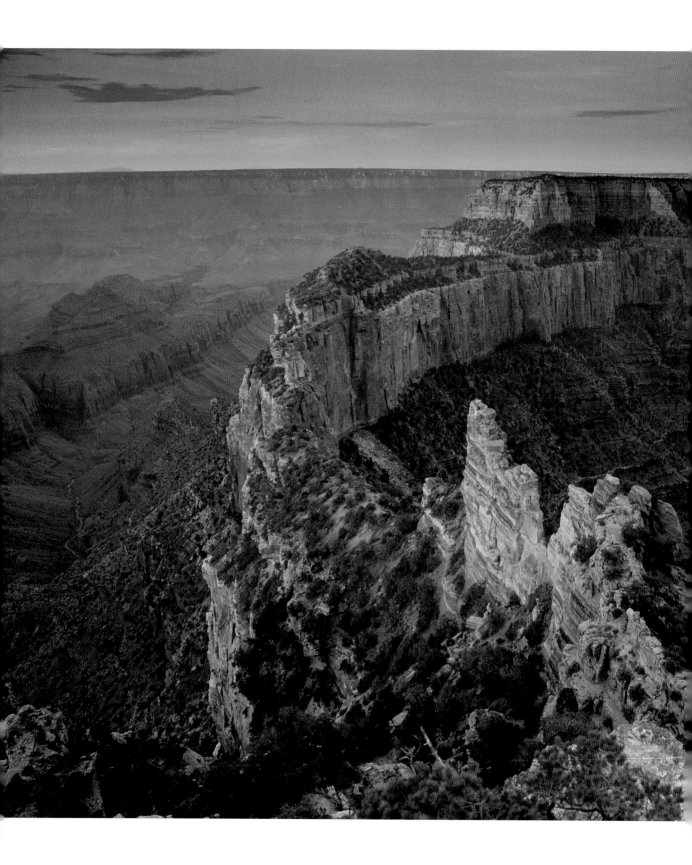

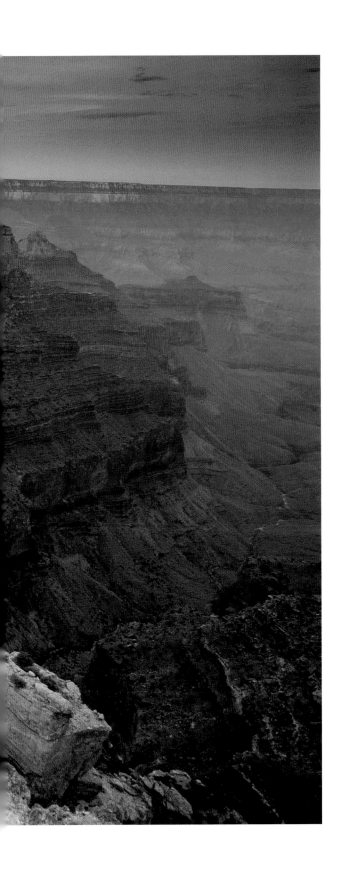

LEFT When seen from Cape Royal at sunrise, 'Wotan's Throne' could be a dramatic backdrop to a scene in a fantasy drama. Through the processes of erosion, the butte – an isolated hill with vertical sides and small, flat top – has become separated from the North Rim of the Grand Canyon. It is one of the 140 Grand Canyon named features that pay homage to mythologies from all over the world. Geologist Clarence Dutton coined them while exploring with John Powell's third expedition to the canyon in 1881.

▶ RIGHT Like some psychedelic skateboard
park, 'The Wave' formation of intersecting
U-shaped troughs is on the slopes of the
Coyote Bluffs at Vermillion Cliffs National
Monument, Arizona. It is made from Jurassic
Navajo sandstone worn by wind and water.

▶ 146-147 Over millions of years, the wind and
windblown sand have sandblasted the richly
coloured sandstones of the 1,000-metre-high
and 50-kilometres-long Vermillion Cliffs, and
carved out extraordinary rock formations like
this alcove and double arch.

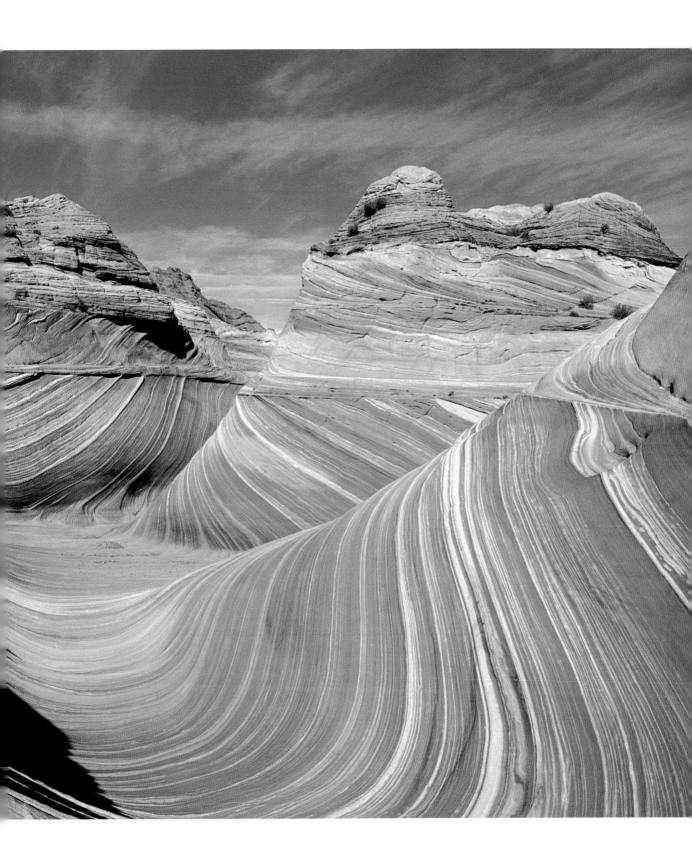

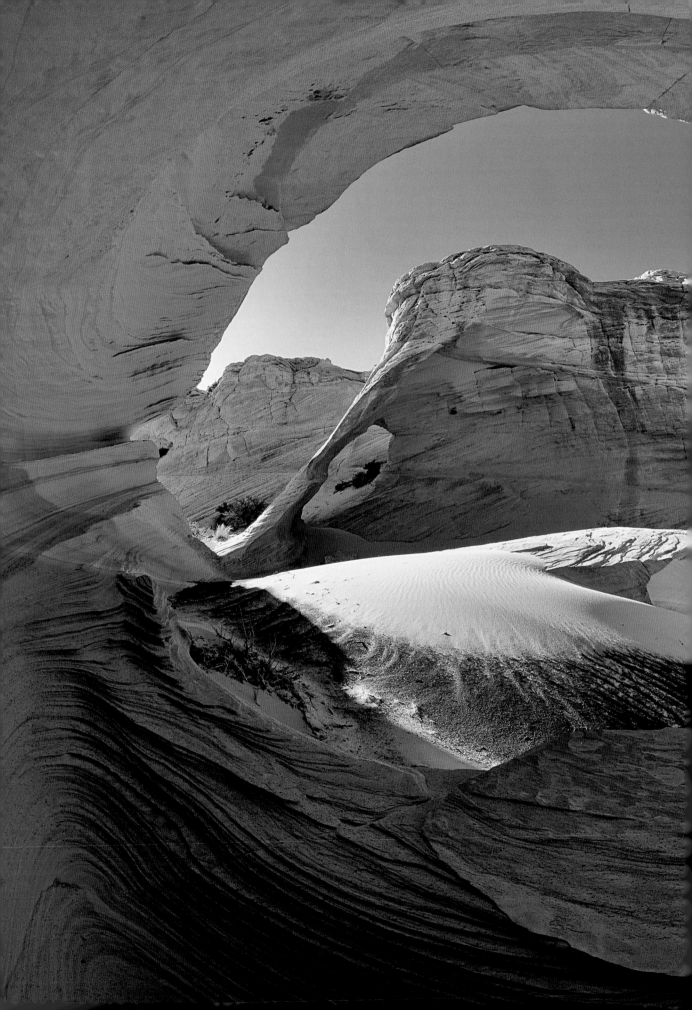

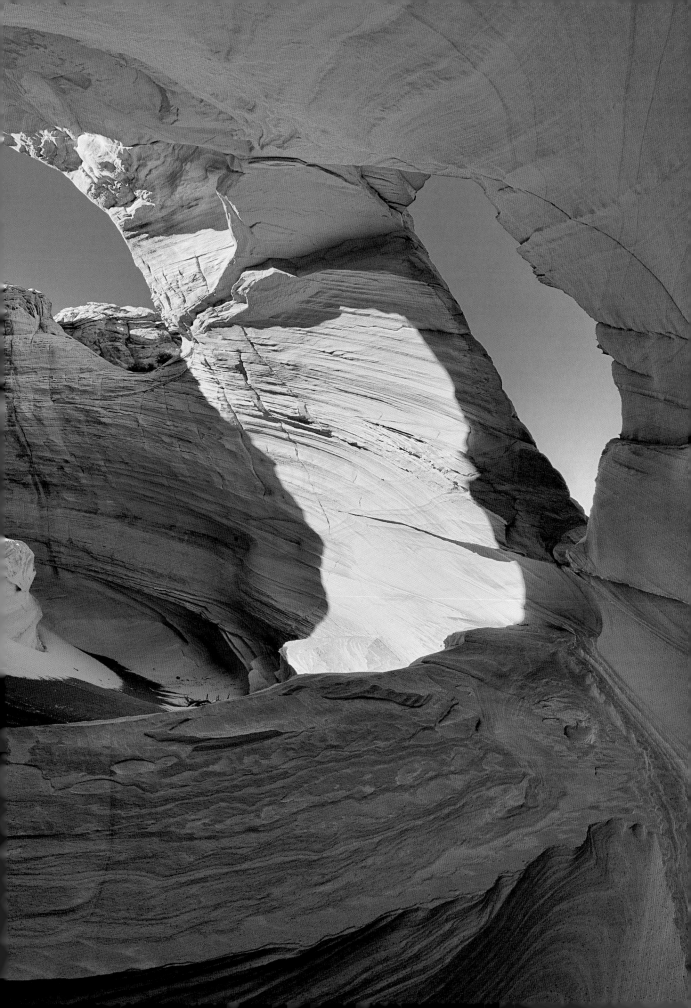

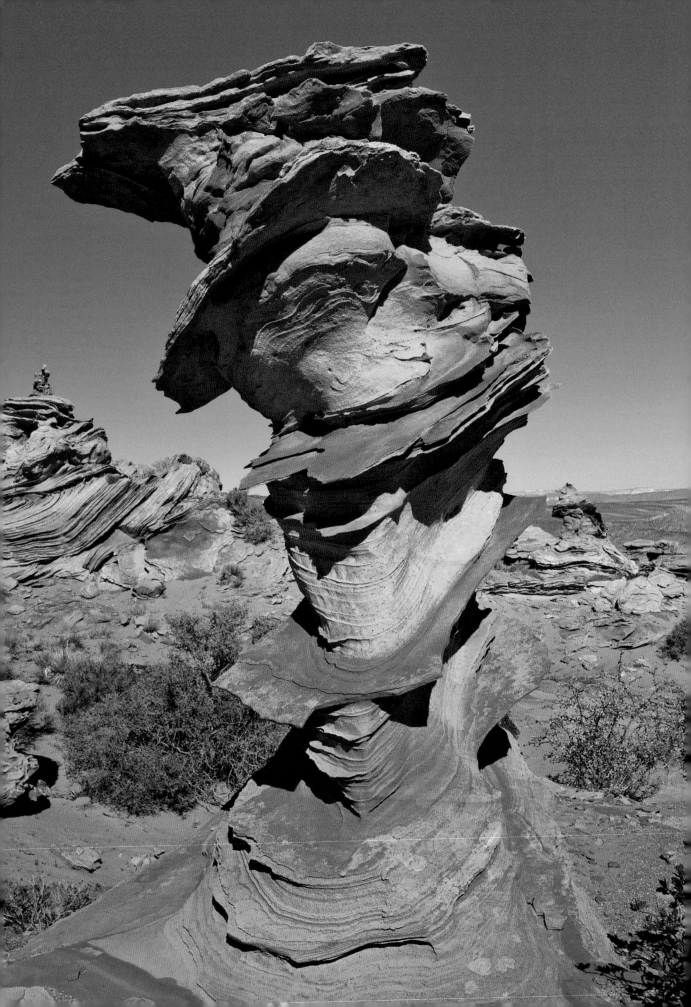

WIND

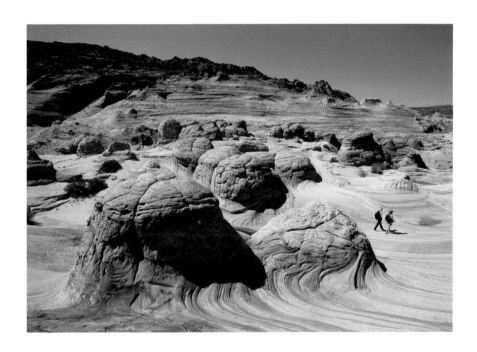

▶ LEFT A rickety sandstone rock formation looks as if it is about to topple over on the Colorado Plateau at Vermillion Cliffs. One day, of course, it will! It's all part of nature's continuous processes of building, wearing down, and recycling.

▶ ABOVE The swirling colours of petrified sand dunes and sandstone ridges are close to the Paria River Canyon at Vermillion Cliffs. This is wild backcountry. The place is remote and access is on foot only, hikers dwarfed by the chaos of ancient rocks.

WIND

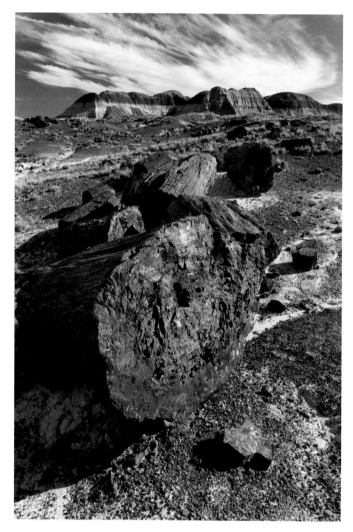

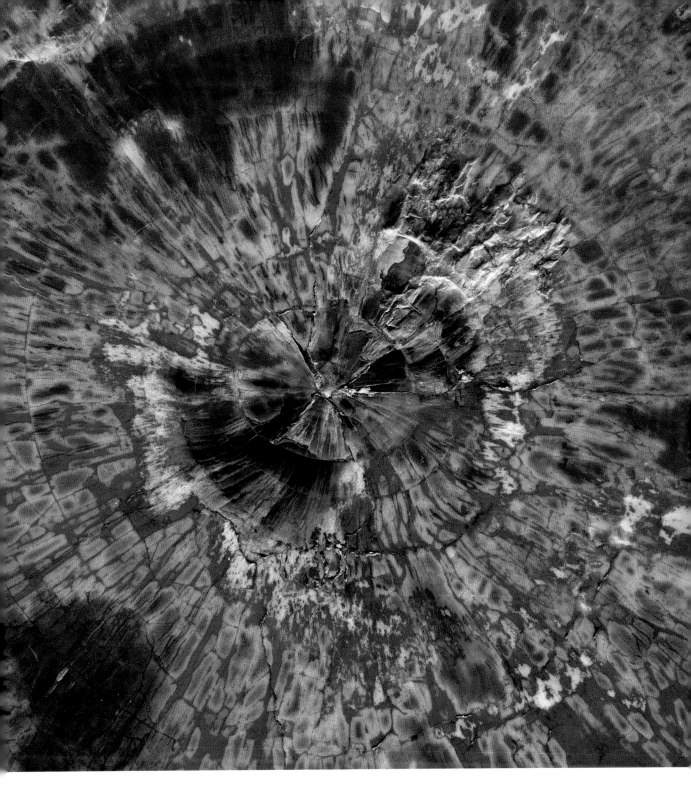

▷ LEFT About 200 million years ago, at the dawn of the dinosaur age, logs were swamped by a river and then buried quickly in silt. Minerals replaced living tissues and, when the sediments were washed away, thousands of stone trees were left behind in what is now the Petrified Forest National Park, Arizona.

▷ ABOVE When cut and polished, the cross section of a trunk shows a kaleidoscope of colours. It is made of crystals of almost solid quartz, the colours due to impurities of carbon, iron and manganese.

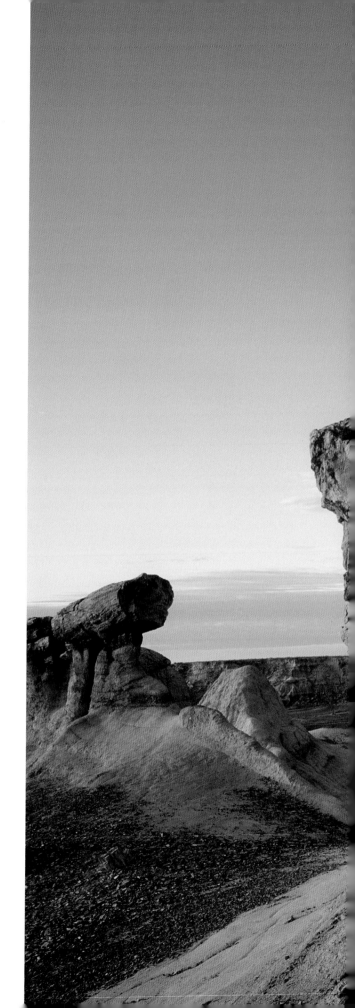

RIGHT A giant's workshop in the Petrified Forest National Park. The petrified trees are hard and brittle, and break cleanly, as if somebody had sawed right through them with a chainsaw. In reality, the fracture occurred when the Colorado Plateau was uplifting, which started about 60 million years ago. The buried trees were under so much stress, that they broke like glass rods. Here, sections of stone trees rest on pedestals of the same clay that once surrounded them, like logs on a giant's saw horse.

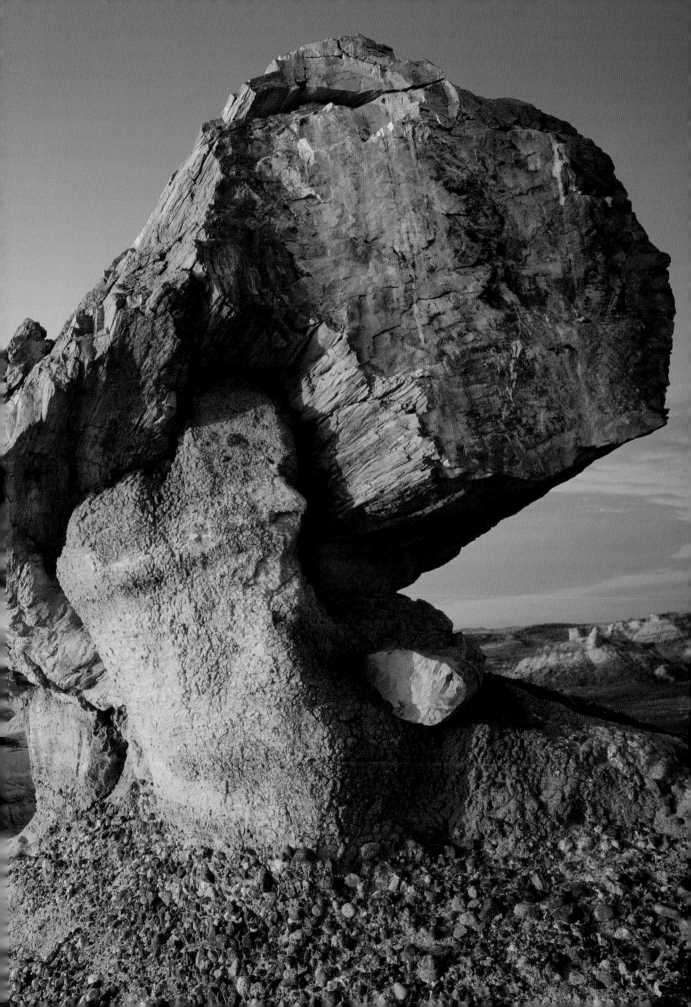

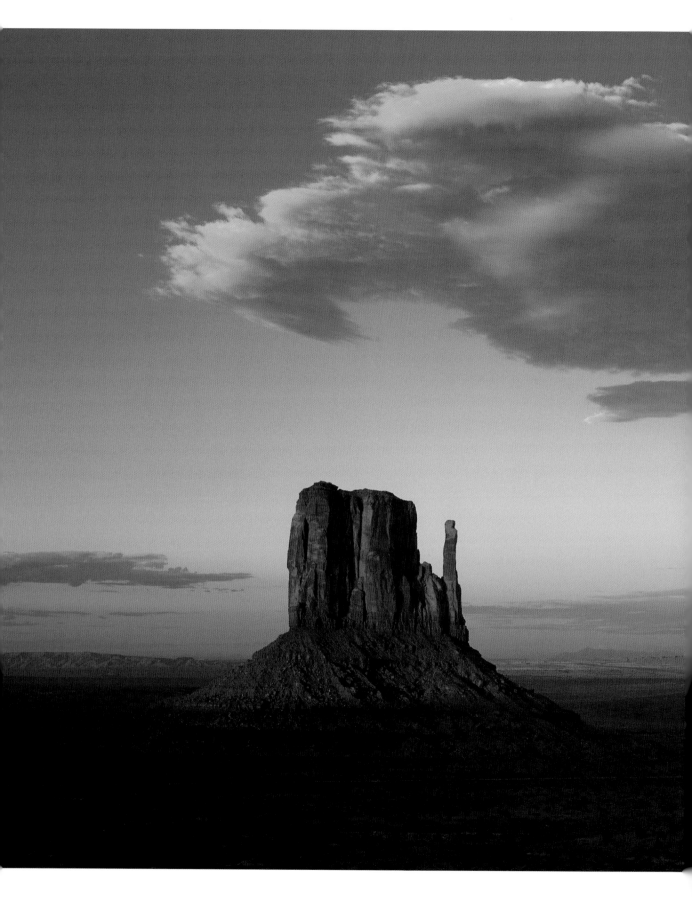

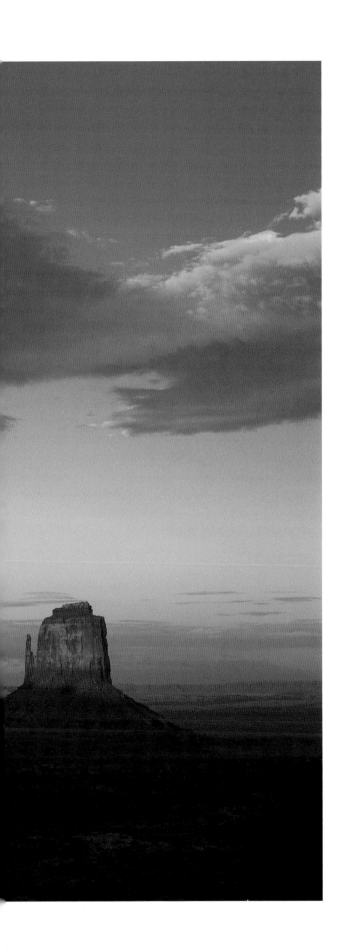

▶ LEFT Made famous in the cowboy films of
John Ford, Monument Valley is the
quintessential image of the American West.
The area is part of the Colorado Plateau, with a
cluster of iconic sandstone buttes, the largest
reaching 300 metres above the valley floor.

▶ 156-157 The 'Totem Pole' is a rock spire that is
all that remains of a highly eroded butte.
Alongside are the 'Yei Bi Chei' rock spires. Their
name comes from a Navajo term for a
celebration, as from some angles the rocks
resemble a group of dancers.

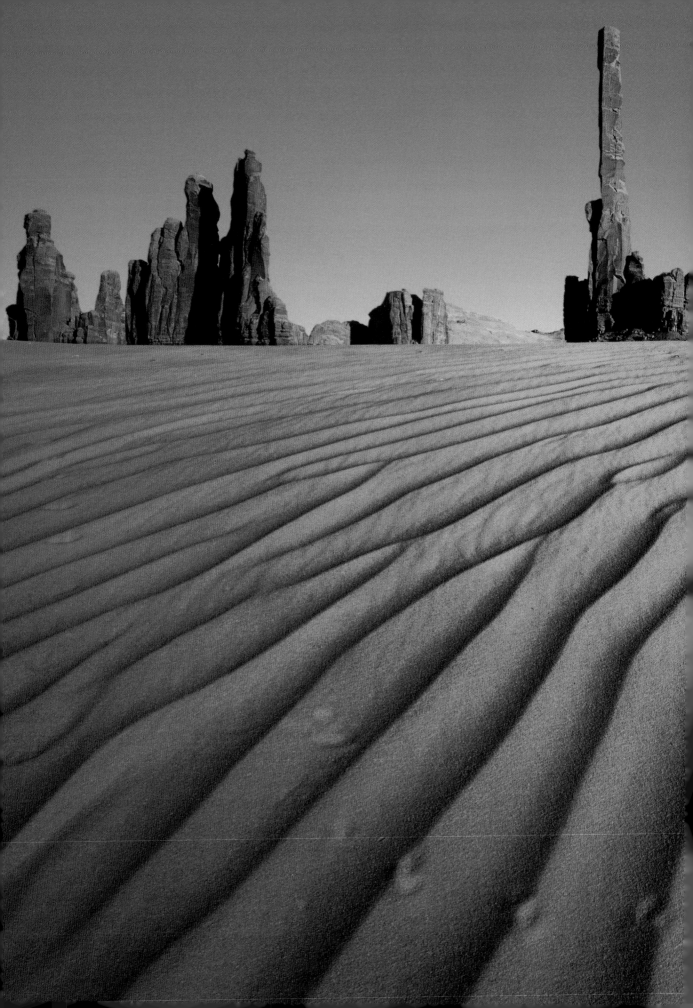

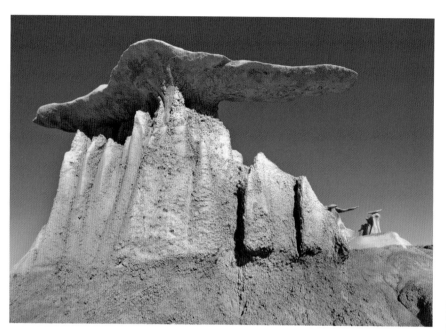

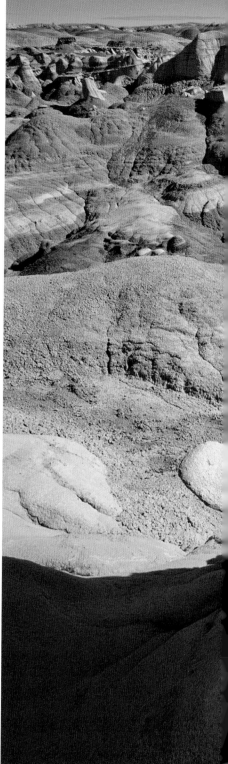

WIND

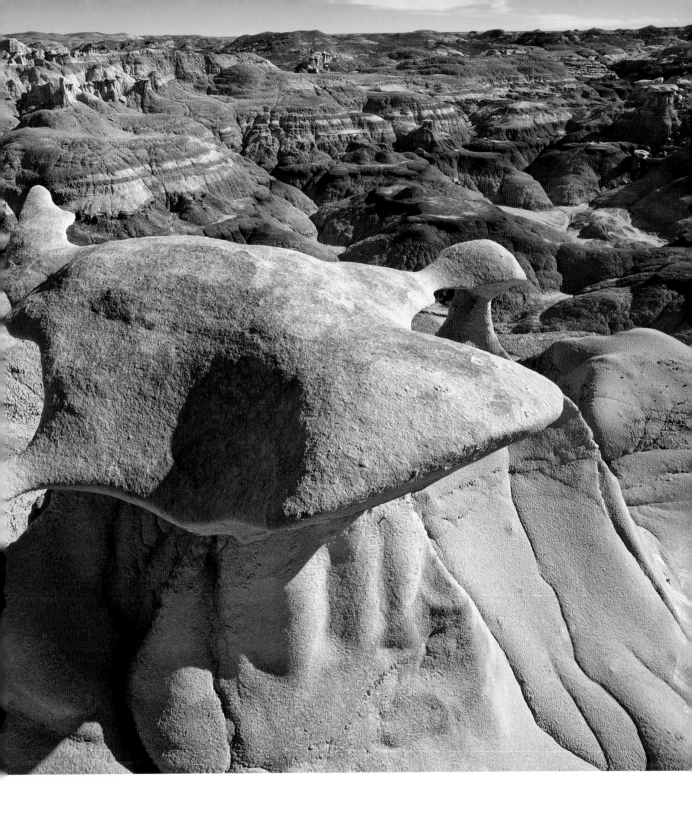

▶ LEFT and ABOVE When hard rocks overlie soft rocks, wind and water can erode them into strange shapes, and the Bisti Badlands, New Mexico have an extraordinary collection. Like the abandoned set of a science fiction film, the place is littered with colourful mushroom-like columns of sandstone and shale, along with formations resembling tall people in hats. They are hoodoos, created by thousands of years of erosion. Where the bottom has been worn faster than the top, they look oddly top-heavy.

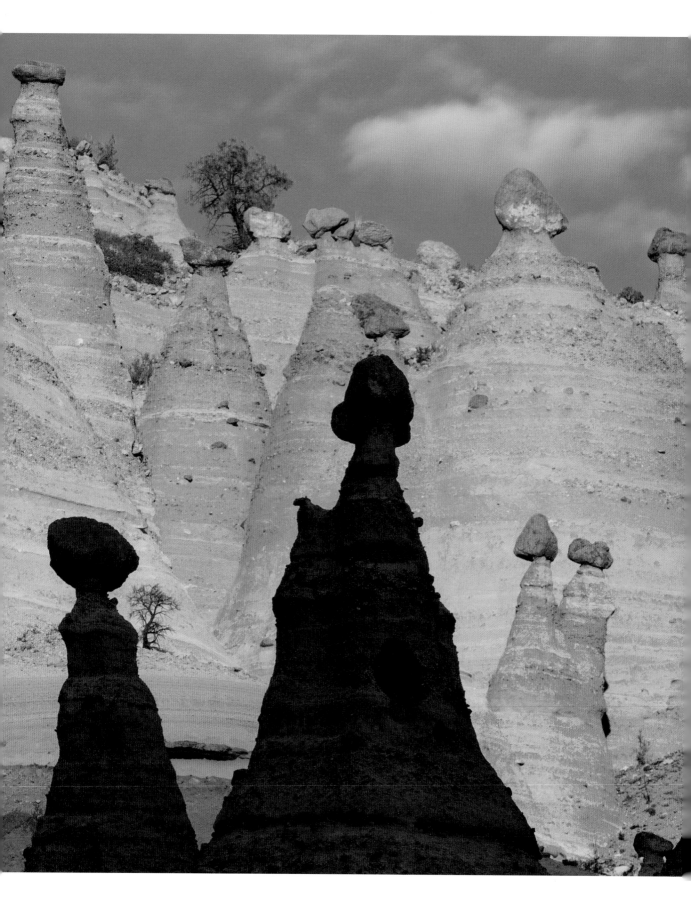

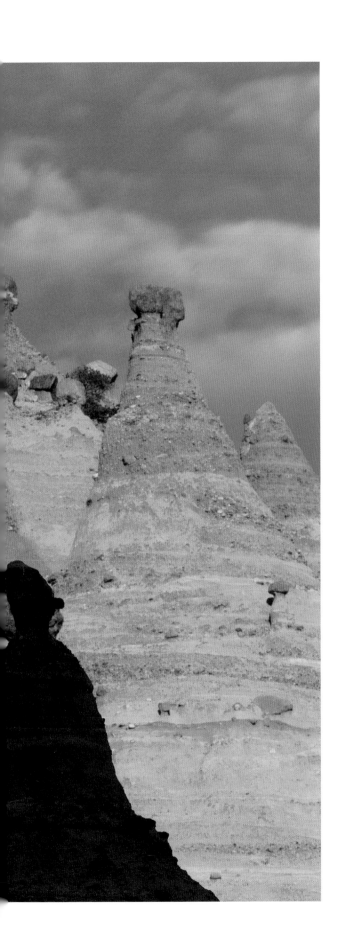

▷ LEFT In the enchanted Peralta Canyon, row upon row of conical tent-shaped hoodoos are made from eroded volcanic tuff and pumice supporting hat-shaped caps of harder rocks. The volcanic rocks were the result of pyroclastic flows from volcanic eruptions about 6-7 million years ago. The flows were fast-moving clouds of searingly hot gases and volcanic debris, known as tephra, which moved away from a volcano at high speed, typically 60 mph, but could be up to 400 mph. They buried everything in their path.

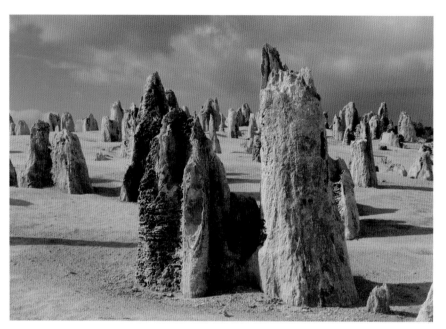

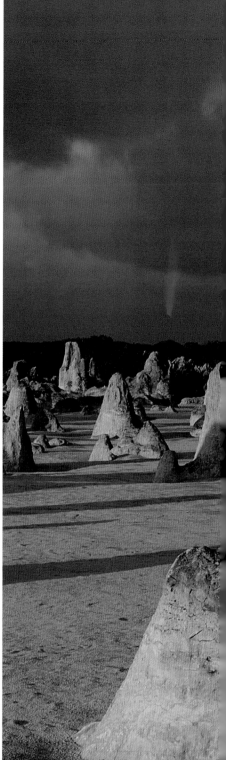

WIND

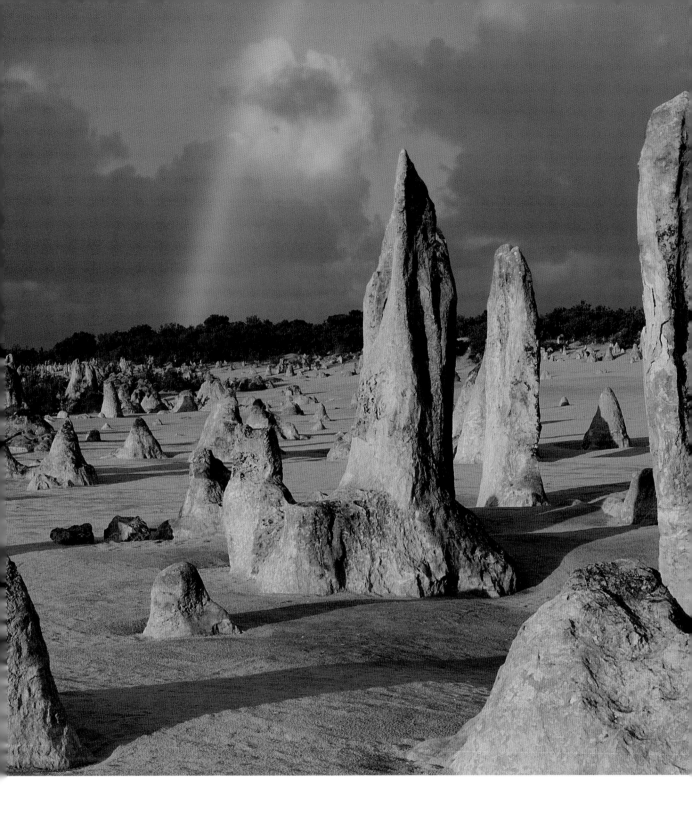

▷ LEFT and ABOVE The weird and wonderful rock formations in Pinnacles Desert, Western Australia, resemble compass termite mounds. They are made from the shells of ancient sea creatures that were ground into fine sand and turned into limestone. How they formed is still being debated, but coastal winds played a big role in shifting the rest of the dry sand around the limestone, exposing thousands of these limestone pillars, some up to 5 metres high. Now, they stand like sentinels on a plain of wind-blown sand.

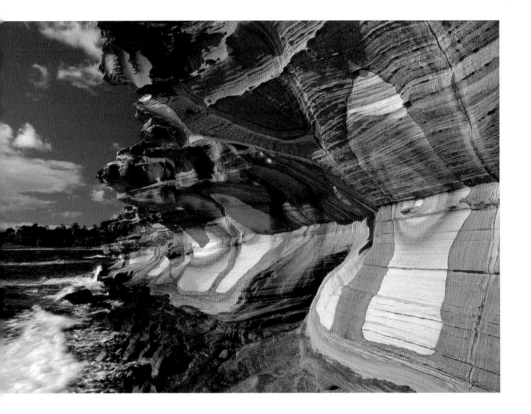

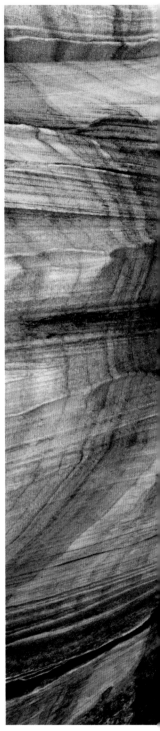

▷ ABOVE and RIGHT Like the striped sweets in a candy jar, Painted Cliffs, Tasmania, are made of patterned Triassic sandstone. The colours were created by groundwater percolating down through the sand stone and leaving traces of iron oxide, which stains red. In recent years, sea spray and dried crystals of salt have weathered the rock into honeycomb patterns. Waves containing rock fragments also crash against the cliffs, and they have gradually worn the cliff face, so the cliffs overhang the beach.

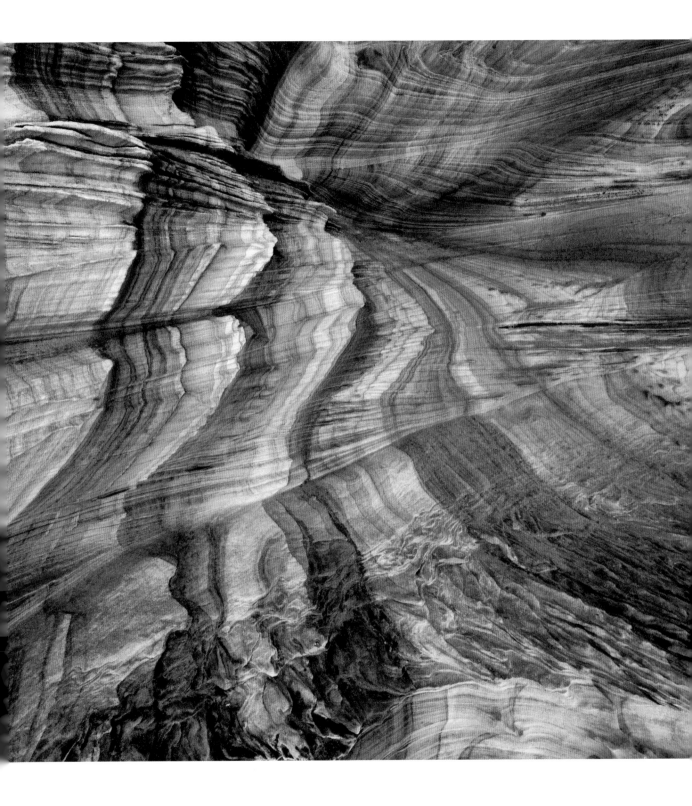

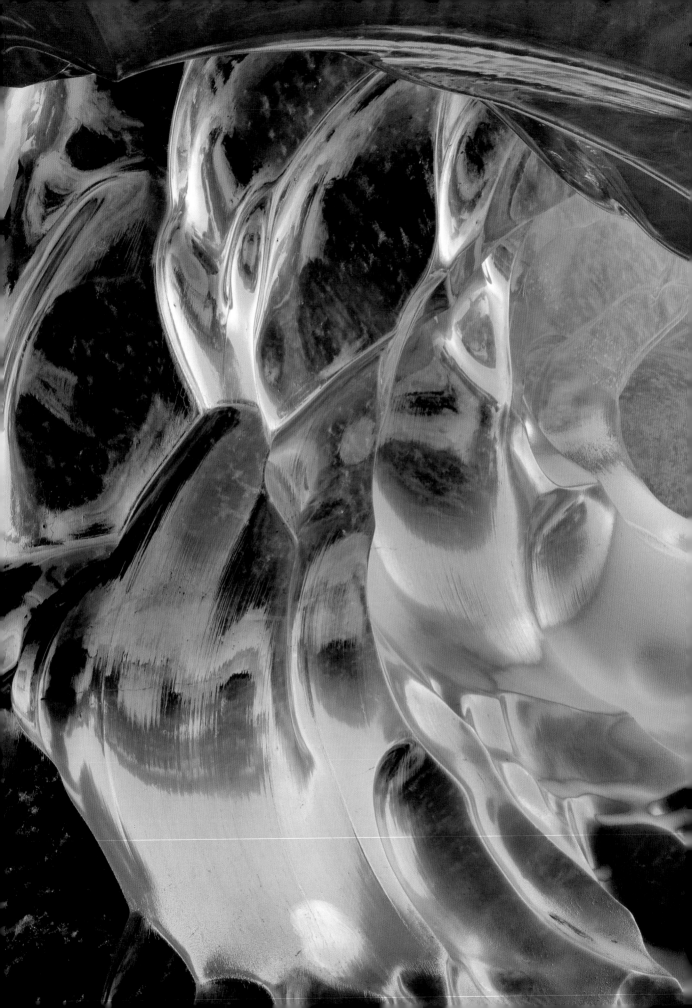

ICE

Brittle, Transparent, Crystalline Carver

Ice is solid water, and it has some amazing properties. When water freezes it expands by about 9 per cent, which can have a dramatic impact on the landscape. It can shatter rocks, especially in places where the daytime temperature is above freezing but at night drops below zero, such as in mountains. Rainwater that has fallen during the day seeps into cracks and crevices, freezes and expands so much that it causes the rock to splinter and the fragments to break away. This is especially true of porous sandstone rocks that absorb water. Although wind and water might have sculpted the landforms, we see in places such as North America's Badlands that frost weathering is often the basic process that starts the whole thing off.

Ice is also about 8 per cent less dense than water, so it floats. This is critical for the biosphere – the place where plants, animals and all the other life forms live. If ice did not float, natural bodies of water, such as lakes, would freeze from the bottom up, so when ice formed nothing would be able to live there. Without the unique properties of ice, life would be unable to exist in frozen lakes and seas.

About 2 per cent of all the world's water is frozen. The freshwater locked up in ice caps, glaciers and permanent snow represents vital reservoirs both for wildlife and people. They are formed when: the temperature is rarely above freezing; there is heavy snowfall in winter; and not all of it melts in summer. If these conditions are met, snow accumulates year on year, each layer pressing down to compact the snow below. The compressed snow re-crystallises. There follows a period when ice crystals grow larger, the air pockets between them get smaller, and the compacted snow increases in density. After more than a hundred years, a glacier is born.

A glacier is basically a river of ice, but is not usually made of pure ice. It's dirty. A glacier carries rock fragments, sediment and dust, fresh snow, and liquid water, and it moves very slowly downhill under its own weight. Stresses and strains within the ice cause deep cracks or 'crevasses', and great house-sized blocks of ice called 'seracs' are pushed up.

The debris carried by the glacier, rather than the ice itself, scours the underlying bedrock like sandpaper, and, on their way down to the sea or a lake, glaciers tend to follow the paths of

▶ LEFT In the depths of winter, blue glacier ice caves in Iceland's glaciers have become a new tourist attraction. The more sunlight that shines through the ice, the bluer the cave, and the 'Crystal Ice Cave' in the Breidamerkurjökull glacier is known for its stunning blue colours.

ICE

V-shaped river valleys, but scrape out the valley sides to produce broader U-shaped valleys. All the eroded rocks and soil are dumped into piles at the glacier's terminus.

Glaciers can be quite long. The Margerie Glacier on the Alaska-Canada border has a length of 34 kilometres. It starts on the southern slopes of Mount Root and flows down to the sea, calving small icebergs into Glacier Bay. Its ice cliffs tower 76 metres above the sea's surface, and they are especially attractive to wildlife. Freshwater upwellings from meltwater occur in the sea in front of the cliffs, which is attractive to fish. They fall prey to fish-eating birds, including North America's iconic bald eagle.

Argentina's Perito Moreno glacier has a similar length but with a much bigger source. It is fed by the Southern Patagonian Ice Field in the Andes Mountains, the third largest reserve of freshwater on the planet. From there, it descends for about 30 kilometres to calve icebergs into Lake Argentino. Occasionally, it shows an odd quirk of nature. The weight of the ice pushes the glacier right across the lake, blocking off one end. With no outlet, the water builds on one side of the glacier, up to a height of about 30 metres, until the ice can take the pressure no more, and the water breaks through the ice barrier in a spectacular rupture and mini-tsunami.

Both glaciers are unusual. They have bucked the trend of glaciers worldwide. Most are receding due to climate change, but the Margerie glacier is stable, neither lengthening nor shortening, and the Perito Moreno is actually getting longer. Nobody knows why!

The world's two largest ice sheets feed glaciers on the Antarctic mainland and the Arctic island of Greenland. Antarctica has the bigger ice sheet. If it all melted, the global sea level would be raised by 58 metres. Greenland comes a distant second, and if it should melt the sea level would increase by a further 7.2 metres, and it is starting to do just that. Greenland's ice is dotted with sparkling blue pools and striking aquamarine streams. They look

like jewels, but their beauty hides a darker secret. They show that the island's glaciers are melting at an alarming rate, about six times faster than normal, and they have already added 13.7 millimetres to global sea levels since the 1970s.

In the Antarctic and on Greenland, and also in parts of the Canadian and Russian Arctic, ice sheets and glaciers flow down to the coast where, instead of calving immediately, they form a platform that floats on the ocean surface — an 'ice shelf' — and the largest on the planet is the Ross Ice Shelf in the Antarctic. It is about the size of France, with ice nearly 750 metres thick in places. Its almost vertical ice cliffs are over 600 kilometres long and tower up to 50 metres above the sea's surface. The shelf itself pushes out into the Ross Sea by about 3 metres a day, but when seawater melts the underside of the leading edge, exceptionally large icebergs break free. In 2000, an iceberg about the size of Belgium floated away from the Ross Shelf, the largest ever tracked by satellites in space.

Icebergs, from the Dutch word ijsberg or 'ice mountain', can be impressive masterpieces of the Earth. On the surface, however, we only see the top 10 per cent. The rest is hidden under the water, and, as icebergs travel in the ocean currents, they can be a hazard to shipping, especially smaller icebergs — 'bergy bits' if they are about 5 metres above the surface, or 'growlers' if the size of a grand piano — because they are harder to spot. Both are generally the result of large icebergs breaking up.

Large icebergs are classified as being either tabular, with steep sides and a flat top, which typically calve from ice shelves, or non-tabular, which can be all manner of shapes: domes have a rounded top, pinnacles have one or more spires, a dry-dock has an eroded channel or slot, and wedges have one side with a short steep face and the other with a longer slope.

Most drift either southwards in the Arctic or northwards in the Antarctic. They drift in the ocean currents at speeds between 0.3 and 1.8 mph, and are less affected by the wind because the bulk of the iceberg is below the water. They eventually end up in warmer waters and melt away, but before they disappear they can take on amazing shapes, like gigantic ice sculptures. Their colours can vary — white, green, blue and even black. Ice is transparent, but it absorbs most of the colours of sunlight, except blue, so it appears blue; and the older the ice, the deeper the blue. Green can come from algae attached to the ice, and black is the result of it having no bubbles, but maybe with particles of bedrock from the parent glacier. As the portion underwater tends to melt quicker than the top, icebergs frequently roll over,

ICE

and may do so several times, creating large waves each time. They can, however, last for a long time, up to ten years for an average Antarctic iceberg, the giant tabloid bergs having an even longer lifespan.

As most icebergs calve from glaciers or ice sheets, they are made of frozen freshwater. When they melt, they add to the volume of the sea and raise the sea level, unlike sea ice, which is frozen seawater. When sea ice melts, the sea level remains the same. During the winter, extensive areas of sea ice form in the Arctic and around the entire Antarctic mainland. It is much thinner than an ice shelf or glacier, generally less than 3 metres thick, and it forms in a particular order.

When seawater freezes, it first forms small crystals known as 'frazzle'. What happens next depends on how rough the sea is. In calm conditions, the ice crystals arrange themselves into thin sheets called 'nilas', which tend to have an oily appearance. The sheets slide over each other, forming thicker layers, and gradually the sea ice builds. If the water is choppy, the ice crystals combine into 'pancakes' that slide over each other to build rafts, or collide and create ridges. If the sea ice is attached to the coast or the seafloor, it is known as 'fast ice', and the ice that drifts with the wind and ocean currents is 'pack ice'. 'Leads' are channels of open water in the sea ice, and 'polynyas' are more persistent openings kept free of ice by upwellings of warm water or by the wind.

Some sea ice persists from year to year and gradually thickens to become multiyear ice. First-year ice is thinner and more likely to melt in summer. Surveys have shown there is less multiyear ice and more first-year ice in the Arctic at present, and this is significant, for it could lead to ice-free summers in the near future. This does not only affect the lives of polar bears and walruses; it is something that could affect us all. Ice reflects sunlight back into space. When the ice melts it exposes more of the dark parts of the Earth's surface, so they absorb more heat. It means ice is not only an agent of erosion and deposition, shaping some of Earth's great masterpieces. It is also vital for the health of our planet.

▶ RIGHT Disrupted pack ice litters the sea in the Gerlache Strait, which is known for its many much larger icebergs. It separates the Antarctic Peninsula from the Palmer Archipelago, and is thought by many to be the most beautiful area in Antarctica.

▶ 172-173 Vibrant blue water pools and meltwater channels on the surface of Greenland's Sermeq Kujalleq Glacier – the world's fastest moving and most active glacier – indicate how climate change and global warming are melting the Greenland ice sheet.

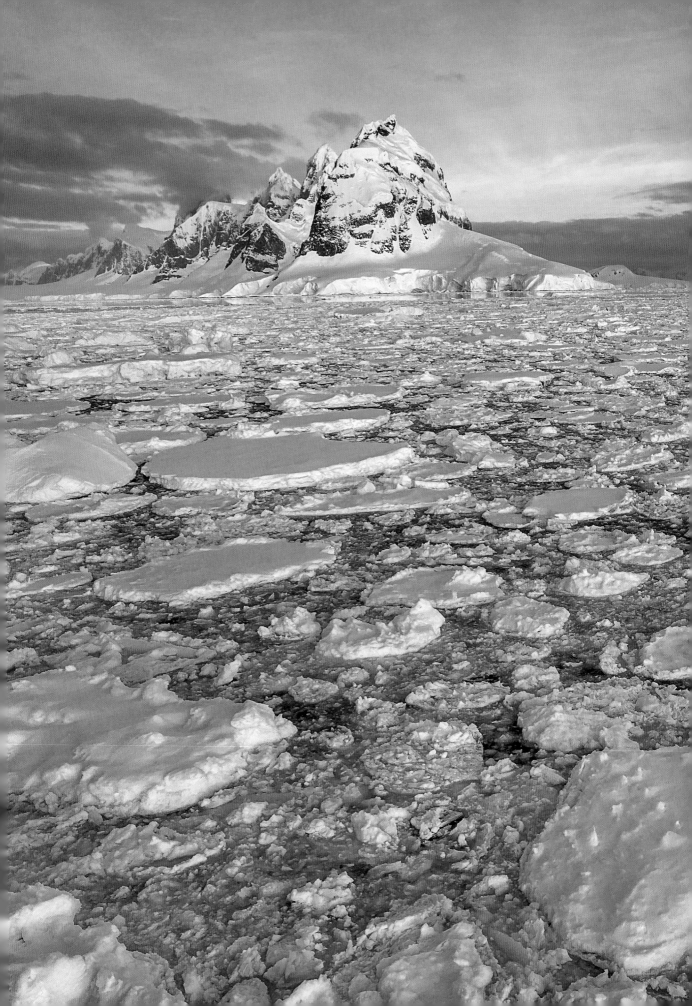

ICE

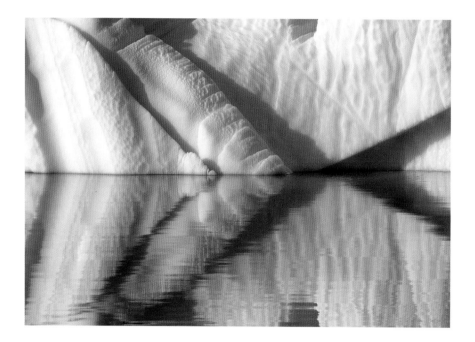

▶ ABOVE An iceberg is like a modern sculpture when reflected in the icy waters of the Arctic Ocean off the east coast of Greenland.

▶ RIGHT On the west coast of Greenland, an iceberg floats in the sea off Disko Island. The wavy blue stripe is probably where air bubbles have been squeezed out during melting and the ice has refrozen.

▶ 176-177 An enormous iceberg has been set adrift from the Sermeq Kujalleq Glacier in the Ilulisat Icefjord, on Greenland's west coast. Two-thirds of the berg is hidden below the surface. As the lower parts melt in the sea, it might become top heavy, so the entire berg could flip over, causing a mini-tsunami to crash into settlements along the shore.

▶ 178-179 When the Breidamerkurjökull glacier receded from the Atlantic Ocean, it created the Jöksárlón Lagoon, the largest and deepest glacial lake in Iceland. While the glacier once calved icebergs into the ocean, the lake is now 1.5 kilometres from the ocean's edge.

▶ 180-181 A woman walking in the ice cave within the Breidamerkurjökull glacier shows just how big and dramatic these glacial ice caves can be. While the cave is stable throughout winter, its size, shape and colour can change during the summer melt, and the roof of the cave could even collapse entirely.

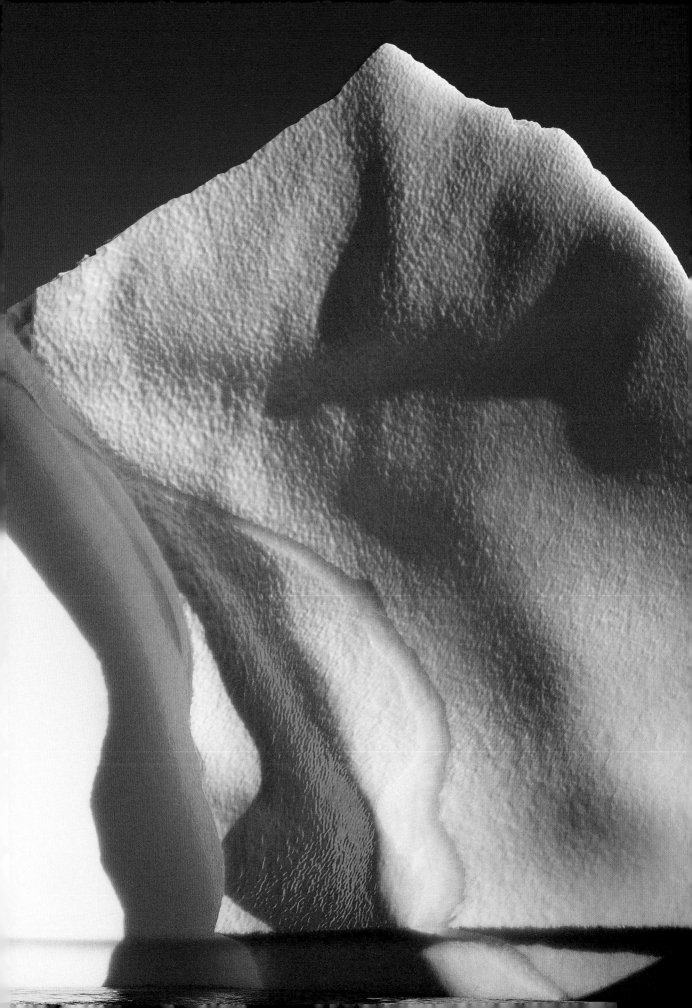

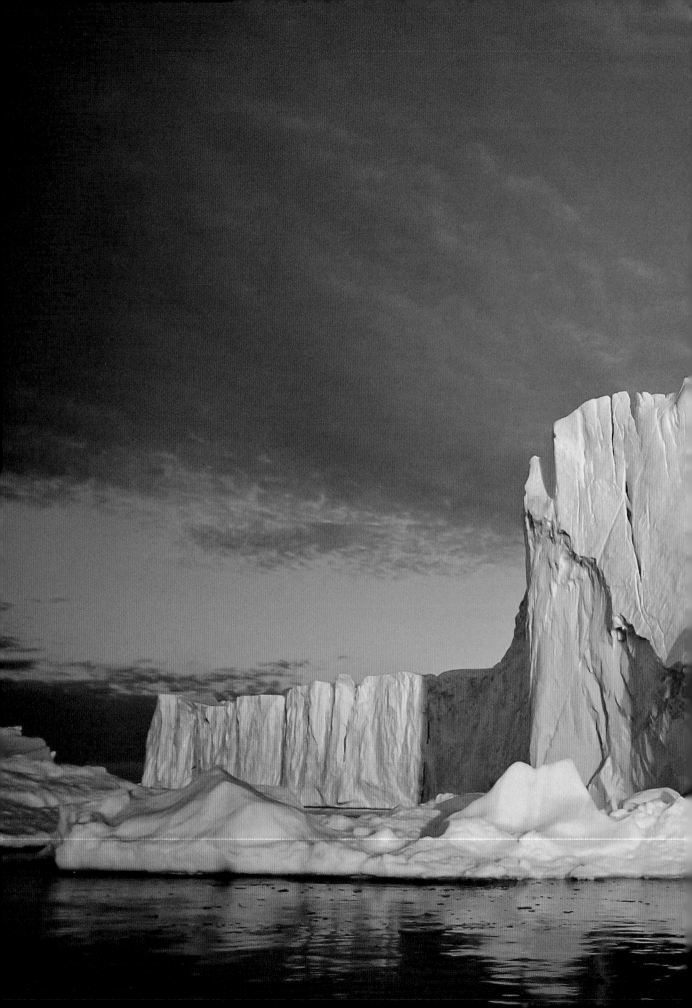

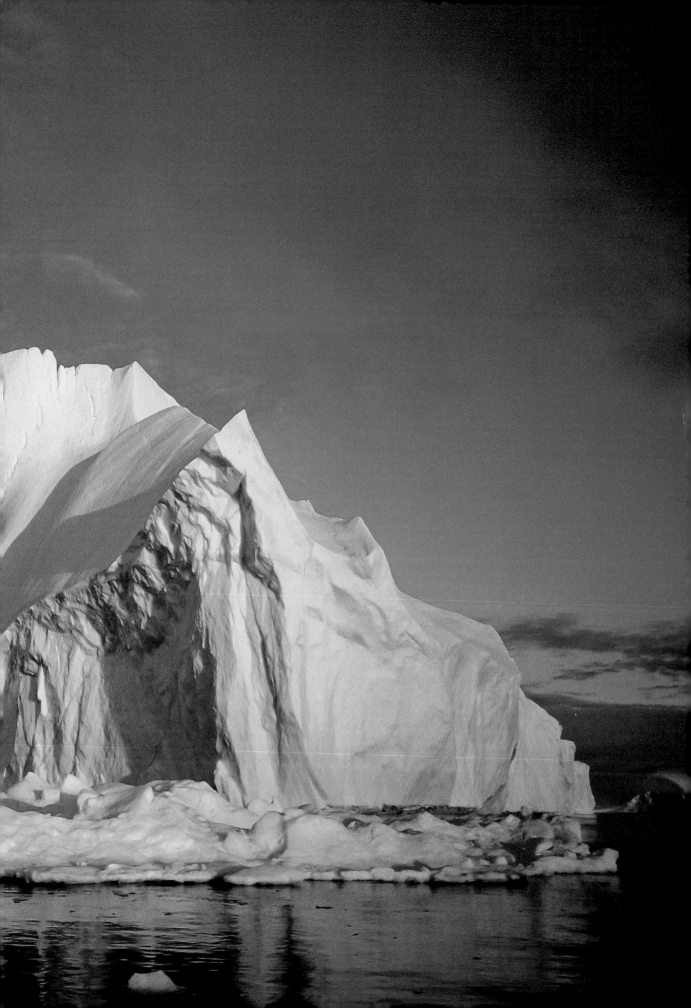

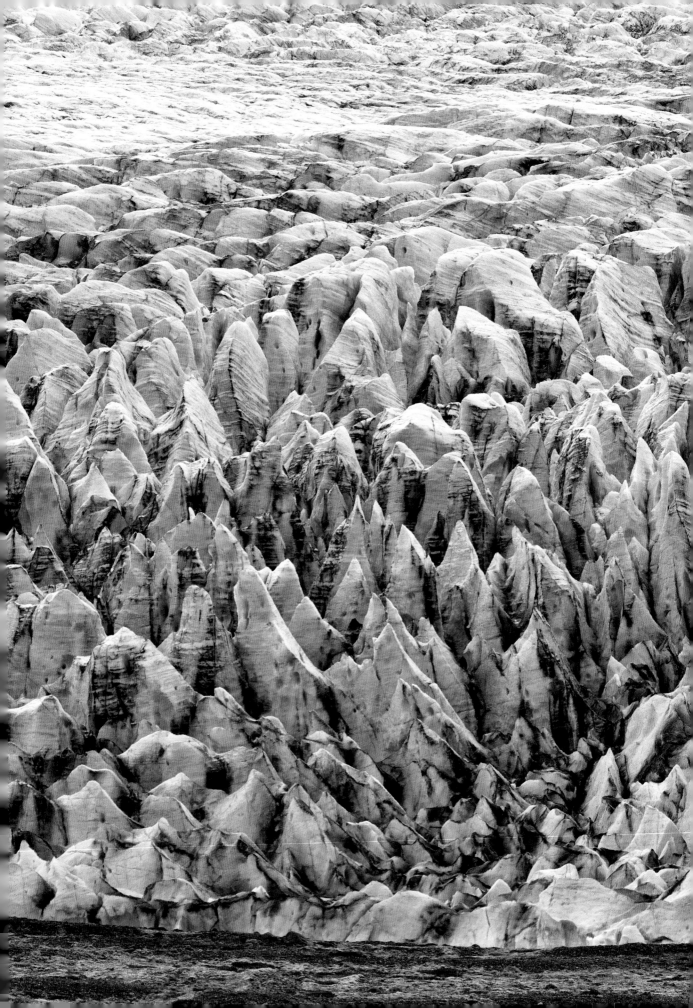

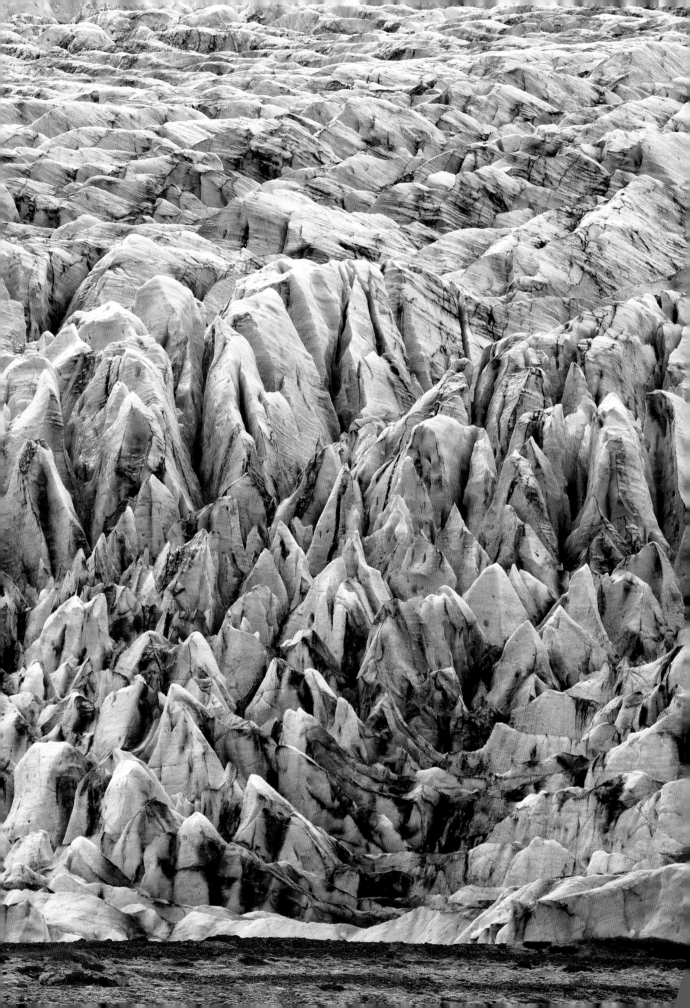

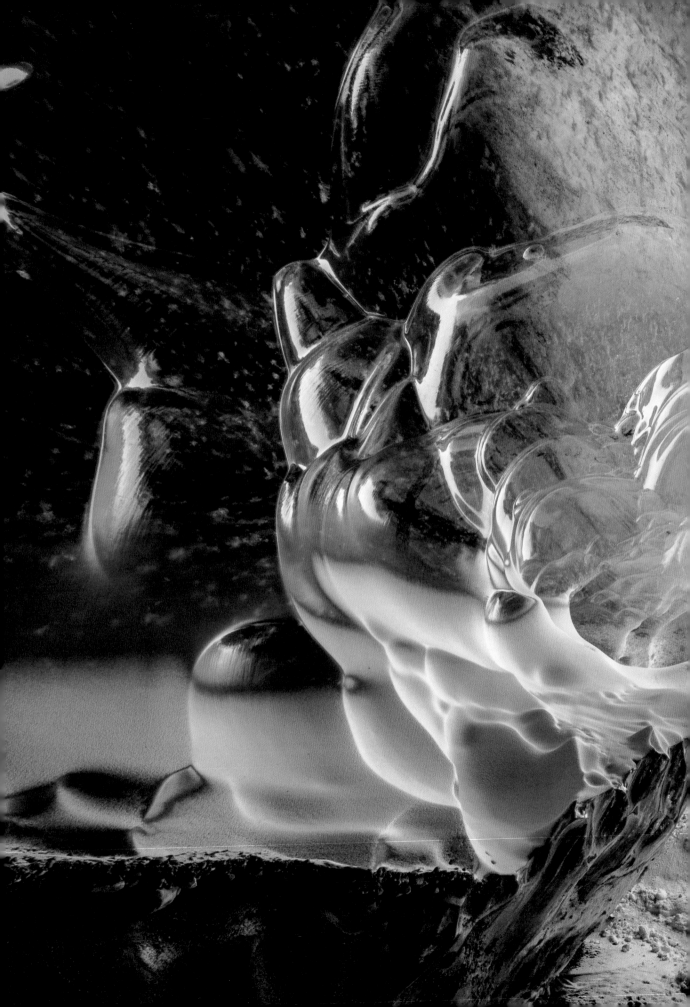

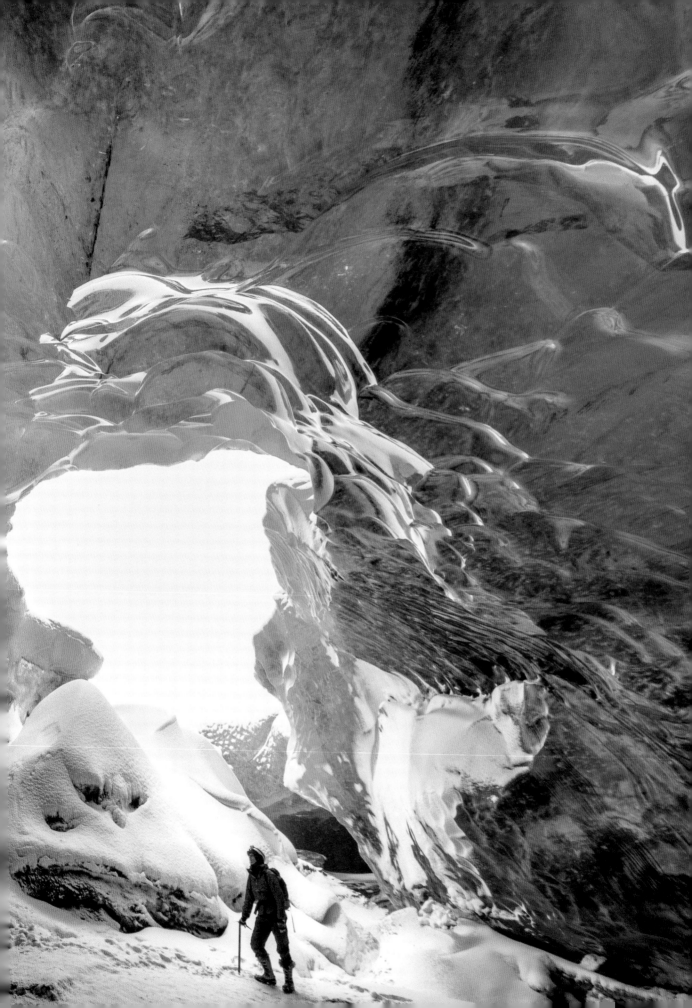

▷ RIGHT Close to the tongue of the Engabreen Glacier, a folded rock formation of metamorphic gneiss and marble rocks has been worn smooth by ice. The Engabreen is a northern outlet glacier from the Svartisen ice cap. It has the lowest terminus of any Norwegian glacier, just 7-8 metres above sea level. It has receded and advanced in recent years, but now almost reaches the shore of Engbrevatnet. This small lake is separated from Holandsfjorden by glacial debris, but linked to the sea by a short river.

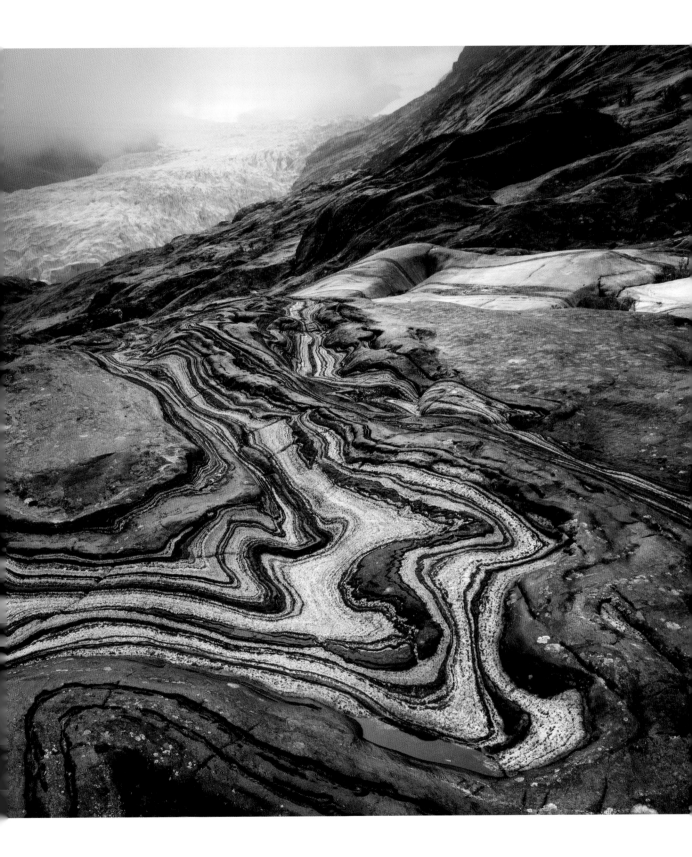

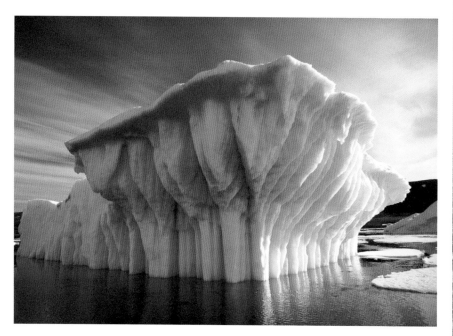

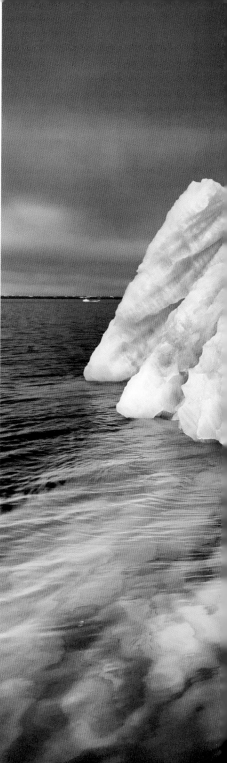

ICE

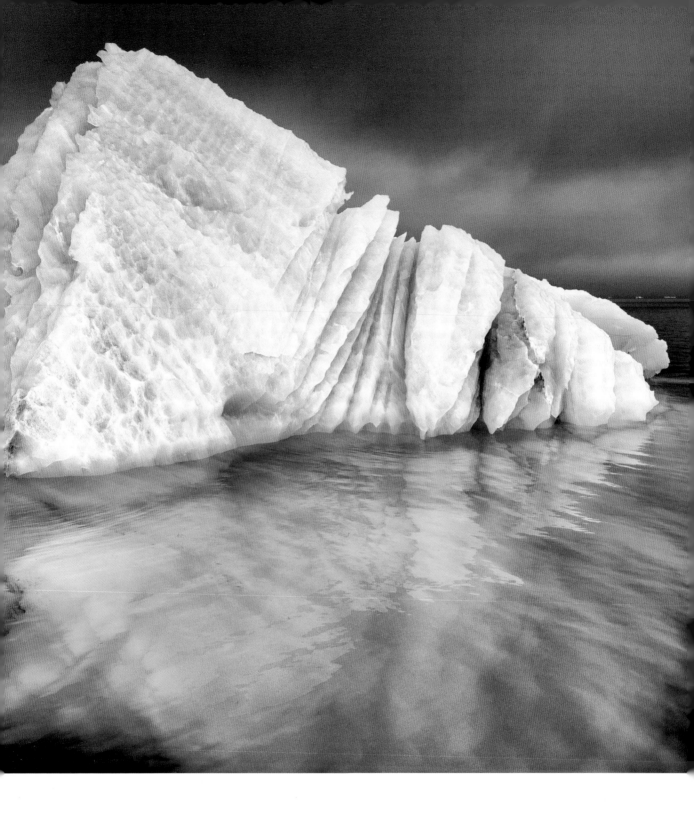

▷ LEFT This fluted iceberg has run aground on the Greenland coast. Air bubbles released from the melting of the ice have moved up to the surface, helping to erode the ice into deep grooves. They also make a fizzy sound as they escape.

▷ ABOVE With a striking resemblance to the large glass and metal Pyramide de Louvre, this natural ice sculpture floats in the sea off the coast of Svalbard, northern Norway. A hint of the two-thirds below the surface can be seen through the clear water.

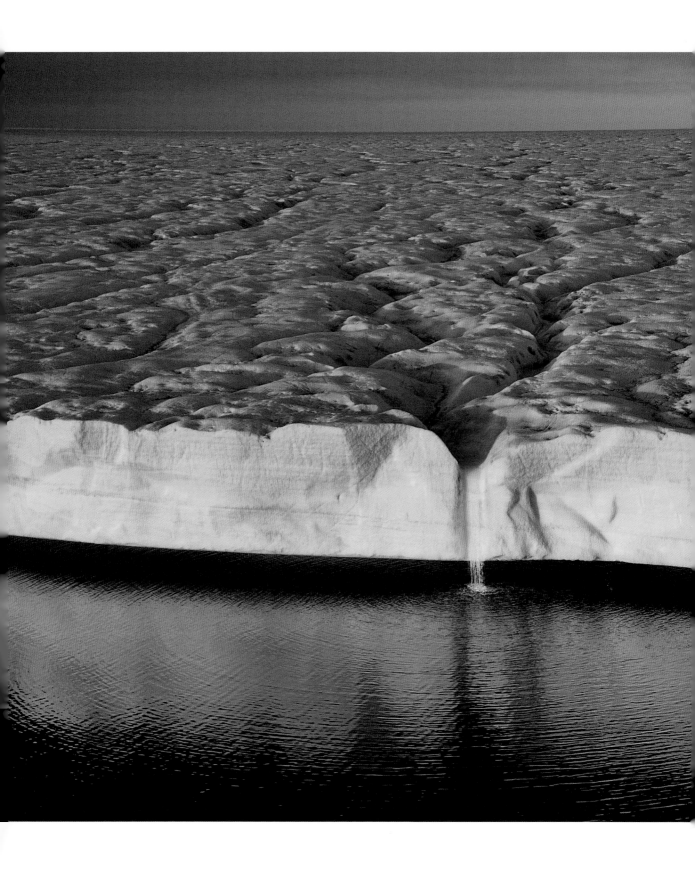

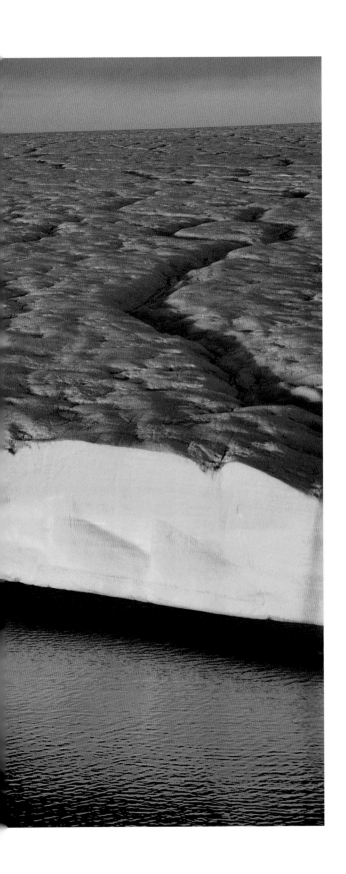

LEFT A waterfall drains surface water from the Austfonna polar icecap on the island of Nordaustlandet in Norway's Svalbard Archipelago. The 2,500 cubic kilometres of ice is up to 560 metres thick and, while most of it sits on land, on its eastern side the ice floats outwards on the Barents Sea. In recent years, scientists studying the glacier have noticed that it is thinning by about 50 metres and moving about 25 times faster than previously. Warming ocean currents are thought to be responsible.

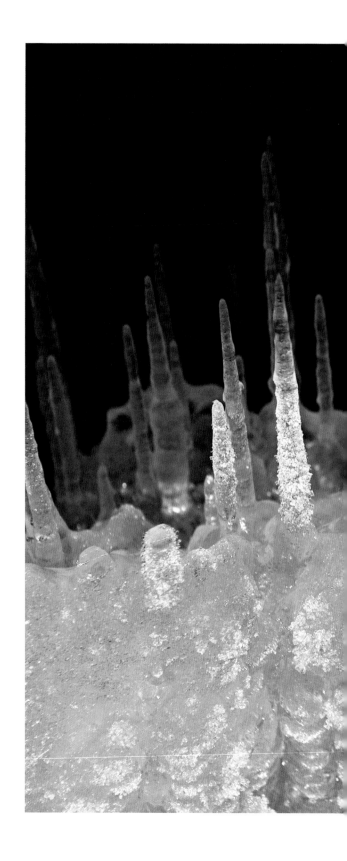

▷ RIGHT A formation of spiky ice stalactites was discovered at Lake Baikal in Siberia. The lake is the world's largest, deepest, clearest and oldest freshwater lake. It sits in a rift valley, where the Earth's crust is being pulled apart, so the lake widens by about 2 centimetres per year. From early January until May or June, the lake is covered by ice with a thickness of 1.4 metres. Where hummocks occur it can be more than 2 metres thick. The ice is quite clear, with a transparency of about a metre.

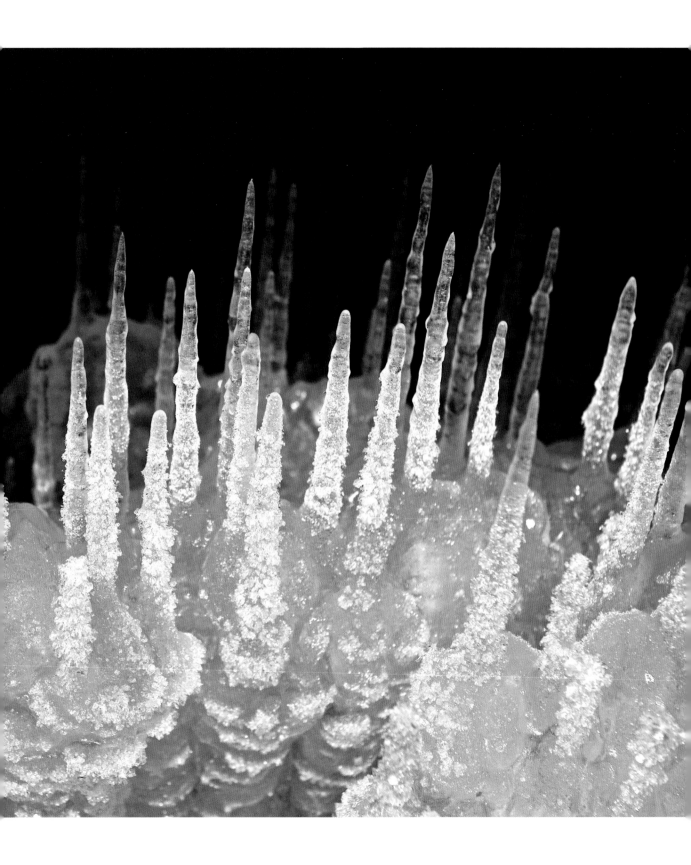

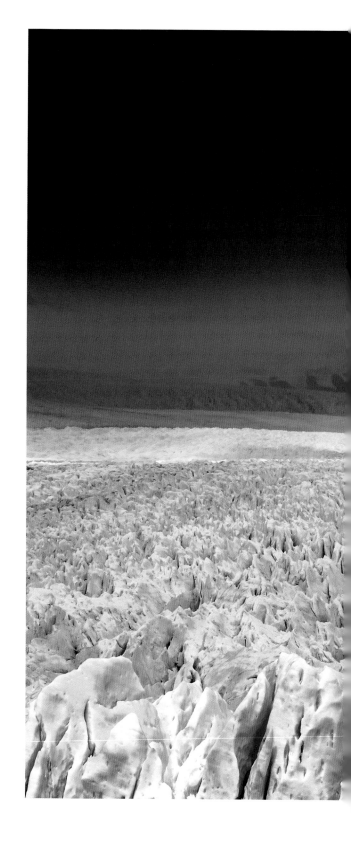

▶ RIGHT The surface of the ice of the Perito
Moreno Glacier, in Southern Argentina, is
pockmarked by deep crevasses. The glacier is
fed by the Southern Patagonian Ice Field,
shared with Chile, which nestles amongst the
peaks of the Andes mountain chain.

▶ 192-193 A massive blue iceberg floats in the
stormy Southern Ocean near the subantarctic
island of South Georgia. A seabird, flying across
its eroded arches, gives an idea of its immense
size. Antarctic icebergs can tower 60 metres
above sea level.

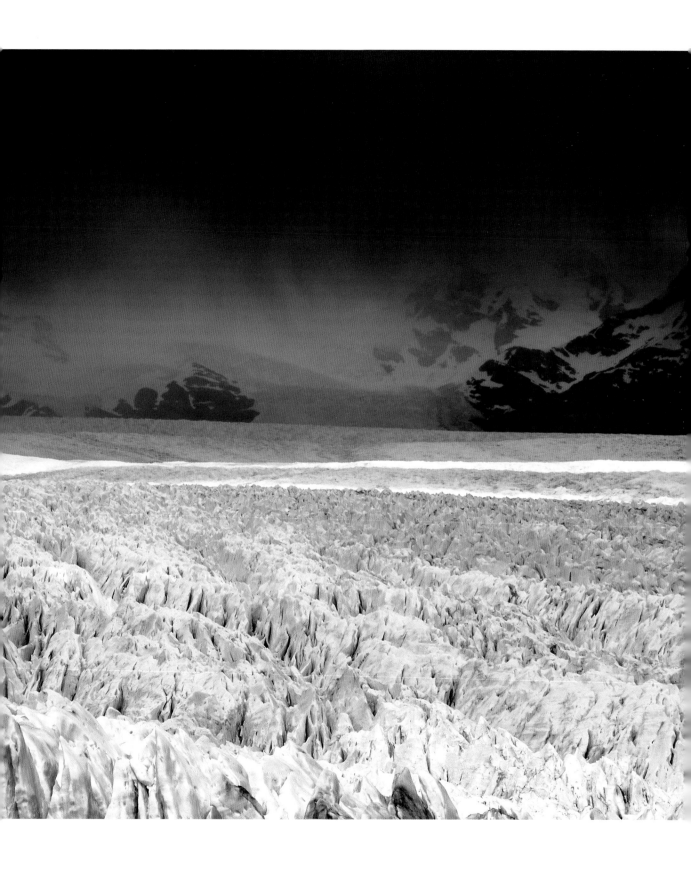

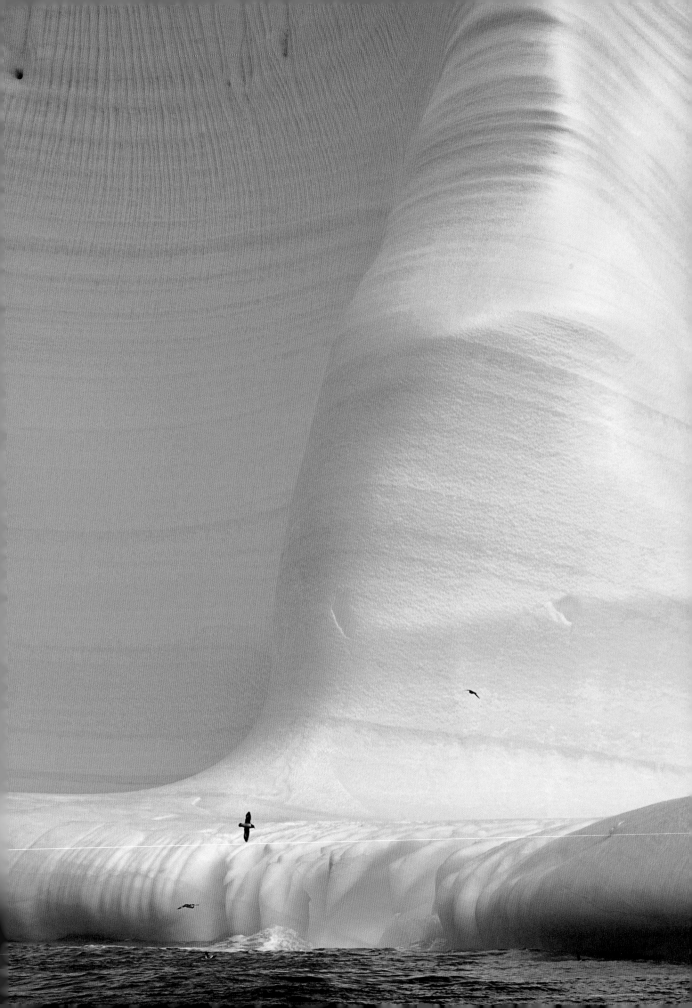

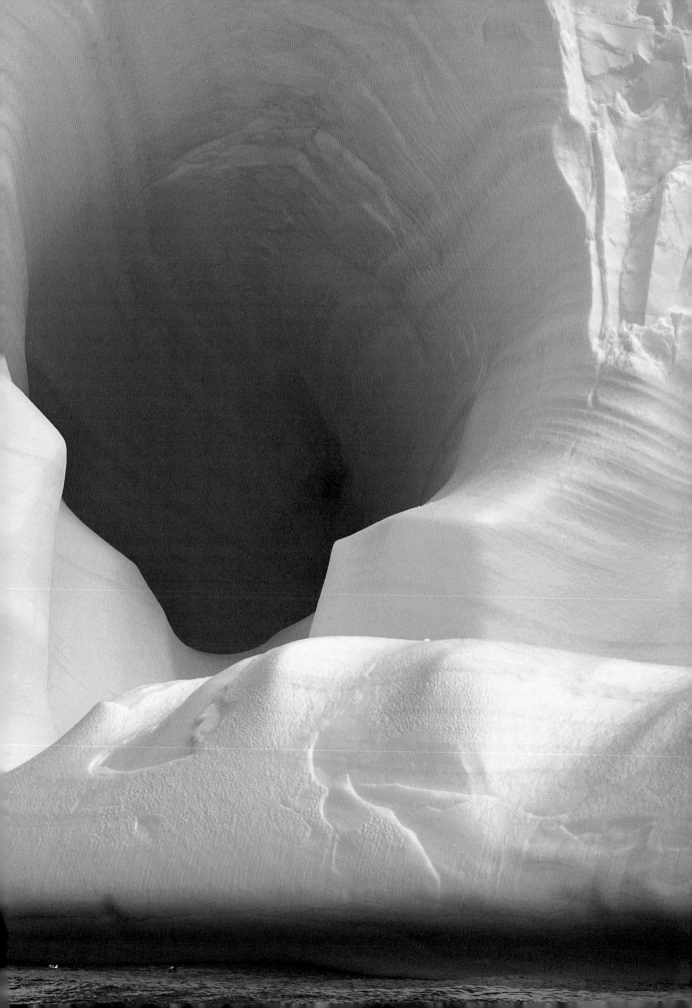

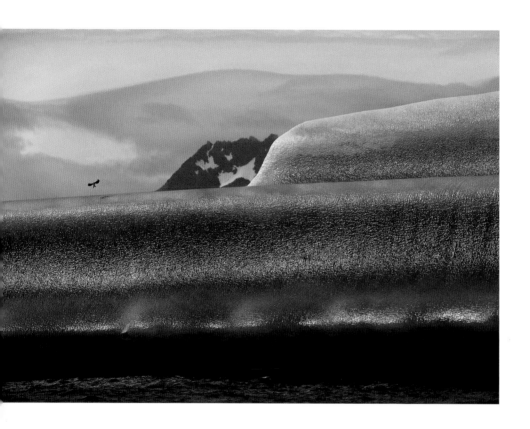

▶ ABOVE A blue-eyed cormorant lands on a shiny, smooth black iceberg near South Georgia. Many seabirds breeding on subantarctic islands use icebergs as staging posts during their long flights in search of food for their chicks.

▶ RIGHT Smooth, black icebergs, like this one off South Georgia, have a high density and are free of bubbles, so there is nothing to scatter sunlight; they appear dark. They might also contain dark rock material from the base of their parent glacier.

▶ 196-197 The Ross Ice Shelf is Antarctica's largest. Its vertical ice cliffs are more than 600 kilometres long and up to 50 metres high above sea level. An ice shelf is a thick plate of ice, formed from glaciers on the land, but which floats on the sea.

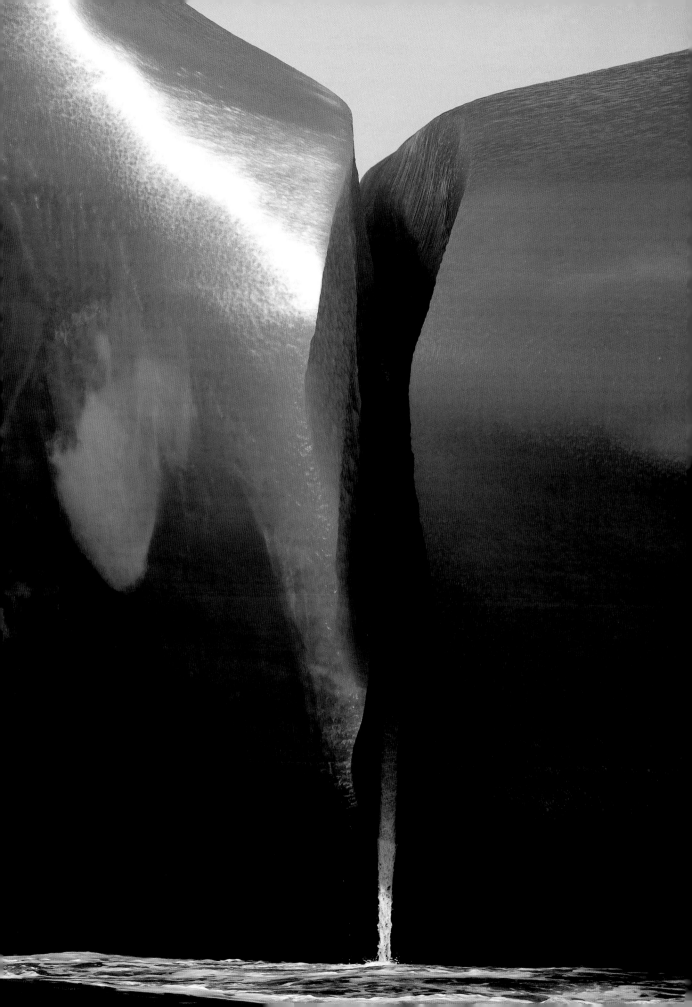

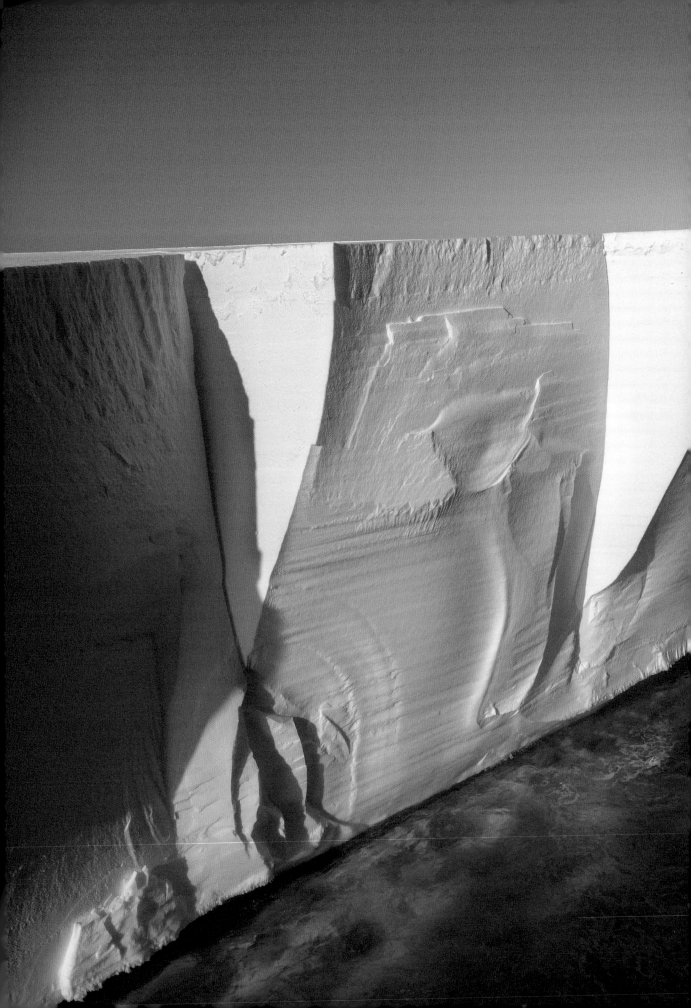

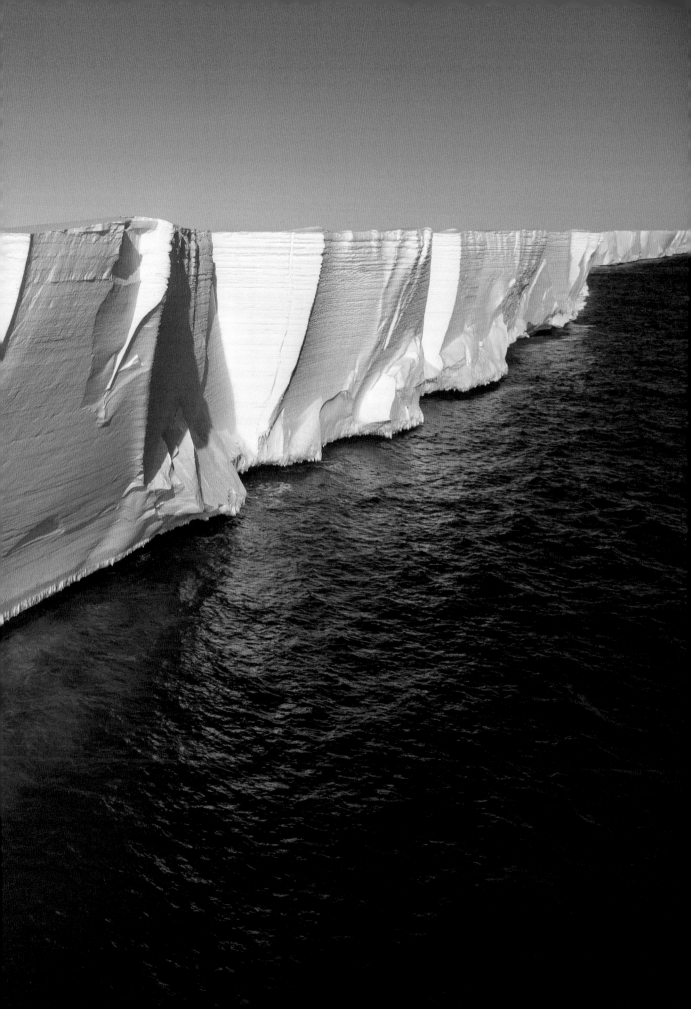

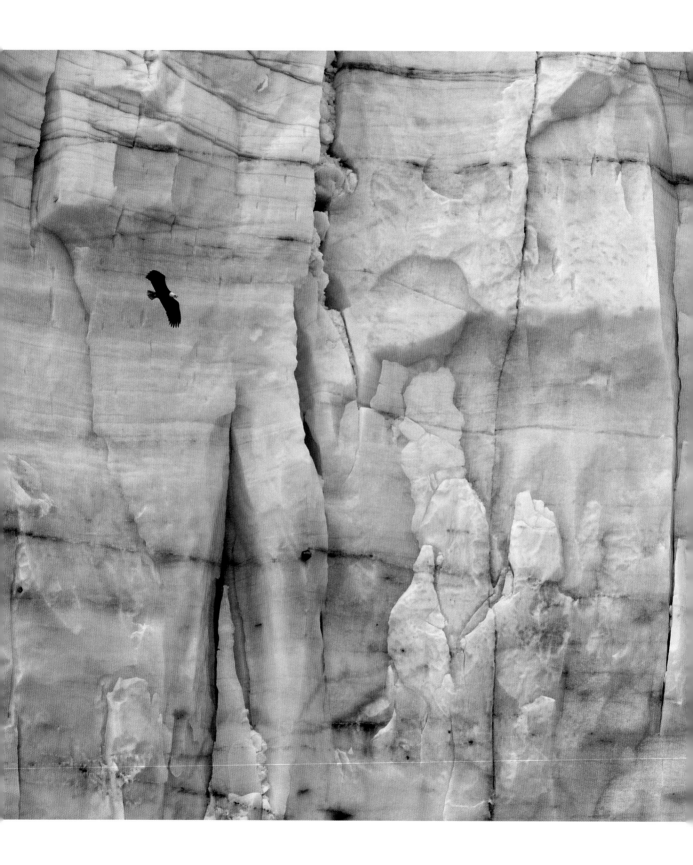

LEFT A bald eagle flies across the colossal wall of ice at the terminus of the Margerie Glacier, in the Tarr Inlet, Glacier Bay National Park, Alaska. Margerie has its origin on the southern slope of Mount Root, about 35 kilometres from the ocean. The glacier calves directly into the sea, when the cracking ice and release of trapped air sounds like gunshots. A loud roaring boom follows, as the crumbling ice falls into the water. The glacier is a remnant of the Little Ice Age that began 4,000 years ago.

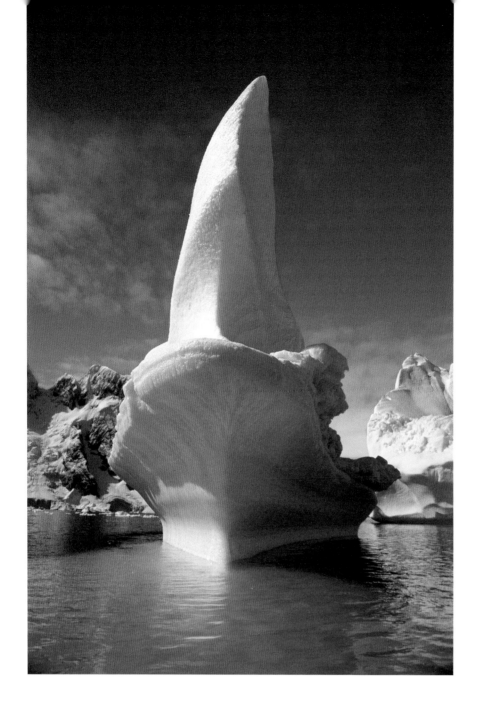

ABOVE and RIGHT Icebergs can melt into all sorts of strange formations, like the prow of a ship (above) or a human face (right). The bergs break off from ice shelves, glaciers or other icebergs and drift in the ocean currents. They can last a long time. The record-breaking iceberg that broke away from the Ross Ice Shelf in 2000 is still visible more than 18 years later. It is now in four large chunks, floating off South Georgia, but warmer seas mean it will soon melt entirely.

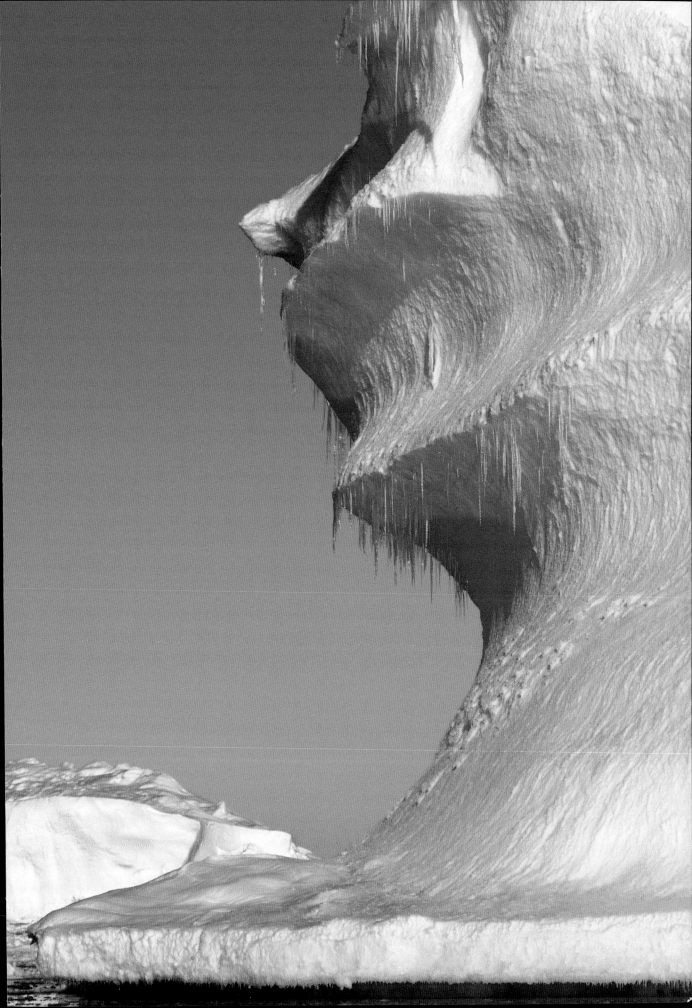

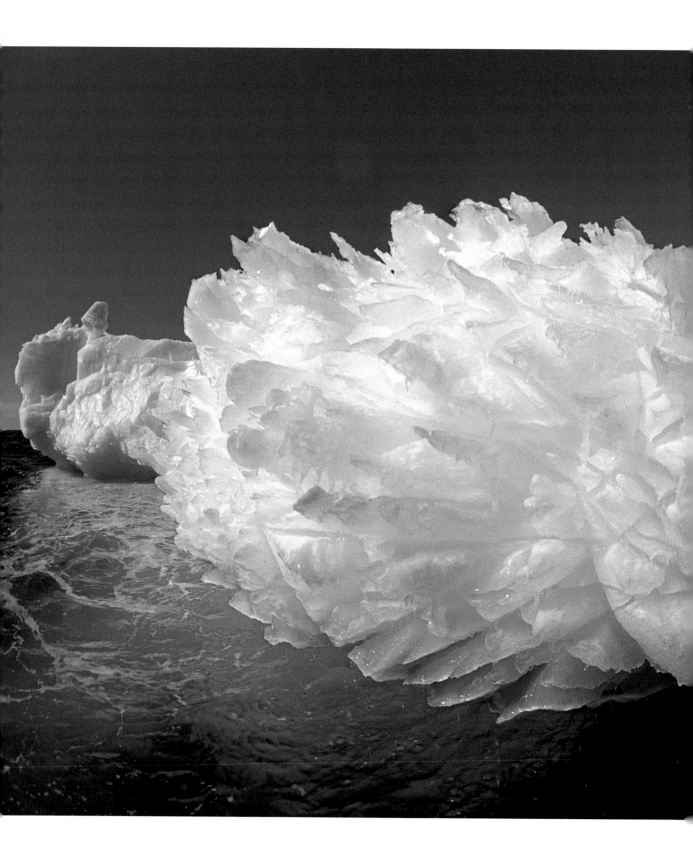

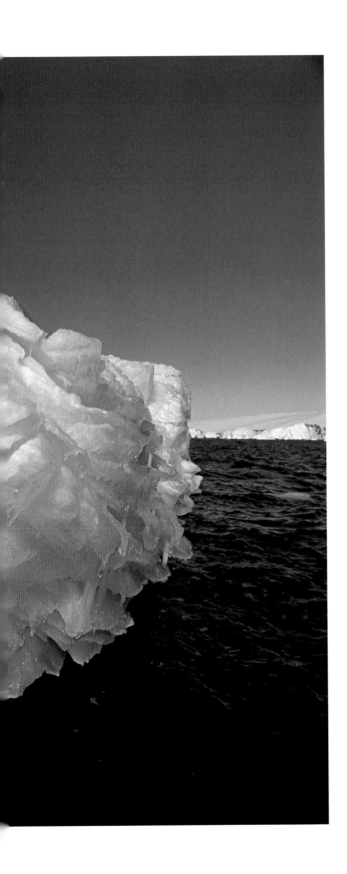

LEFT One of the most bizarre shapes for a melting iceberg must be this unusually spiky hedgehog iceberg floating off Adélie Land, a French administered segment of east Antarctica, and the prime location for the feature film *March of the Penguins* (2005).

204-205 A large iceberg has become top-heavy and overturned, revealing its underside is lined by parallel grooves eroded by seawater. The iceberg was spotted near Enterprise Island in the Gerlache Strait, on the northwest coast of the Antarctic Peninsula.

206-207 Ripples and other shapes can be seen at the centre of an exceptionally clear piece of glacier ice in the Antarctic. Trickles of melt water have refrozen like a pattern of veins on the ice's surface.

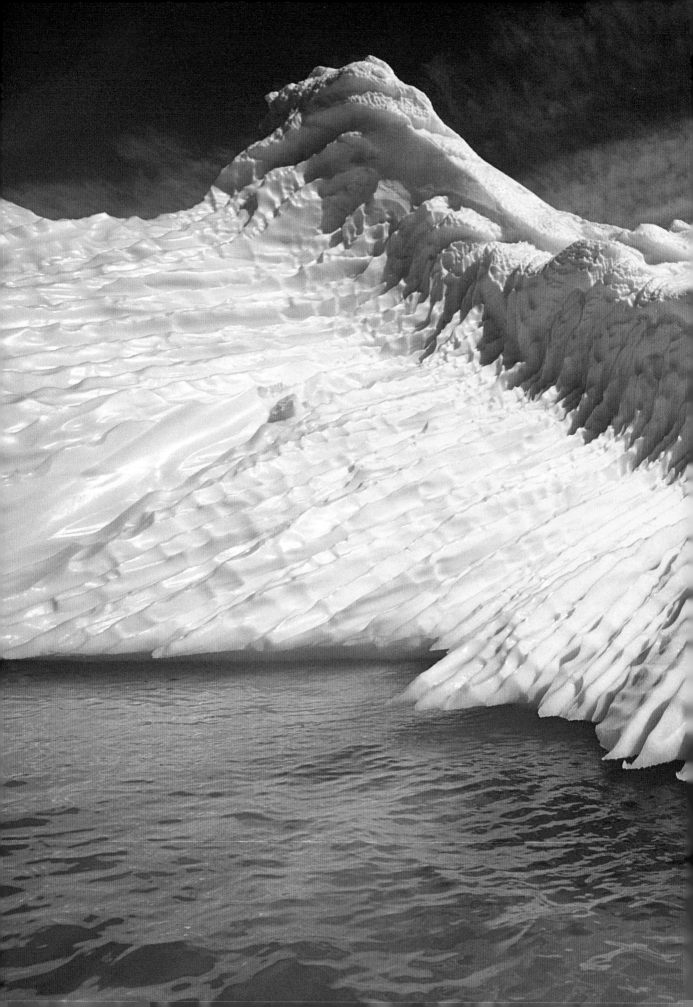

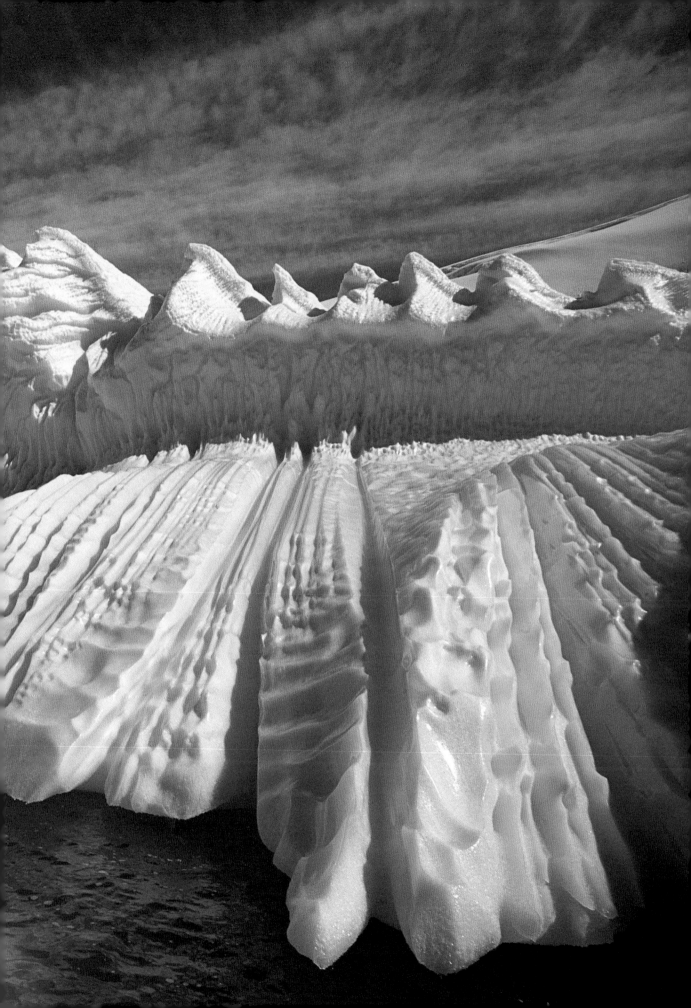

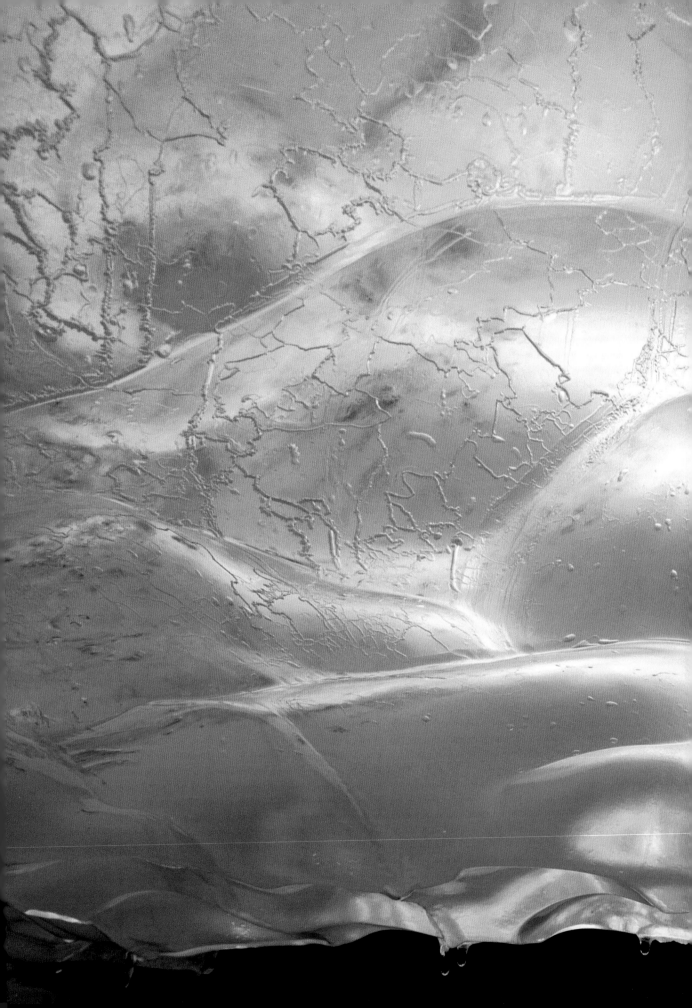

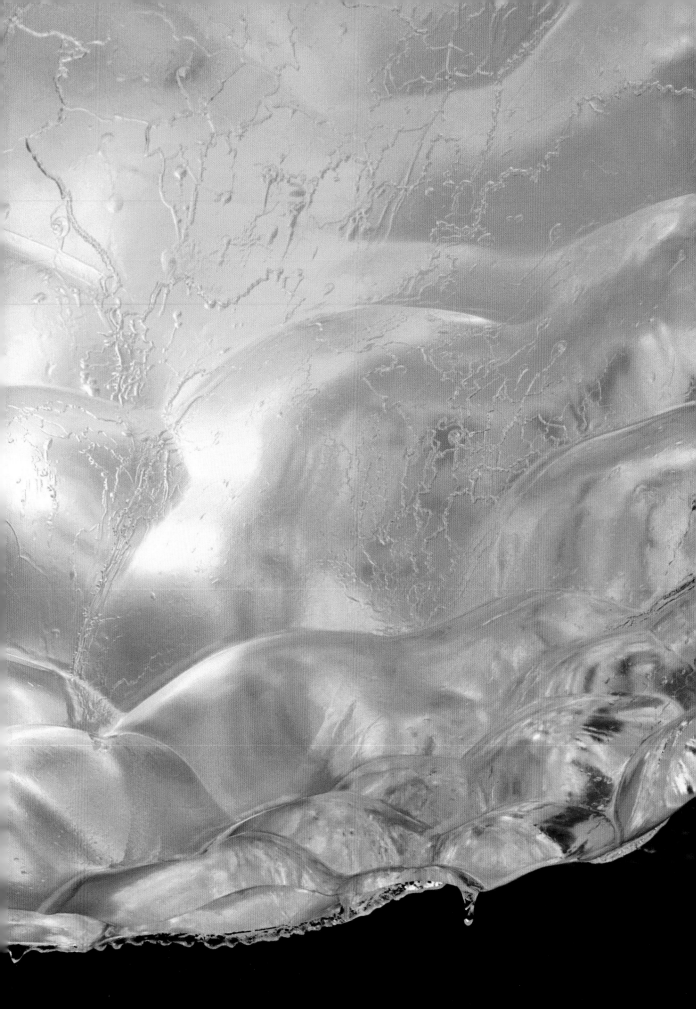

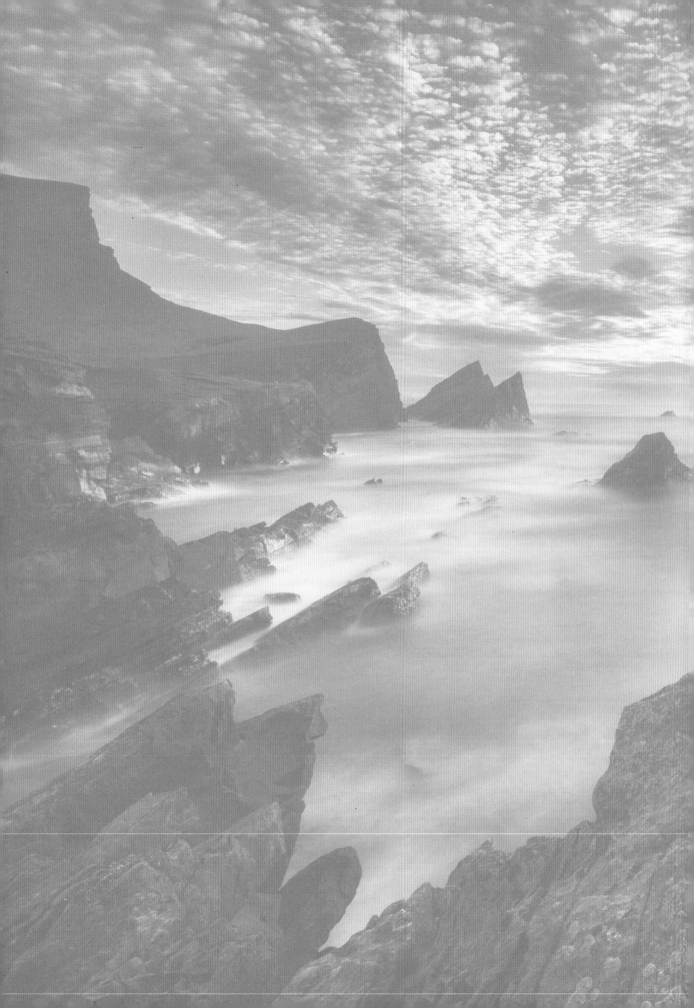